Jeff Smith's SENIOR PORTRAIT PHOTOGRAPHY HANDBOOK

A Guide for Professional Digital Photographers

AMHERST MEDIA, INC. ■ BUFFALO, NY

Published by:
Amherst Media, Inc.
P.O. Box 586
Buffalo, N.Y. 14226
Fax: 716-874-4508
www.AmherstMedia.com

Publisher: Craig Alesse
Senior Editor/Production Manager: Michelle Perkins
Assistant Editor: Barbara A. Lynch-Johnt
Editorial Assistance from: Sally Jarzab, John S. Loder, Carey Anne Maines

ISBN-13: 978-1-58428-267-9
Library of Congress Control Number: 209903893
Printed in Korea.
10 9 8 7 6 5 4 3 2 1

Table of Contents

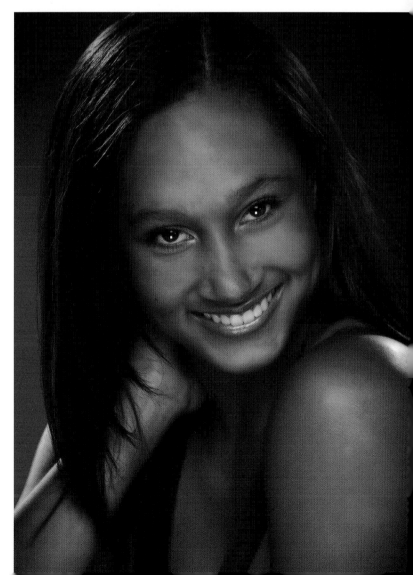

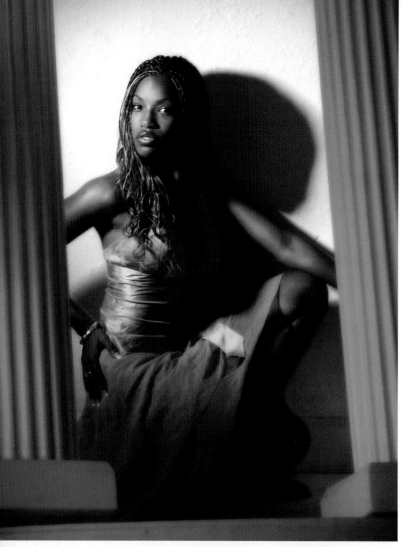

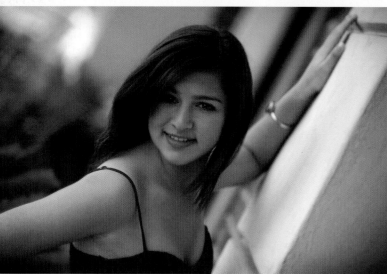

Introduction

I've written nearly a dozen books, but this one has been the most challenging because the senior market changes so quickly. The way I photograph seniors is different today than it was even two years ago. Therefore, I wanted to explain not only the way in which we work with our seniors currently but also how to keep up with a fast-changing market like this one.

It's a Business

If there's one lesson you take away from this book, it should be that photography is a business—a profession. Therefore, both the creative and the practical decisions you make must be designed to help you generate a profit. I say this up front because, while we will discuss all the things that make our hearts sing as photographers (posing, lighting, equipment, etc.), I will also be discussing ideas that may help you become a photographer who actually makes money doing what you love to do.

Being a Professional

Every professional photographer can remember the first time a photo turned out exceptionally well and the thought entered their mind that they could make this their life's work. For me, it was my during my freshman year in high school—but whenever it happened to you, whatever the details behind the story, the feelings are the same. The desire to do something that is as cool as photography for

a living becomes our passion. At that point, all of us wonder what the next logical step should be.

Fortunately, while I was still studying photography, an older gentlemen at our local camera store gave me some invaluable advice. He explained to me that until I had the skills to create professional-quality work, I shouldn't charge for what I do. I was a little upset by this advice, but then he added, "You are good, and someday you will be one of the guys who has a studio and hears all the horror stories about young, inexperienced photographers and the disasters they create for the buying public."

He was right. Today more than ever before, we are photographing clients who have horror stories about a "photographer someone in the family knew"—a person with a digital camera who offered them a picture package for $75, then delivered low-quality snapshots the client could have taken at home with their point-and-shoot cameras. Clients get very upset about these experiences with inexperienced photographers who present themselves as professionals.

This problem was re-emphasized to me when I recently attended a local lighting seminar. The speaker brought up the issue that many photographers who have come up in the last few years have focused more on fixing problems in the computer than in correctly capturing the images in the first place. As the speaker started demonstrating simple portrait lighting techniques, there were many attendees elbowing each other and completely fascinated by the ef-

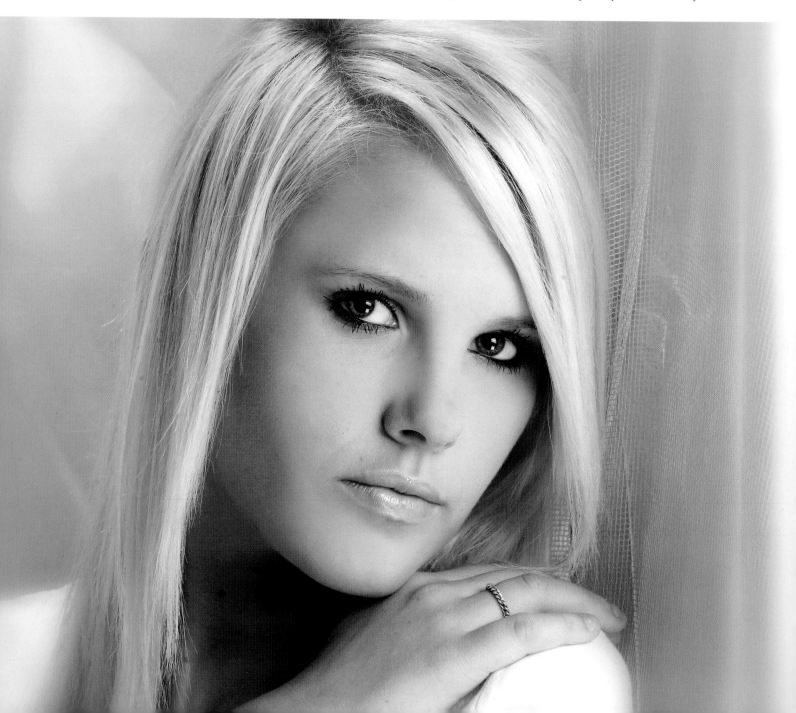

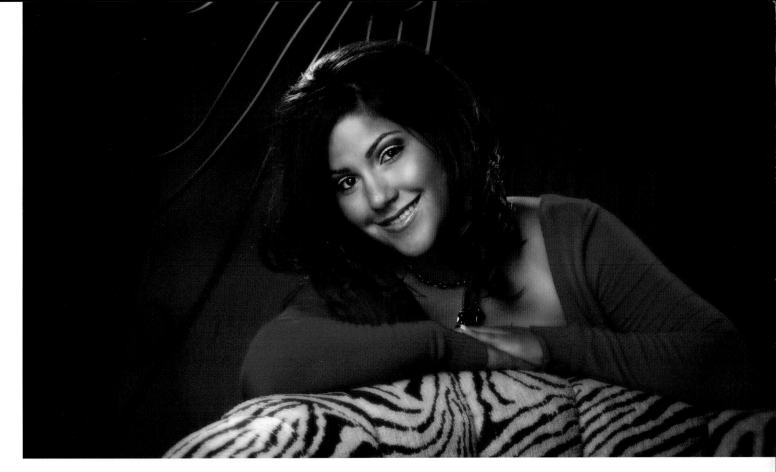

fects of simple, proper lighting on the subject. These were folks who, moments before, had been discussing past portrait clients.

I'm here to tell you that the rules of photography and professionalism haven't changed with the coming of the digital age. While you may be able to rescue bad images in Photoshop for two or three clients a month, there aren't enough hours in the day to Photoshop-away these same problems with the volume a professional studio must have. If you are taking people's money and don't know as much about photography as the full-time photographers do, you are ripping them off and doing yourself a disservice. There are no shortcuts; there are no passes. You must learn first, then hang your shingle. Paying clients should not be your training ground. Treating them this way is bad for your career in the long term and bad for the profession as a whole.

If you take the time to really master your craft, when you are ready to charge clients for your services, you will be able to create beautiful images that clients will be happy to purchase. I have been doing this for a long, long time—and even though I photograph clients every working day

of the week, I take time to practice, to grow, and to take my craft beyond where it is today. That's what it means to be a professional.

About This Book

This book will give you many of the tools you need to improve the photographic quality of your teen and senior images and the profitability of your studio through better marketing and business practices. Along the way, we'll cover a variety of other issues that will affect your success in this field. As with all my books, I have illustrated this volume with images of my actual clients, not hand-picked supermodel-types. I don't think it does you any good to learn techniques that only work on beautiful people, since the vast majority of the clients professional portrait photographers must work with everyday are not. Above all, you'll find this to be a practical book. The techniques covered are based on my actual experiences running a successful portrait studio that specializes in teen and senior portrait photography. I hope you enjoy learning—and that you put this knowledge to use in your own business.

CHAPTER ONE
The Senior Portrait Market

High school seniors and teenagers (ages thirteen to sixteen) are the clients that my studio works with exclusively. We contract with three high schools, but we also do non-contract photography of seniors and teens from all of the high schools in our area. In addition to senior portrait clients, our studio aggressively markets to the "sweet sixteen" ladies, as well as to those students graduating from junior high school.

Teenagers as Your Demographic

The senior/teen market is like no other in portrait photography. It is the most trendy, fashion-oriented demographic, it is also made up of clients who technically have no money of their own. They must rely on the kindness of others, namely their parents and grandparents, to get what they want.

Herein lies the first challenge: at every session, you will be working for at least two clients—each of whom wants something different. Seniors and teens usually want to look like they are twenty-five years old and on the cover of a magazine. Dad and Grandma want to see that angelic teenager they love (or at least their teenager made to look that way!). Moms are typically split; about a third of them

are even more conservative than Dad or Grandma, but the majority tend to give in to their children's more adult tastes.

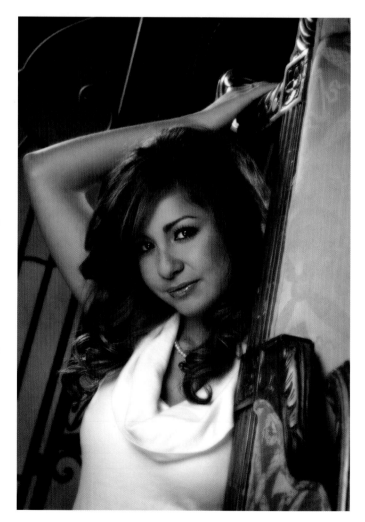

Teens are still kids, so you must find a way to make them look like cover models without creating images that are at all explicit or suggestive.

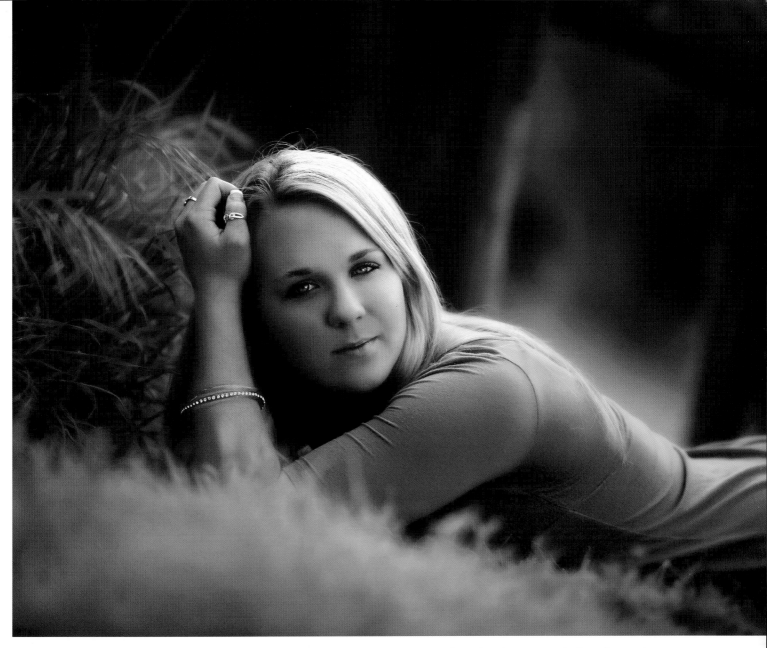

At every session, you'll need to create images that please the teenage subject—but also their mom, dad, and grandparents.

If you shoot for or advertise to only one of these demographics, you will lose the other. Lose the parent and you lose the money; lose the senior and the whole booking goes somewhere else to begin with.

First and Foremost, Teens are Kids

The first rule in working in this market is that you are working with children. Even though they may look like they're twenty-five, these teens and seniors are still children and you must work with and photograph them accordingly. It may seem like I am contradicting myself, but let me explain.

When I see the way some photographers depict seniors, I am confused and amazed. I am fairly convinced that the market for a high school senior in a G-string swimsuit or bustier is fairly limited. I think these images are taken for the photographers (who are predominately male) rather than for paying clients. If you like taking naughty pictures of adult women (as long as they are consenting), that's your business; if you like taking this type of pictures with teens and seniors, that's a problem.

While you must make your teen subject look like a supermodel, with all the allure of a girl on the cover of a magazine, you must learn to do it with your subject fully

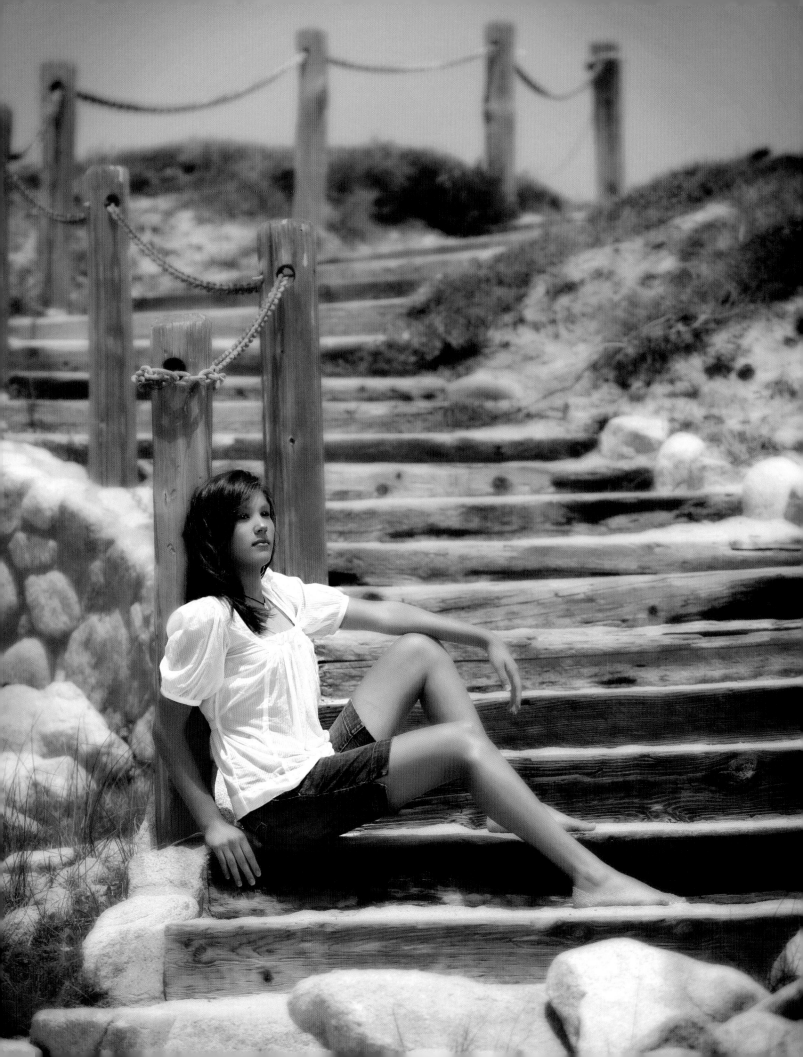

clothed—again, we are working with pre-adults. Fortunately, in photography, allure has little to do with the amount of skin showing. It is much more about the overall look of the pose, lighting, and expression. There is a definitely line between "allure" and "sleaze"—and you had better be able to find that line when working with these young subjects. In the images you'll see throughout this book, the clothing was selected by the senior/teen together with the parent—and a parent must accompany their senior/teen throughout the session. While some of the clothing may show cleavage, or the young lady may be in a short skirt, the overall look is alluring and fashionable, not sleazy.

Regional Variations

Working with seniors has a great deal to do with things other than photography, and photographers who don't really understand their local market will find it very hard to attract seniors and teens to their business. The following are the basic issues you can expect to encounter in the senior market, but these vary from city to city and state to state.

Contracted *vs.* Non-Contracted. In many areas, the high schools are contracted to one photography studio, and each senior from that high school must be photographed by that studio for the yearbook. (*Note:* In most cases, these contracted studios are larger companies that produce a senior portrait that look very much like an underclass portrait—but not always. We contract with three local high schools and offer seniors a wide variety of images choices—everything from being photographed in the studio with a Dodge Viper or Harley Davidson motorcycle to having their portrait created at interesting locations all around our city.) In other areas, the high schools don't have contracted studios. In this case, each senior selects the individual photographer they want to be photographed by and each photographer is allowed to submit senior portraits to the yearbook.

Live with the Reality. The way the high schools in your area work is just the way they work. You have two choices: find a way to succeed in getting your local seniors to come to your studio, or move. Whatever you do, don't

ABOVE AND FACING PAGE—*With creative posing and image styling, you can design images with both the allure that teens want and the more classic look that parents appreciate.*

spend your time whining about the contracting process or how unfair it is. You must know how the high schools in your area are set up and understand that if all the high schools are contracted and you don't have those contracts (you market directly to get your senior bookings), your numbers will always be lower than those of photographers in areas with open high schools—all other things being equal. Even if you live in a contracted area, however, there is no reason you can't get a reasonable number of senior bookings each year. Notice I said "reasonable"; if you live in a rural area with one contracted high school that graduates just a hundred seniors each year and you want to spe-

There will always be seniors who are willing to invest in something different than what is offered by the contracted studio.

nomic classes), you can count on 10 to 25 percent of seniors doing no senior portraits at all—or doing just the yearbook portrait offered by the contracted studio and purchasing no prints from the session. If we look back on the aforementioned high school with one-hundred graduating seniors, that means that up to twenty-five of them won't buy senior portraits at all.

In a contracted high school that has a competent photography studio (not the best, not the worst) 30 to 40 percent of the remaining seniors (after the 10 to 25 percent who don't buy anything) will purchase their senior portraits from the contracted studio, just because it is easy and they have to go to the studio for the yearbook anyway.

So, in that class of one hundred students, that leaves about forty-five students (or less) who may buy senior portraits from someone other than the contracted studio. That number will be even lower if the contracted studio is a good one that offers these forty-five students a wide variety of great-looking images. (*Note:* These are averages. The number of students seeking portraits from non-contracted studios will be higher in more upscale schools and lower in less privileged schools).

Continuing on with this example, of those forty-five students from the class of one hundred seniors, thirty to thirty-five will be girls and ten to fifteen will be boys. Let's face it, most boys aren't into having their portraits taken. The number of girls responding to senior portrait ads will always be two to three times as many as guys—and this is true at almost any age level. In many markets, we actually buy "girls only" lists to reduce the number of non-response pieces we send out.

Some photographers will read this and feel depressed, but you shouldn't. Those forty-five seniors are the cream of the crop. They are the seniors who are willing to invest in their senior portraits because they want something better than what is offered by the contracted studio. These are the seniors who will generate orders of $1,500 to $5,000—if you learn how to create portraits (and a portrait experience) that will excite them. You have to give them their fifteen minutes of fame.

cialize in senior portraiture . . . well, I have some bad news for you. It's not going to happen. The numbers just aren't there.

The Numbers

Many photographers get frustrated with senior portraiture because they don't understand their local market and the basic percentages of seniors who buy portraits. In a typical high school today (with a normal cross section of eco-

Creating the Experience

Today, more than ever before, seniors and teens are looking for an experience when they decide on a portrait studio. They want that feeling of having their fifteen minutes of fame. They see it on television, they look at images in magazines, and that is the experience they want to have at their session.

Great Portraits Aren't Enough

In truth, the experience your clients have during their time with you is often even more important than the portraits

The experience of the session actually impacts order sizes even more than the quality of the images produced.

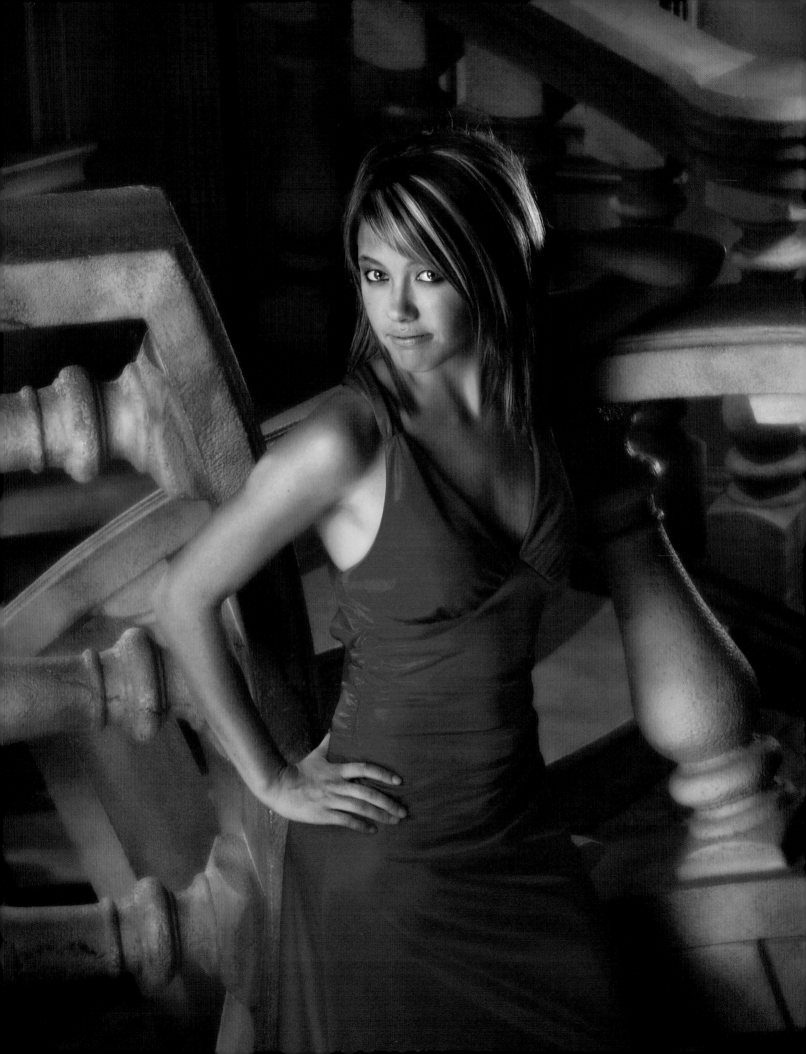

RIGHT AND FACING PAGE—*A great experience combined with great portraits will help you get your share of the market.*

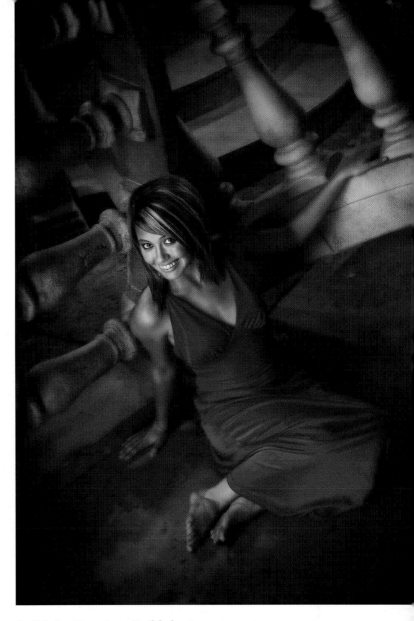

themselves. Statements like this infuriate many student photographers and photography professors, but that's the reality of the marketplace—and not just in photography. I'll bet there's at least one restaurant in your town that has so-so food, but the experience of going there is so good (so fun, so elegant, so *something*) that you pay the price, eat the so-so food, and look forward to the next time you can go back.

I am not advocating creating a so-so product. What I'm saying is that, even if you can create the finest teen/senior portraits in your area, if you don't create an *experience* that will excite this market, you won't be photographing much of this market—or at least as much as you could. If you create beautiful portraits and combine it with an experience that makes the kids who are looking for something special feel as though they are getting their fifteen minutes of fame, you will get your share of this market.

I am not the only successful senior photographer who knows the importance of creating an experience for your clients. I was at a convention recently and attended a seminar with senior portrait photographer Kirk Vulcan. He was doing a demonstration in an outdoor area, when he instructed his model for the class (a high-school senior herself) to walk down an outdoor path and then walk back to him with her best "model down the runway" walk. The light was terrible, the background was so-so, and the girl walked as though she had a back injury. This man is an excellent senior photographer, so I wondered how he could be so wrong in his choice of location, lighting, and directing the model. When the girl got to the end of the pathway and turned to make her way back toward us, however, he said under his breath (to the group of photographers) that she was never going to see these images, because everything was wrong—but this type of exercise made her feel like a model and increased her enthusiasm during the rest of the session. He definitely gets it.

So, while I am going to show you how to take beautiful images, the first step to work on is creating that supermodel experience for your clients.

Build the Emotion, Build the Investment

I have always worked on creating an experience for clients who choose our studio. From the decor of the space, to the way my staff greets and takes care of them, to the names of the products and the way in which they are displayed, everything is directed toward making them feel like superstars. We make it all about the experience, which is why we are successful. It's also why we have a high buy rate in our contract schools and photograph so many seniors from other high schools in our area.

As you are shooting, you should also constantly reinforce how beautiful the subject looks. As the images download, show Mom the images so she can join in telling the teen how great they look. I want to make every mom tear up at least once during their child's session. Here's the

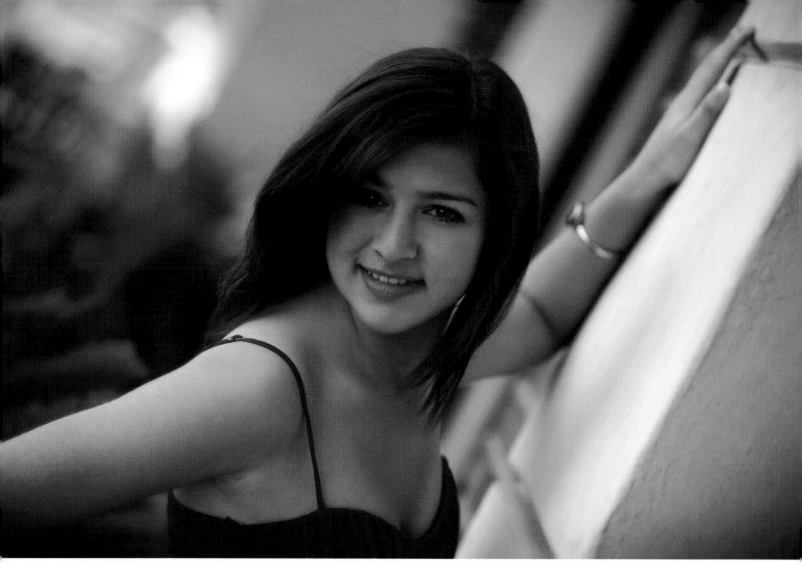

Your subject's expression will be best when they are looking at someone, not something.

bottom line: the more energy you can generate during the session, the more you can emotionally move your subject (and their parents) with the images and experience you create, the more business you will earn and the more money you will make from each session.

Keep it Moving

Most photographers shoot like old portrait photographers, slowly and methodically—because that's how we were taught to do it in school. To make the senior or teen feel like a model, however, you need to speed up the process. Have a latté or two before the session, then speak and shoot with energy.

Now, although I am a fan of shooting quickly for the experience it gives your clients, there are two points I must make.

First, I like shooting from a camera stand (a tripod is fine, but I move a great deal—both around the camera room as well as up and down). Shooting from a stand lets me make eye contact with the client and see the image in the split second it is captured. This improves the client's expression because they are looking at some*one*, not some-*thing*. When the camera is supported (not hand-held), I also know exactly what image I am creating without have to wait for a little preview on the back of the camera. So what's the problem with this? Well, this is how portrait photographers shoot—and teens don't want to be photographed by *portrait* photographers, they want to be photographed by *fashion* photographers like the ones they see on television photographing models and celebrities. Therefore, once all my shots are done for a particular background/set/outdoor area, I take my camera off the stand

and start shooting hand-held images. I quickly change the angles of the camera, try different compositions, and work closer to the subject. I may only take five or ten shots—but that's enough to give the subject what they expect from watching photo shoots on television.

Second, while I advise shooting in an energetic, fast-paced style, I *don't* put my camera on hyperdrive and take hundreds of images that I (or someone else) must then edit down to a workable number. Time is money. When I hear photographers say that they capture several hundred images in a single senior portrait session, I immediately think that, while they might be great photographers, they're not great businesspeople. I can take ten images—five smiling and five non-smiling—from the camera stand and another five to ten hand-held shots and have more than enough images for my client to select from. This lets me create the super-model experience without wasting undue time editing images. We will be talking more about this in chapter 8.

Break the Rules

When photographing teens and seniors, how many times do you find yourself shooting a portrait while lying on the ground? Or while up near the ceiling on a ladder? How many times do you tilt the camera to throw off the vertical and horizontal lines in the portrait? I hope you can answer that you do it often. Teenagers like images that seem different—portraits they perceive as unique—and it's amazing how much you can add to a portrait by taking it in different ways. Many photographers get so settled in their shooting that they select the height of the camera based on their comfort and not the camera angle that would best record the portrait. Many photographers think that vertical and horizontal lines must appear vertically and horizontally in the portrait. While that may be the ideal in architectural photography, you need to let go of that concept immediately if you're shooting senior portraits!

Viewing the Images

The Advantages of Selling Immediately After the Session. The excitement you've built through your marketing (to get the client into your studio), the consultation (to get them excited about the big day), and the session (to make them feel like a super-model) shouldn't come to a crashing halt when you put down your camera. If you were an impatient senior or teen and just had the experience of a lifetime taking portraits that you feel are going to be beautiful, what is the next thing you'd want (and expect) to do? View the images! If you don't allow your clients to view their images immediately after the session, you are thinking like a photographer, not a businessperson.

The Excuses You'll Hear for Not Doing It. There are many excuses that the average photographer gives for why they don't show the images to their clients immediately after the session—and most of those excuses have to do with (again) thinking like a photographer, not like a businessperson.

I Need Time to Edit Down the Session. The first excuse stems from an issue we have already mentioned: shooting too many images. When this happens, in order to show the clients their previews, the photographer must first edit down the total number of images to a manageable size. But take a step back. When photographers shot on film, was this ever a problem? Film photographers never needed to take three-hundred shots to provide the client with forty or fifty beautiful images. Today, the use of digital capture has led many photographers to adopt the attitude that if they just take enough frames, there's bound to be some good ones among them. The truth is, if you can't keep a session under (or around) a hundred images, you have a control problem—a lack of control. You let excitement overrule your common sense and when something looks good you take forty shots of the same exact scene, pose,

BUSINESS SENSE IS NO LAUGHING MATTER

I poke fun at most photographers' business sense, because from what I have seen it is well deserved. The next time you are at a seminar, take a moment to see how many photographers look like they are actually pulling down the big bucks. I live in a medium-sized city and there are just a handful of photographers running successful businesses—but there are hundreds of photographers running around trying to pay the rent. Unfortunately, many photographers don't realize they are running a business that sells photography, not creating photography that sells itself—because there is no such thing.

and expression. That creates a lot of material that someone must then edit. I limit myself to fifteen shots per scene—no matter how beautiful the portrait or the model may be.

Too Much File Processing is Required. The second excuse photographers make for not allowing clients to view their images immediately after the session is that they shoot in the RAW mode. The largest portrait you will sell most sen-

ior/teen clients is 20x24 to 24x30 inches. When working in the controlled environment of your studio, if you need to shoot RAW files to make a portrait this size look good, there is something wrong. Many photographers choose RAW files for all their studio shoots because it gives them the latitude we used to have with print film, which would produce a usable image even when it was way overexposed

or slightly underexposed. Shooting JPEGs on a digital camera is more like shooting slide film; it offers very little room for error. But then, back in the days of slide film we didn't have custom white balance, a histogram of the image, and a digital display that showed you each image while highlighting any overexposed areas for you. With these tools, if you can't be consistent enough to shoot

JPEGs in the studio, you are either just plain sloppy or you need to work on your basic shooting skills.

I Need to Retouch the Images. Another excuse photographers use to avoid viewing images immediately after the session is that they need to retouch them to fix the problem areas before the client sees the portraits. What Einstein came up with this one? According to this logic, you'd shoot five-hundred images of a single client, spend an hour editing them down to a hundred images, then invest a whole lot more time doing even light retouching on each of those files—the vast majority of which the client will never order. In the days of film, the previews weren't retouched; clients just had to realize that their skin *would* be perfect in the final images. This is not to say that the idea of showing retouched images isn't interesting—but if you have to cash in the excitement of the experience to do it, I wouldn't. Just because we *can* do something with digital, doesn't mean we *should*.

Simplify the Process. In our quest to improve things, more often than not we just end up complicating them. Years ago, department-store photographers started showing digital captures of the same image they had just recorded on film. They realized that the client's excitement alone could overcome many of the shortcomings of their photography and maximized their sales by providing a straightforward method of showing the images without overwhelming or confusing the client. Once digital photography became mainstream, however, photographers

Showing clients their images immediately after the session capitalizes on the excitement and energy of the session—and that means bigger orders.

Only show what you intend to sell. If you are selling slideshows or presentations, by all means show them. If, however, you are selling printed portraits, keep your client focused on the portraits by showing only still images.

started complicating the entire process with slideshows and multimedia presentations that, while inspiring a good emotional response, also tended to confuse the heck out of the buyers.

People can only make one decision at a time; if you show them a hundred images in a slideshow, you're going to generate mass confusion, not massive sales. In fact, the first thing clients see is typically what they'll want to buy—so you may find that while you are trying to sell them wall portraits and prints, they keep asking you how they can buy the slideshow they just watched.

Only one decision at a time—that's the key. First, go systematically through the images and have the clients pick the best pose from each background/setting—just one! When this is done, pull up the individual eight or ten favorite poses they chose and fill the package they have ordered from those poses; most clients won't have trouble making decisions once you've narrowed the images down to this point. Next, sell them all the add-on products you offer (frames, folios, album, templates, etc.) and collect your money.

Don't Overdo It

The experience of the session *is* the most important part of the session to this market—but that doesn't mean you can throw logic and business sense to the wind in order to do everything for your client. Let me explain what I mean.

When I go into a business—let's say it's a spa—I feel more pampered when they have one person greet me, then another person take me to an area to get ready for my massage, then the person doing the massage come to take me to my little room. All that attention makes me feel special. If I go to a spa and one lady greets me, take me to the changing area, then gives me the massage . . . well, I feel as though I have been robbed of the experience. No mat-

ter how good the massage may be, it never seems as good as when there is a whole staff of people taking care of me. The owner/manager of the spa might think that being attended to by a single member of the staff will make me feel like I'm getting more personal attention, but it actually makes me feel like the person giving the massage is less "special," for lack of a better word. After all, if they were so good at giving massages, why would they also be working, basically, as the receptionist?

In contrast, let's look at the kings of respect: doctors. When you go to a doctor's office, you see three to five people before you ever see the doctor. When he or she enters the room, they have a presence—which they wouldn't have if they were also the ones photocopying your insurance card, directing you to the waiting room, weighing you, and taking your temperature.

While a senior might be in my studio for more than three hours, I only see them for thirty to sixty minutes. My staff takes care of everything for them. I only create the images; I don't greet, I don't show portraits, I don't work in Photoshop. When I am behind the camera, I can generate $800–$3000 in sales per hour for my studio; the minute I do anything else, my value plummets to $9–$12 per hour—the hourly rate I could expect to pay someone hired to do those other jobs.

I've attended programs by senior photographers—often those who describe their business as a "boutique studio"—who personally meet with each senior portrait client before the session and then spend three hours taking five-hundred images. Then, since they shot all those images, they spend another ninety minutes editing. Next, they do some light retouching on the edited images and personally create a slideshow of all the portraits. Finally they spend anywhere from ninety minutes to two-and-a-half hours in the sales room. After all this, they then boast, "We have an average senior sale of $1800 or $2000!" For all the personal time they put in, they had better.

I counted up the hours one of these "boutique" photographers spent with a senior from the first meeting to the end of the sales process—and that one senior had taken up somewhere between eight and nine hours of his time. Time is time; just because you take work home doesn't

mean the meter stops running. He then said he had an $1800 session average, which means he generates $200 per hour for his studio with every senior client. Now, imagine he changed his style and photographed each senior for only one hour and had staff do everything else. Even if his average sale went down to $400 per session, he would double his hourly sales! That's something to think about.

So, yes, it's possible to go too far in trying to create an experience for your clients. You must think like a businessperson, not an artist. If you serve the parents champagne and caviar while they wait, you had better see a proportionate increase your sales to cover the cost.

Part of the experience we offer is that we are a busy studio; there is a demand for what we do. This produces its own energy—it helps create the experience without costing us a thing. Seniors want to go to the hottest spot; while a "boutique" experience might work for some of them, a lot more of them prefer to be somewhere with excitement in the air. Ultimately, you have to work toward creating the best possible experience for your seniors, while still doing what is right for you and your studio—and your profits.

So, now that we have gotten some of the business stuff out the way, let's talk about photographing seniors in the studio.

The busy environment of our studio appeals to teens. They want to be part of the excitement!

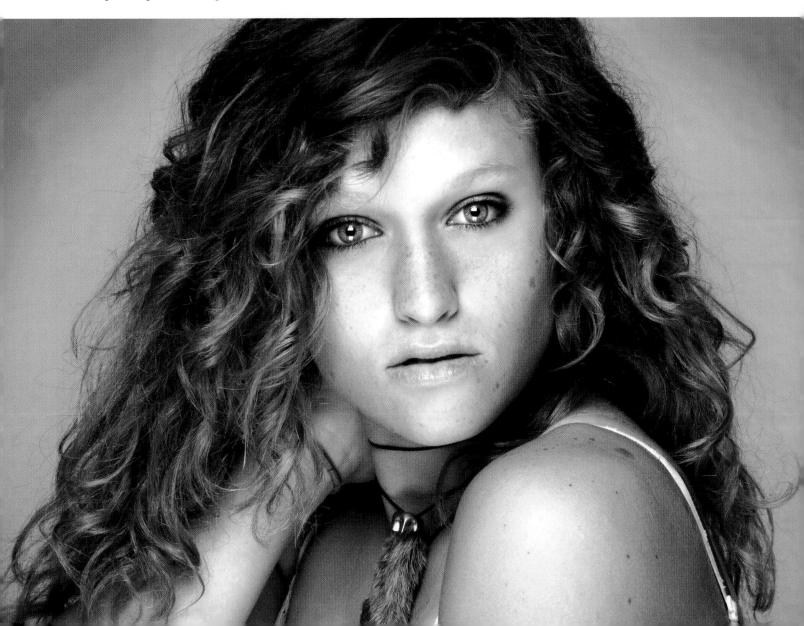

CHAPTER THREE
Design and Style

There are two styles of photography created by studios. There is the photography that the photographer likes to create and there is the photography that sells. Many photographers spend their entire careers trying to sell clients on images that were created to suit the photographer's tastes, not to fulfill the client's expectations. Successful photographers, on the other hand, determine what sells and then learn to enjoy and improve on the style of photography that sells to their clients. That may sound easy, but it's not.

Creating Lasting Appeal

Not only must you produce images that both teens and their parents will want to take home with them, you need to ensure that these portraits are of such a quality that people will still be enjoying them for years to come. That's real customer satisfaction—and that is what builds repeat business and great referrals.

It's a sad fact that, while wines and cheese often become better with age, many portraits don't. This typically happens when the elements in a photograph don't come together to visually "make sense." For a photograph to visually make sense and have a sense of style that ages well, each aspect of the portrait must coordinate with all the others. This is achieved when the clothing the subject is wearing is coordinated with the pose, scene/background,

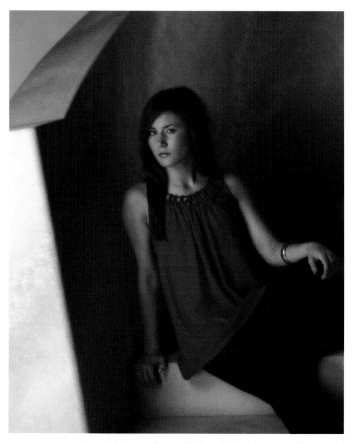

ABOVE AND FACING PAGE—*When all the elements are effectively coordinated, a portrait will have lasting appeal.*

and lighting, as well as the predominant lines and textures of the portrait. All of these things are selected to achieve the overall look that is appropriate for the intended use of the image.

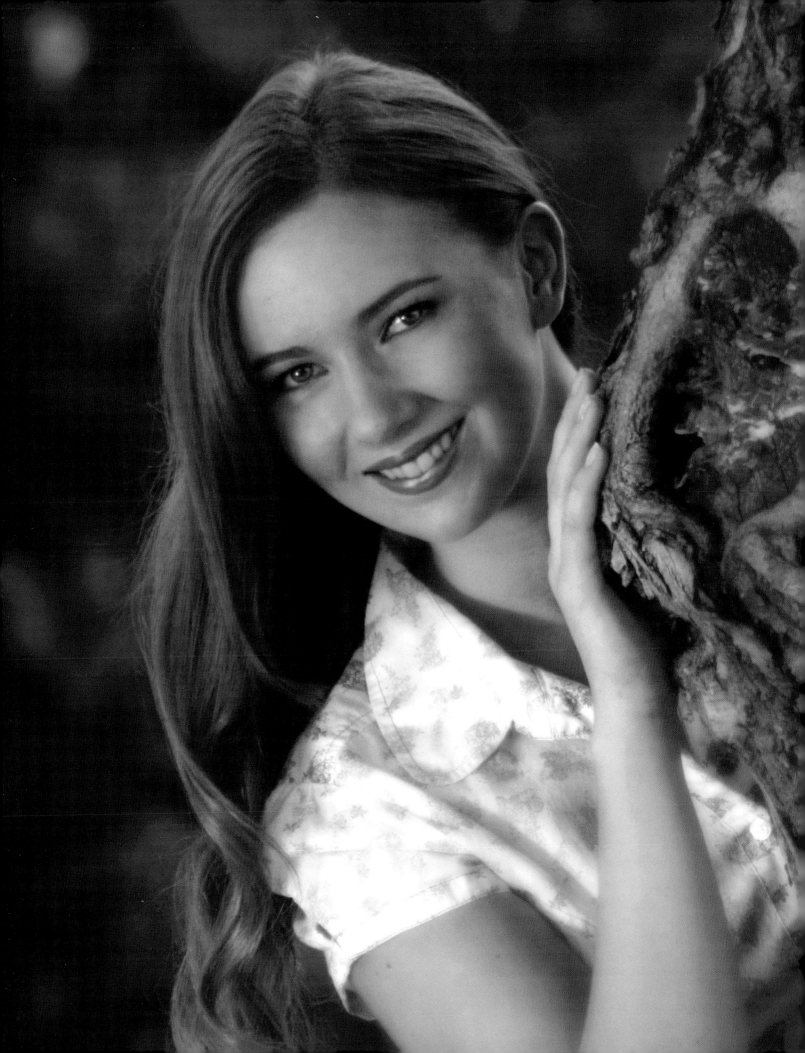

ABOVE AND FACING PAGE—*Long sleeves, solid middle to dark tones, and classic styles are ideal clothing choices for portraiture.*

Here's a common scenario. A teenager comes to a photographer to have a senior portrait taken. After the session, the senior and her mom see the proofs, get excited, and place an order. When the order comes in, they pick it up and the teen shows the portrait proudly to her friends. As time goes by, however, she starts to notice flaws. The background suddenly doesn't seem to go with her outfit. She also notices that her dress is a little wrinkled and her hair doesn't look so great. Before long, she begins wondering why she made such a stupid mistake. Will she be back for more portraits? Will she refer her friends? Doubtful.

Photographers do the same thing, of course. They see the proofs from a test session and get excited. They order a sample for their studio. When it comes back from the lab, they aren't as excited. They start to notice things they didn't notice when they first saw the image.

This is a good lesson on the difference between momentary excitement and lasting appeal. It's easy to create momentary excitement. Even snapshots can do that. It's a different ball game altogether to create a work of art that stands the test of time. Doing so means, again, making conscious decisions about everything in the frame. Think of the great portrait painters of the 19th century. These artists didn't just "happen" to create masterpieces, they carefully crafted every element of each image. They planned every aspect of the portrait to ensure it was just right. Even though the clothing and hair styles are no longer in fashion, everything in these images works together so flawlessly that they are still a pleasure to view hundreds of years later. There's no reason not to strive for the same quality in your portraits.

Style Starts with Education

As a professional photographer, you are responsible for everything in the image—yes, everything! However, controlling everything within the frame isn't always easy, because you are dealing with clients who don't always want what it is best for them. For this reason, designing a great

ABOVE AND FACING PAGE—*You can't completely control the client's clothing choice, but you can work with it effectively.*

portrait begins with educating your clients about how to plan properly for their session. Whether you meet with clients in a face-to-face consultation, present the needed information on DVD, or put an educational video on your web site, you must make sure your clients understand their responsibilities. It's particularly effective to use before-and-after images to show what *not* to do. At our studio, the staff goes over all the required information on the phone and then directs the client to our web site. We also send each client a confirmation letter that illustrates all the do's and don'ts. We ask that they sign and return this confirmation letter, acknowledging that they understand their role in the outcome of the session.

Factors You Can't Change (Much)

There are many things that you can control during the session—the equipment you use, the lighting, the subject's pose, the background selection, etc. However, there are also some things you'll just have to work with. These "constants" will, to a great degree, determine the choices you'll need to make about the things you *can* control.

Your Subject's Appearance. I work with teenagers all day long, every day of the week, and maybe 5 percent of them are attractive enough for their egos to handle looking at a portrait that shows them as they really are—a portrait that only depicts reality. Almost every person has something in their appearance that they would change if they could. There are two general types of problems that you will come across when working with your clients. These are the imagined problems and the real problems.

Imagined Problems. The "imagined" problems are normally found in very attractive, very photogenic clients. Usually, these problems are so slight that the person who has them is the only one who can actually see them with-

out a lot of careful searching. These issues are the hardest to correct because most photographers never take the time to speak with their clients about them before their session. Since no problems are readily apparent, the photographer doesn't give it a second thought. A typical imagined problem is something like, "One of my eyes is smaller than the other," "One of my ears is lower than the other," or "My smile seems crooked." As you look for this "freakish abnormality," you often have to study the subject for several minutes to figure out what on earth they are talking about.

Women seem more prone to imagined problems than men. One reason is for this is that women often feel they have to live up to a higher standard of beauty (although this is rapidly changing as guys are also becoming more and more image-conscious). Additionally, women's clothing is generally more revealing than men's clothing, so any figure flaws they may have are that much more obvious. Guys' clothing, on the other hand, is usually loose and helps to conceal some problems.

Real Problems. The "real" problems are the issues that almost every one of us has. We are never as thin as we would like, we think our noses are too large, our ears stick out too much, and our eyes are too big or too small. These problems are easier for most photographers to correct because they are more easily identified as things that need to be disguised in the final portrait.

We may sympathize with real problems more than imagined problems, but all of a client's problems need to be softened in the final portraits if the session is to be profitable. This should be a major consideration when making design decisions about each portrait.

The Clothing They Brought to the Session. Clothing is one of the elements of a portrait that you must try to control—but it's really out of your *complete* control. Probably the best advice I can give you in regard to your clients' clothing is to have them bring in everything for you to look at. I am not kidding. We tell our seniors to bring in everything, and they do. The average girl brings in ten to twenty-five outfits; the average guy brings five to ten. By doing this, you always have other choices when a favorite outfit is a bad choice for a particular subject.

Long Sleeves. We suggest long sleeves for all portraits that are to be taken from the waist up. The arms, a common problem area, are much less noticeable in a full-length pose, so short sleeves are less of a problem in these portraits.

Dark Clothing. We also suggest that anyone who worries about weight should bring in a variety of darker colors of clothing and several choices that are black. Black clothing will take ten to thirty pounds off your subject when it's paired with a black or very dark background.

Black and White Clothing. For studio portraits, we ask that subjects bring in one item that is white and one item that is black. These two colors will eliminate any problems with color harmony in a selected background. White will coordinate with any lighter background; black will coordinate with any darker one.

Outdoor Portraits. For outdoor portraits, we suggest that the clients avoid both black and white clothing. Instead, only mid- to dark-toned clothing (burgundy, green, blue, khaki, etc.) is recommended. This coordinates best with the colors in an outdoor setting, allowing us to create portraits with a more unified feel.

High Heels. Anytime a woman will be in a dress, we ask her to bring in the highest heel she owns—at least 3 inches high—to wear with it. Wearing these makes the legs look longer, slimmer, and more toned. If the legs are showing, pantyhose should be worn (unless the subject has very tan legs with great muscle tone). The nylons will not only make the legs look better by darkening them, but will make them appear firmer and more even in skin tone. (*Note:* Pantyhose should never, however, be worn with open-toed shoes.)

Style. We also tell our subjects not to bring only formal clothes or only casual clothes. We want to see three distinct styles of clothing: casual, trendy, and elegant. Jeans, shorts, summer dresses, and t-shirts fall into the "casual" category. Leather and jean jackets, fashionable blouses and shirts, as well as dresses that the average young lady would wear out "clubbing" would be considered "trendy." Suits, tuxedos, and gowns would be considered "elegant."

Proper Fit. We warn clients against wearing jeans or pants that are too tight around the waist. These create a roll where the tight waistband cuts into the stomach. Tight

For outdoor portraits, casual clothes in middle to dark tones are a good choice.

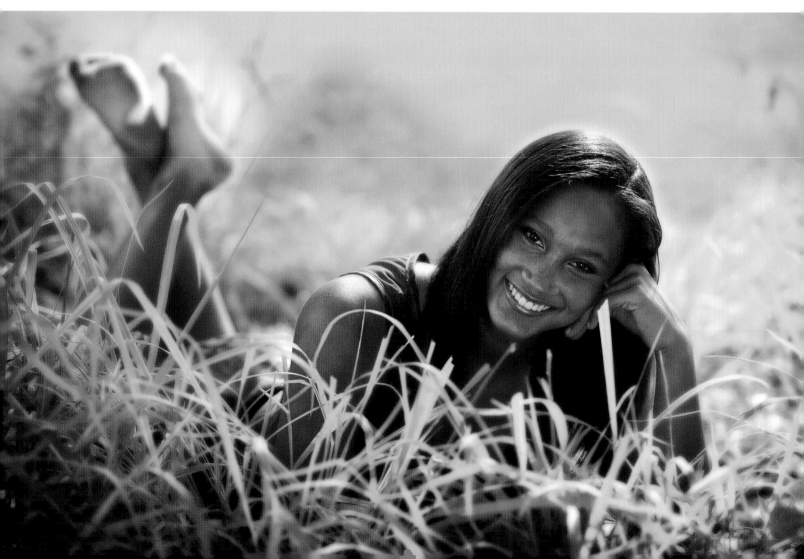

clothing also affects the subject's ability to pose comfortably. I have had some subjects turn beet red because of tight pants as they try to get into a pose. For this reason, we ask all of our clients to bring in a comfortable pair of shorts (or, in the winter, sweat pants) to make it as easy as possible to get into the poses that won't show areas below the waist.

If women have a frequent problem with tight jeans, guys (especially young guys) have the baggies. This cool-looking (so they think) style has the crotch that hangs down to their knees, while at the same time revealing undergarments to the world. Just try to pose a client in a seated position when there are three yards of material stretched out between his legs! Try to have him put his hands in pants pockets that are hanging so low he can't even reach them.

In general, clothing that is loose-fitting on a person who is thin or athletic will add weight to them in the portrait, especially if it is loose at the waist or hips. Tight clothing will add weight to those people who are heavier. With tight clothing on a heavy person you can see tummy bulges, cellulite, lines from waistbands, and every other flaw that weight brings to the human body.

The Right Undergarments. Many women forget to bring in the proper undergarments. They bring light-colored clothing, but only have a black bra and underwear. They bring in a top with no straps or spaghetti straps and they don't have a strapless bra. In this case, they either have to have the straps showing or not wear a bra, which for most women isn't a good idea.

Guys are no better. I can't count the number of times I have had a guy show up with a dark suit and nothing but white socks. Some men (okay, most men) tend to be a bit sloppy, which means that the clothing they bring often looks like it has been stored in a big ball at the bottom of their closet for the last three months. Many show up with clothing that used to fit ten years ago—back when it was actually in fashion.

Jewelry. If the client is wearing a ring, bracelet, or necklace, you need to determine whether it needs to show in the image. If the jewelry is related to the purpose of the portrait (like a class ring), look for the best way to incor-

porate it into the image. If the jewelry doesn't hold special meaning, you may decide to ask them to remove it, or you might hide it in order to avoid creating distracting glints of metal in the image.

The Makeup They Normally Wear. The use of makeup will have a major impact on the session and the style of the images created. While it might seem like this is something you can control completely, it's really not. Remember: this is a senior portrait, not a fashion shoot. Therefore, the makeup in the teen's image should (by and large) reflect them as they really are. It would be just as wrong to apply black makeup to the typical cheerleader as it would be to demand softer makeup on a goth girl who is never seen by her family without her black makeup on. This is where you, as the professional photographer, need to adapt your techniques and design an image that is appropriate for the individual's look and style.

The seniors who come into our studio do have the option of having their makeup done by our makeup artist, but the majority of students prefer to do their own makeup—and with a little direction, they look great. Again, educating your client is the key to having control

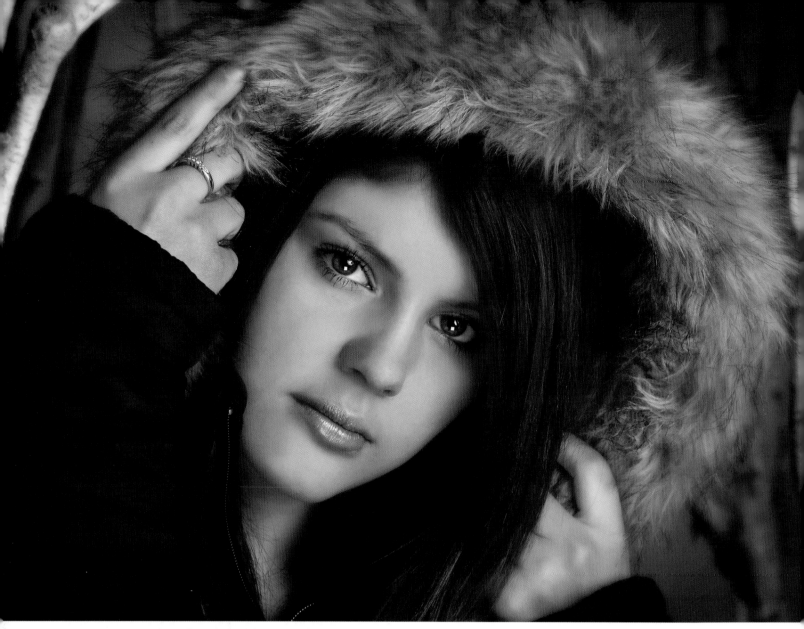

In portraiture, the subject's makeup should make them look like themselves.

over something that is out of your control. (*Note:* If the subject's hands or feet will show in their portraits, you may even want to recommend a manicure/pedicure and suggest appropriate colors for the nail polish.)

Using Your Creative Controls

My process of portrait design is simple: I start with the elements I have the least control over (the subject's appearance, clothing, and makeup), then adjust those elements I *can* control to coordinate with those I *can't*.

Basically, you can look at the subject's choice of clothing/makeup as a clue as to the type of image that should be created. When a young lady walks out of the dressing room in a pair of shorts, barefoot, and with a summery top on, it doesn't take a rocket scientist to figure out you'll be creating a casual image. When a girl comes out in a prom dress, again, it isn't difficult to select a glamorous background, lighting, and posing strategy to suit the dress.

Of course, you can also decide to use elements that aren't the obvious choice—in fact, many of the trendy styles of clothing that are worn today virtually eliminate the normal limits when it comes to the unique backgrounds and unusual poses you want to try. Even when you're going for an unexpected look, though, you need to make sure that everything in the portrait comes together and makes sense visually.

The Studio Background. When working with a senior in the studio, we have huge variety of sets and props that are designed to coordinate with different styles of clothing. Once the senior starts to put on a certain outfit, my staff starts putting together the background/set they will be using. How do we decide which one to use? Let's look at that process.

Lines. The predominant lines and textures in a scene or background are what visually communicate its overall feeling, so be sure to evaluate these carefully. The lines of a scene can include the painted lines of a studio background or columns of a set. (*Note:* These same considerations apply outdoors, as well, where lines can be produced by trees, blades of grass, buildings, and even paths or walkways.)

Heavy, straight lines going vertically or horizontally through the frame produce a strong, structured environment; this often works well with more formal clothing. Diagonal lines also produce a strong feeling but are less structured and rigid, coordinating well with more casual clothing styles. Lines that are curved or bowed are softer, producing a feeling of romance or understated elegance.

Color. Another consideration in selecting a background is to choose a color that harmonizes with the color of the subject's clothing. Some photographers' answer to producing color harmony is to put a colored gel on the background light that matches the clothing color. While this is a very easy way to ensure your background coordinates with the client's clothing, it is very limiting from a creative standpoint.

When we design sets and paint backgrounds, we try to use neutral colors that will coordinate with many colors of clothing. Backgrounds and sets that are monotone (white, gray, or black) can be used with just about any color of clothing, so coordination won't be a problem.

Contrast. A related consideration when pairing backgrounds and clothing is contrast. No matter what the color, if you pair up a lighter tone with a darker tone you are increasing contrast—and determining where the viewer's eye will be led.

The Outdoor Background. Although all the same basic considerations apply, the coordination of a back-

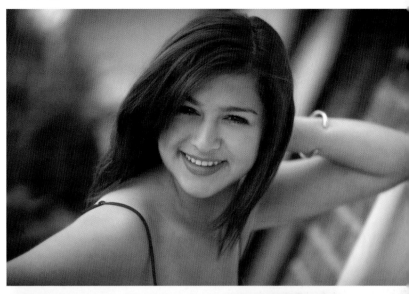

Vertical lines (bottom) give images a formal feel. Diagonal lines (top) create a more casual mood.

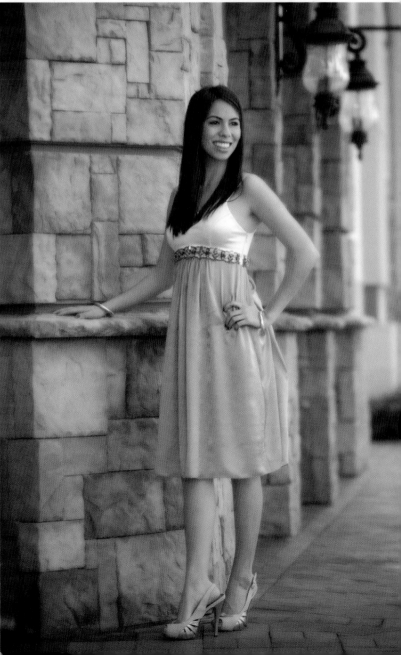

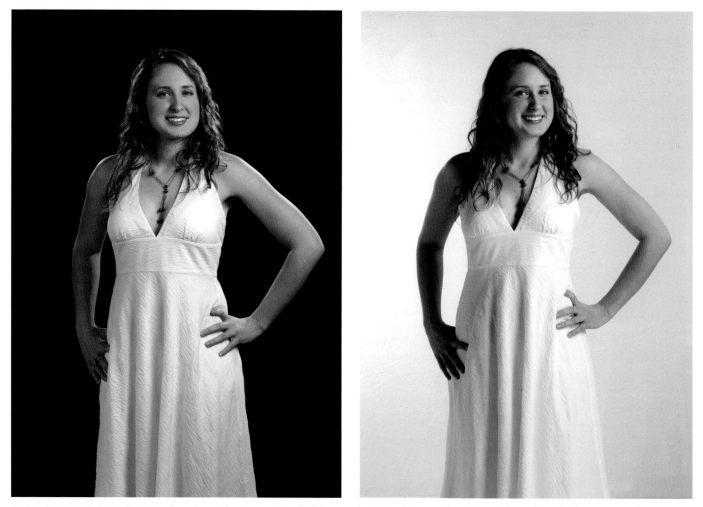

ABOVE (LEFT AND RIGHT)—*Tonal contrast between the clothing and the background outlines the subject's figure, emphasizing it. Tonal blending between the clothing and the background subdues the subject's figure, keeping the emphasis more on the face.* FACING PAGE—*After selecting the background, your next concern is the lighting.*

ground or scene to the client's clothing is much easier in the studio than on location. After all, it's much harder to swap out a tree than a canvas.

Therefore, seniors who have chosen to have outdoor locations as part of their session receive detailed information on how to dress to coordinate with the overall look of the location. If they have selected a typical park location, we ask them to wear shorts, jeans, summer dresses, letter or leather jackets, or anything else that is more casual. Should the senior select to be photograph in a interior location that is more elegant (their home, a theater, a museum, etc.) the senior is told to wear more elegant clothing and makeup to coordinate with the location.

When working outdoors, keep in mind that you can't change colors; you only have control over how light or

dark the color of any given background will record in the image. If a client wears a white (or a lighter tone) and you are photographing her in the average park scene, you can let the background record as lighter than it actually is in order to better coordinate it with the lighter clothing. Should the client wear black (or near black) in a scene that has direct sunlight illuminating it, you will need to darken the scene by adding light to the subject or increasing the shutter speed to reduce the light on the background. Outdoor and location portraits will be covered in greater detail in chapter 6.

Lighting. Next, the style of lighting is chosen. Again, this is based on the clothing and background/set that have already been selected. If it's a casual "slice of life" image, the lighting will be more traditional; if the clothing and

background are more sophisticated, I may use a ring-light or the diamond spotlight to produce a more glamorous look. Lighting techniques will be covered in greater detail in chapter 4.

Posing. Another consideration is the pose. When I select a pose I am looking at two things. First, I want to choose a pose that coordinates with everything else I have selected so far. Second—and even more importantly—I want to choose a pose that will make the client look their best. Posing techniques will be covered in greater detail in chapter 5.

Expression. The final step is the subject's expression. You can be the best photographer in the world—you can be a wizard at lighting and posing, making every client

Expressions sell portraits.

look beautiful—but without a great expression, your images won't sell. It's important to keep in mind that "a great expression" means "the expression your client wants," not "the expression you think they should have." Photographers, especially male photographers, often think every attractive woman between the age of thirteen and thirty should have glossy lips that are parted just enough to see the teeth. While this expression might look alluring, it is *not* how I would want to see my daughter looking at me in a portrait.

Parents buy smiles—smiles that make their child look like they are really happy, not just as though they were to told to smile. Seniors and teens do like the more alluring smiles noted in the previous paragraph, but they also like natural smiles. I have never seen a woman I couldn't get to smile naturally—and I have only had a few guys in my twenty-five year career who refused to smile once they understood that they would be selecting the images and didn't have to pick the smiling poses if they looked bad.

Understanding human nature also helps. You can't look at another human being with a smile on their face and not want to smile yourself. The old saying that smiles are contagious is very true. Combine a smile on your face with a upbeat tone and a humorous play on words and no one can help but smile—and often laugh.

BE FLEXIBLE

Although I make many decisions before I see the client in their outfit, I am always ready to make changes once the client appears. For example, I may have everything set for a full-length standing pose to show off an elegant dress—until the senior comes out barefoot and says she forget her shoes. Then we go to plan B, which would be simply to take the image in a three-quarter pose and not show the feet.

Many photographers lack flexibility when working with their clients. Many years ago, I observed a photographer working with a client in an outdoor location. His client was a young lady, a few years out of high school, who was in a dark shirt and black jeans with black shoes. When she sat down on a rock by the lake, her pant leg rose to show her white socks underneath. She asked the photographer if her white socks were going to show, and he responded, "Of course they're going to show. If you didn't want to see them, you shouldn't have worn them!" He then proceeded to take the shots full length—almost as if to teach his client a lesson. (And I'm sure he *did* teach his client a lesson—namely, that he was a jerk and she should have selected a more professional photographer.)

This guy could have easily asked her to take off her shoes and socks, or he could have changed the composition to not show the feet, but he was inflexible. Once he had decided on what he was doing, he wouldn't change it to fit the needs of the client. (I should note that he also paid the price that all arrogant photographers pay; he is now fifty years old and still working for his father.)

Some of the best smiling expressions happen when the subject starts to laugh and then the smile just starts to relax down. I always start off by telling my clients that if they start laughing they should stay in the pose and not move. Those will be the smiles they like the best because they will appear the most natural.

Final Thoughts

Portrait design is as complex a subject as you care to make it. I have had a client show me the place in their home where they wanted a portrait to hang, then ask me to co-ordinate everything in the portrait to suit the colors and style of their home and décor. I even selected each person's clothing to match to exact guidelines given to me by my clients. Everything was planned and approved by the client, who knew exactly what they wanted. I would rather work with people like that—people who know exactly what they want and use my skills to help them get it—than people who only express their opinions when they are looking at the images after their session.

Soft, natural smiles are popular among both parents and teens.

CHAPTER FOUR
Lighting

You have light. You have shadow. You have a transition from the beginning of the shadow to its darkest part. Does it matter whether you get your light from flash, windows, or a continuous light source? Absolutely not; you can create beautiful images using all of them. So far, lighting sounds very simple. Why, then, is it so hard for so many photographers?

It's Not that Complicated

I think the reason that so many of us regard lighting as a challenge is that we were taught by people who wanted to impress us—and their complex theories ended up making a simple subject seem very challenging. It didn't help matters that most of them were (and are) sponsored by lighting equipment manufacturers. So why would they advise you to use one light when you could be using five? Especially since all these lights are also for sale at the back of the

LIGHTING SKILLS EVOLVE

Many photographers read my books and e-mail me lighting questions. They are confused because in one book I light my portraits one way, and then they read another one of my books and it says I am lighting my portraits in a different way. That is because, like every photographer, I, too, am a student. I am learning all the time and everything I learn causes my lighting style to evolve and become more refined. In this book, I am not going to discuss every conceivable lighting style—just the styles that work for me, with my clients, at this time.

room! (*Note:* The equipment I'll discuss is what I currently use. While it may look a little better or different than yours, it shouldn't change the final image.)

To put it bluntly: great lighting is not about complex setups or expensive equipment. You can put a bulb in a cardboard box, line the inside with aluminum foil, duct tape a piece of white bed sheet over the end of the box, and take the most beautiful images you have ever seen—provided you know what to *do* with this light. If you already have some type of light box and a continuous or flash light source, you can skip the building stage of the lesson and go right to the next step.

The Basics

Before we discuss the individual lights, let me point out that I will not be discussing the specific settings (metered light output) for each light source. Instead, I will tell you the relationship of each light to the output of the main light. The output of the main light varies based on the aperture I want to use, and this is determined by the lens I am using and how soft I want to make the background. There are bold backgrounds that I typically soften, so I may shoot at an aperture of f/4. Other backgrounds, with a softer texture or design, I may want to shoot at f/11. By

FACING PAGE—*Lighting setups don't have to be complex to make your subject—and your image—look great.*

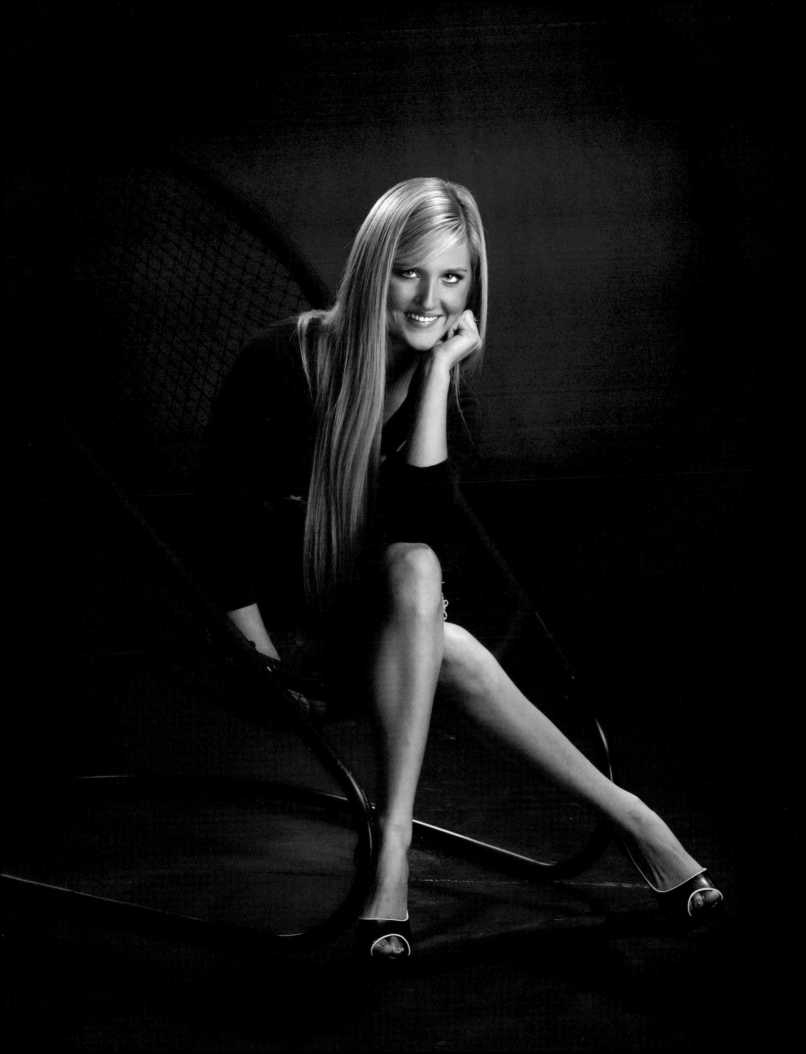

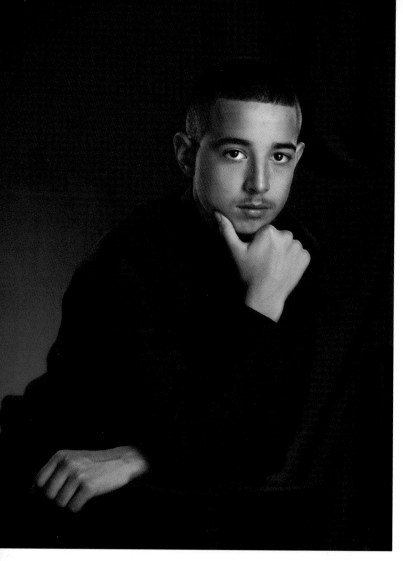

ABOVE—*In low-key setups, the most important auxiliary light is the background light.* **FACING PAGE**—*Adding one or more hair lights provides additional separation and makes long hair shine.*

lights metered together. With the background light set at this exposure, the background will pretty much record as it looks to your eye under normal room lights. To lighten or darken the background, adjust the background light accordingly. For my background light, I use the simple parabolic reflector that comes with the light.

The second light that I consider a necessity in a low-key area is a hair light. This is mounted above the center of the background and angled toward the subject's head. I typically put the center hair light about ten feet high in areas where subjects will be seated or leaning. I place it twelve feet high in areas where the subjects will be standing. Since the light is angled back toward the camera, it should be fitted with a snoot, barn doors, or grid to prevent lens flare. This light should be set to read one stop less than the main light.

Although it's not necessary, I also use two accent hair lights, placed about seven feet high at the sides of the background and angled down toward the middle of the set where the client will be posed. These lights are used for women with longer hair, adding separation and a luminance to the sides of the hair. These lights are also set to meter one stop less than the main light.

For many of my head and shoulders poses, I also add a reflector under the subject to bounce light back up from a lower angle. I currently use the Westcott Trifold reflector. For years, I used a drafting table covered with mylar, and before that I used a piece of foam-core board covered with mylar—and both solutions provide a nice look if you're on a budget. This light source adds highlights to the lips and a lower catchlight in the eyes. It also helps smooth the complexion and lighten the darkness that most of us have under the eyes.

High-Key Setups. The only auxiliary light for a high-key area is basically a light to illuminate the white background evenly. This actually isn't that important to me; we have so much traffic on our white floors that, even with daily repainting, we have to run an action on all our portraits with a true white background and floor to blur the scuff marks and lighten everything to white. As a result, one light from above gives our production department sufficiently even illumination to create a clean look.

discussing the relationship of the other lights to this main-light reading, I hope to give you the flexibility you need to make these main-light choices yourself, then fill in the blanks (working in relation to that main-light setting) to achieve the effect you are looking for.

Auxiliary Lights. The auxiliary lights are light sources other than the main and fill lights. In this section, we'll look at what I consider to be the minimal selections for creating a salable portrait in each situation.

Low-Key Setups. In a low-key (darker background) lighting area, the most important auxiliary light is the background light. The output of this light should be determined according to the light output of the main and fill

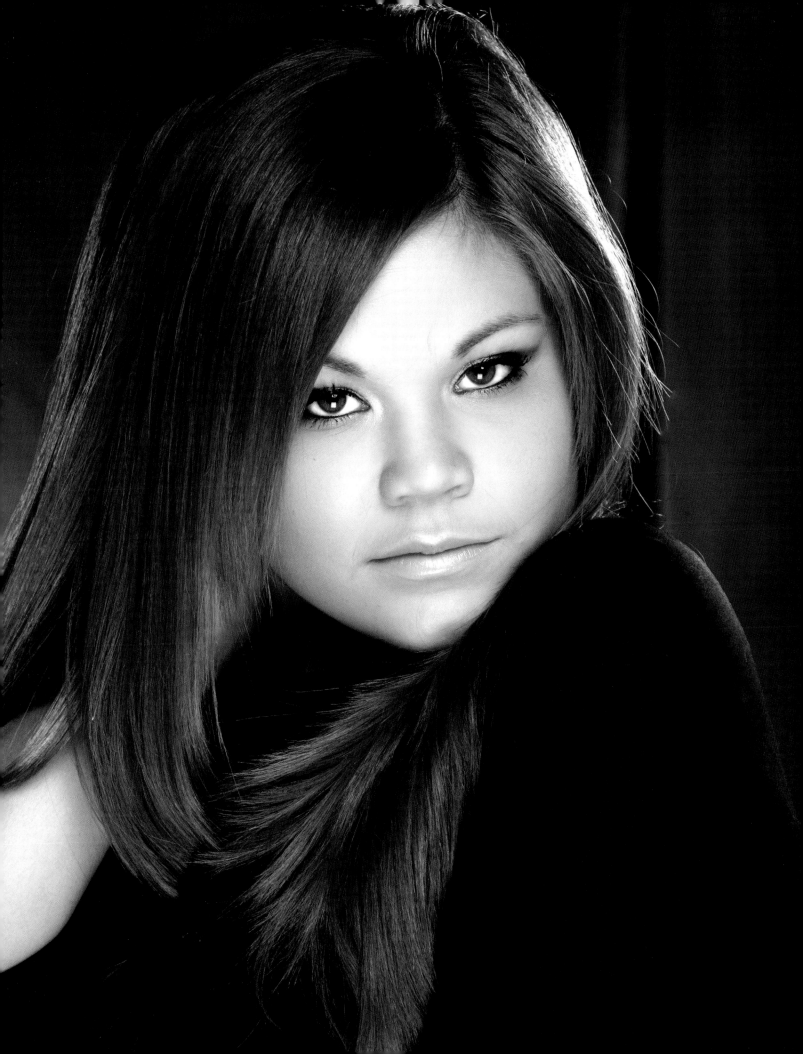

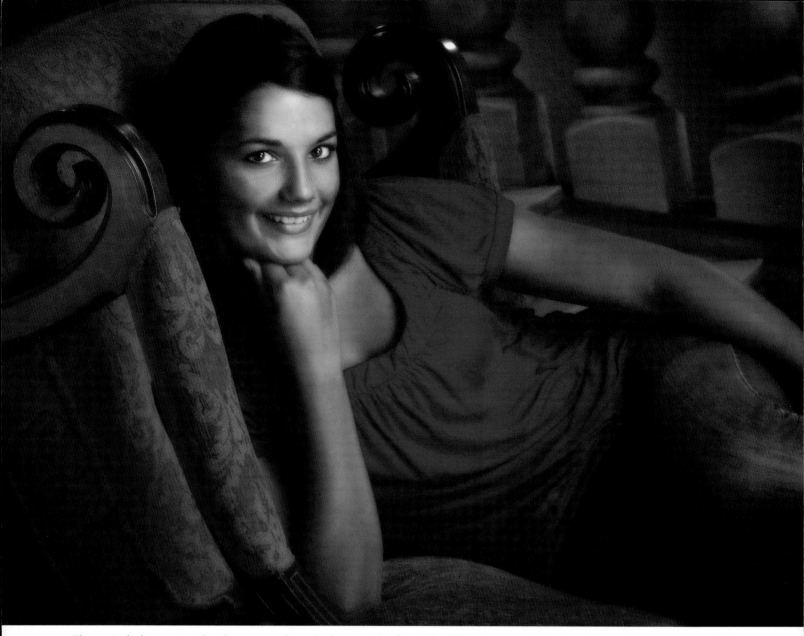

The main light creates the shape-revealing shadows on the face. The fill light source (whether it's a reflector or a strobe) controls how light or dark these shadows will appear.

If you don't want to worry about retouching, though, you can set up two lights, fired into umbrellas, on each side of the white area or to each side above the background. Lights illuminating the white background should be set at the same reading as the main light; you don't want that expanse of white to become a reflector, bouncing light back toward the camera.

I personally don't use any accent lights or hair lights in my high-key setups.

Fill Light. In my first books, I used nothing but reflected fill. Then, a few years later, we went digital. With the first digital cameras, I didn't like the look of the shad-

owing with reflected fill only, so I used a flash and reflected light for fill. Now, in most of my photographs, I am back to reflected fill only. As I mentioned above, your lighting techniques should always be evolving.

I don't like fooling around with small reflectors, so I have a 4x6-foot silver/white reflector at the side of each camera area. I adjust it for each client, because the individual's skin tone makes a huge difference in the amount of fill needed. The choice of white or silver will also depend on the amount of fill you want and the distance the reflector will be placed from the subject. The beauty of using reflectors for fill is that what you see is what you

get—so go ahead and experiment to see what works best for you and your clients.

Whether I use flash or reflected fill, I typically shoot portraits at about a 2:1 or 3:1 lighting ratio (this means the main light is 1.25 to 1.5 stops greater than the fill). For images where corrective lighting is needed, to slim a heavy subject for example, or where diffusion will be applied, I may shoot at 4:1 (with the main light set two stops greater than the fill).

Main Light. The same light source can be made harder (more contrasty) or softer (less contrasty) depending on how it is placed in relation to the subject. If a light source is placed close to the subject, it will be relatively large in relation to the subject and produce softer light. If that same light source is placed far from the subject, though, it will be relatively small in relation to the subject and produce

harder light. This is one means of controlling the effect of the main light.

You have two other important controls over any main-light source you select: the height of the source and the angle of the source. These decisions will determine how the light reveals the shape of the face. The higher the light is placed, the more it contours the face from top to bottom. However, the higher the light is placed, the less it will illuminate the eyes. Once it reaches a certain height, there will no longer be appropriate catchlights in each eye and dark circles will appear under the eyes.

The greater the angle of the light from the camera/fill-light position, the more it contours the face from side to side. This also increases the shadowing of the side of the face and the size and quality of the transition area from the brightest part of the highlight to the darkest part of

The height and angle of the main light controls the formation of shadows on the subject's face.

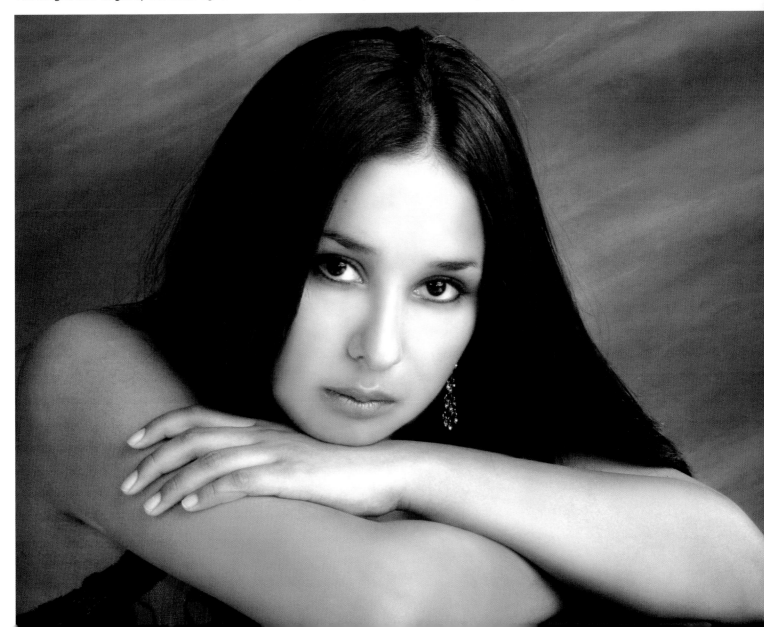

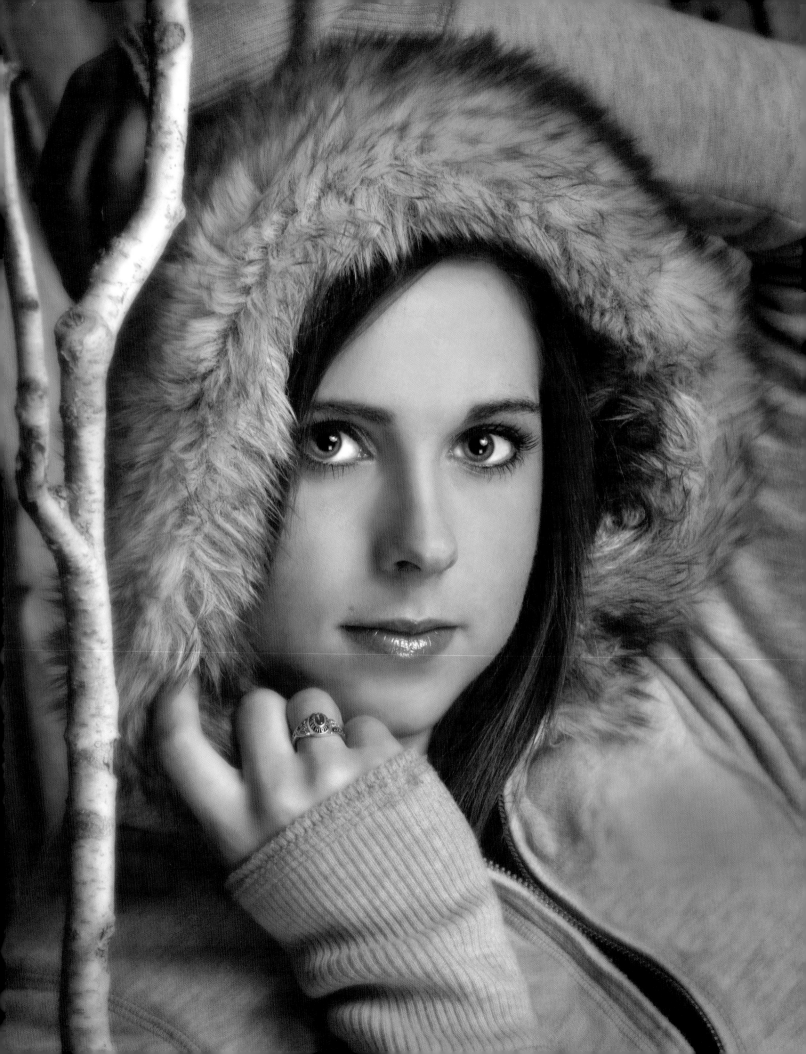

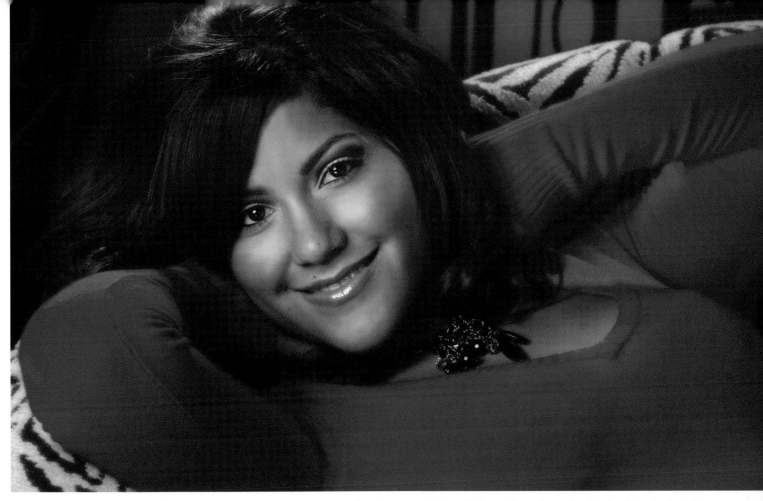

ABOVE AND FACING PAGE—*The most flattering height and angle for the main light will depend on the individual subject's facial features. Maintaining a proper catchlight, however, is always important.*

the shadow. Additionally, as the angle of the light to the subject increases, the shadow on the side of the nose will also grow, thereby increasing the apparent size of the nose in the portrait.

This sounds really confusing, but it isn't. Everyone's face is different and you will need to adjust your lighting for each client in each pose. Some clients have no under-eye circles and eyes that reflect light really well. In this case, the light can be positioned higher to bring out more contouring of the face. Some people have smaller noses and can have the light at a greater angle to increase the transition area from highlight to shadow.

To determine what is best for your subject, get them in the desired pose and raise the main light to a height that is obviously too high. Then, slowly lower the main light until the eyes are properly lit. At this point, slowly move the main light around the subject until the shadow of the nose becomes a problem, then move it slowly back until

you have the best lighting for that person. With the main light adjusted, you can then simply bring in a reflector to achieve the amount of fill that looks best.

Softening the Light

Light Modifiers. Learn to work with the light modifiers you have—and don't think that you have to buy a certain light attachment just because someone else uses it. Many young photographers make the mistake of thinking that small differences in the shape or interior fabric (white, silver, soft-silver, etc.) of a modifier will make a big difference in the final outcome of the image. I am here to tell you: they don't.

If you have a smaller light box that has highly reflective silver fabric inside and thin diffusers for the front of the box, the modifier will provide slightly higher contrast lighting, which I find a plus when shooting digital. However, if you want to soften the light from this modifier, you

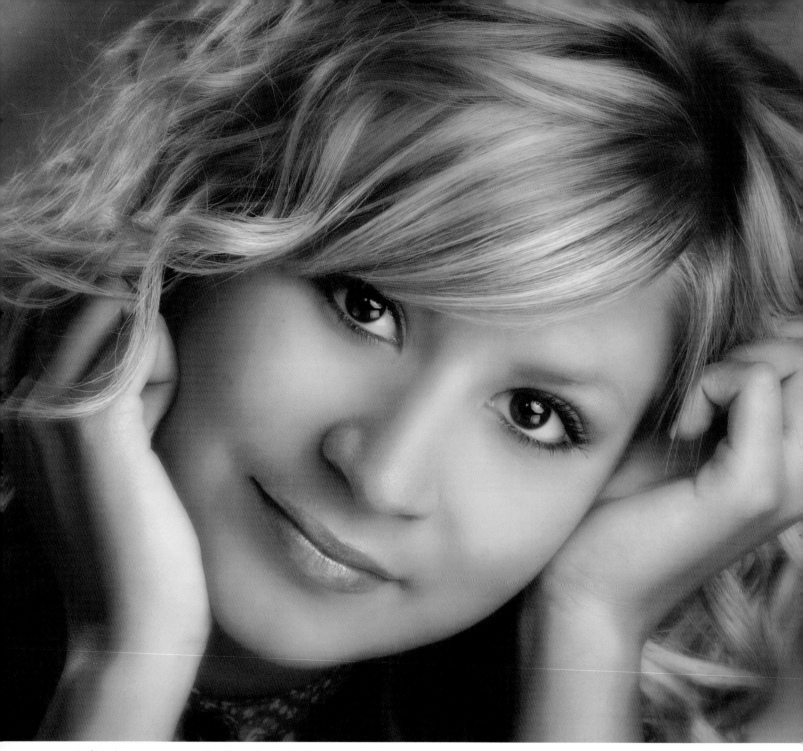

Soft light creates a gentle, flattering look that smooths the skin.

can add the inner diffuser (which most light boxes come with) to soften the light.

Feathering the Light. You can also soften the light by feathering it, which simply means directing the center (brightest part) of the beam slightly in front of the subject and using just the softer light from the edge of the beam to light the subject.

Testing Your Lighting

The piece of information none of my instructors ever shared with me as I was learning about lighting is that I needed to methodically and systematically test my lighting to know the exact results I was going to get. For studio lighting, you need to have a repeatable and consistent manner of photographing so you can quickly and accu-

rately record an image. Once you thoroughly test your lighting and know what to expect from it, you can start to get repeatable results. It sounds so simple—almost elementary—but very few photographers take the time to test out their lighting completely.

Prepare for the Test. To do this, you need just a few things: a patient person wearing a medium shade/color shirt (not white or black); three 12-foot strings; some duct tape; a main-light source; and a lighter-toned (but not white) background. Start by putting a duct-tape X on the floor under the chair where your patient person will sit through these tests.

Testing the Main Light. You have two variables to decide on before you start to test your lighting, the first is the distance at which you want you main light from the subject. The closer the light source, the softer the appearance of the light; the farther away that same light is pulled, the harder that light becomes. Adjust your main light to a distance where you feel it looks good to your eye (with all other lights and room lights off).

The second variable is the height of the main-light source. The easiest way to adjust the height of your main light is to raise it to a point that is obviously too high and then lower it down to the point where you first see clearly defined catchlights in each eye of your patient person—then stop. This is the correct height for the main light, given their height and the height of the chair.

With those variables now set, the next step is to tie a string around the light stand just under the light box. With the light at the distance you have chosen, pull the end of the string toward the subject and cut if off at the length that will touch their cheek. This string on the main-light will allow you to ensure the light remains at a consistent distance to the subject (and, thus, provides a consistent exposure and quality of light) as you start moving it. (*Note:* When I first learned this string technique, I cut the end of the string to produce a 3:1 lighting ratio, then added a red ink mark on the string to indicate the distance at which the light would produce a 4:1 lighting ratio [for diffused images on film].)

A string can provide the key to repeatable exposure by ensuring that your lights are placed at a consistent distance from each subject.

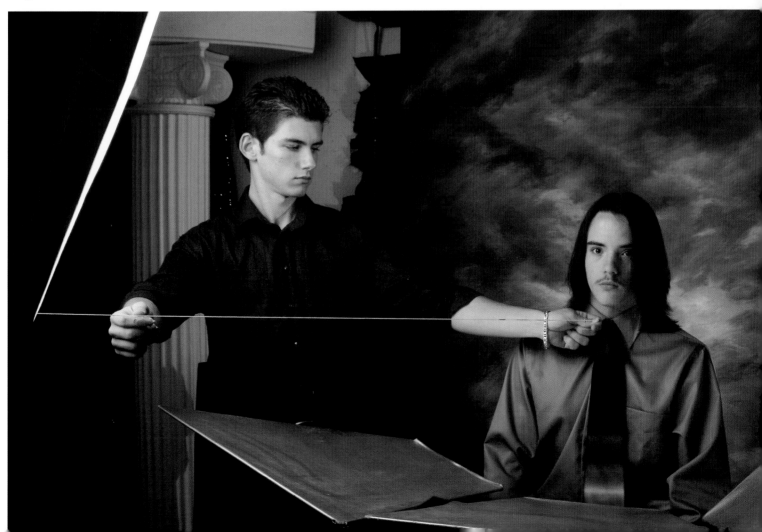

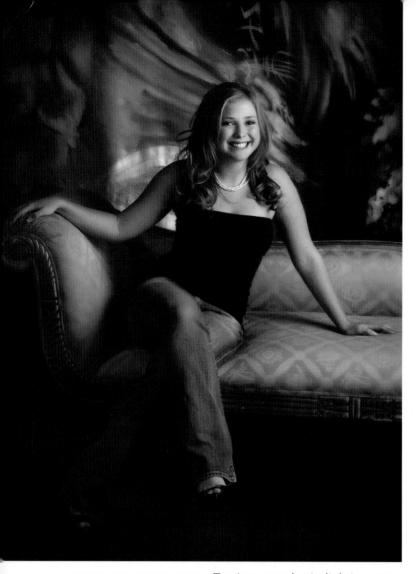

ABOVE AND FACING PAGE—*Testing your basic lighting setup gives you a starting point for each session. Based on the client, you can refine this to get just the right look.*

Now, with the subject completely square to the camera, place your main light at a 90 degree angle to the side of them (left or right doesn't matter). Use the string to make sure it remains at a consistent distance. Put another duct-tape X under the light stand in this position. Take notes of your process to avoid confusion, then take one shot of the subject. Move the main light one foot closer to the camera (again, using the string to ensure a consistent exposure/distance). Mark the floor under the light stand and record another image. Repeat this procedure until you pass what would be a 45 degree angle of the main light to the subject. Step one is complete.

Testing the Fill Source. Now that your floor is marked at each place where the light stand was, you are ready to

test your fill source. The type of fill really doesn't matter; I prefer reflected fill so I can see exactly what I am getting, but that is just my preference.

Start by marking the floor where your fill source will be. If it's a reflector, place it 1 foot away from the subject. Then, leaving the reflector in the same position, take your main light to each of the marked positions you created in the last step and photograph the subject. Then, pull the reflector 1.5 feet away from the subject and repeat the entire process. If you use a flash for fill, mark its position and start with a 2:1 lighting ratio (meaning you should set the fill light 1 stop less than the main). Capture a sequence of images with your main light at each of the marked positions. Then, repeat this process several times, reducing the fill light by a quarter stop for each sequence, until you get to a 5:1 ratio (fill light 2.5 stops less than the main). Once you are done with this part of the testing, you are halfway done with the entire test.

Allow for Different Situations. Identical lighting ratios won't work the same on all skin tones. While a 3:1 lighting ratio may be beautiful on fair skin, photographing a person with a darker complexion at a 2:1 ratio may produce a better look and more acceptable shadows. Your exposure or camera setting will also need to change to account for the differing reflectivity of various skin tones. The subject's clothing color also affects exposure. A white top will act as a reflector and increase the amount of light on the skin; a black top will subtract light.

All this may sound confusing, but it is not. All you need to do is run the same series of tests with another patient model—except this time, select a model with a different complexion. If your first model was fair skinned, chose a very dark-skinned person (or vice versa).

Make Prints. When you complete all of the tests, don't just look at the results on a computer screen. Make an 8x10-inch print of each shot, cropping it closely around the face so that you can see the lighting and shadowing effect on the face as well as the look of the lighting on the eyes.

Evaluate the Results. At this point you have thoroughly tested your lighting and have the results. Now you need to sit down with a few members of your target mar-

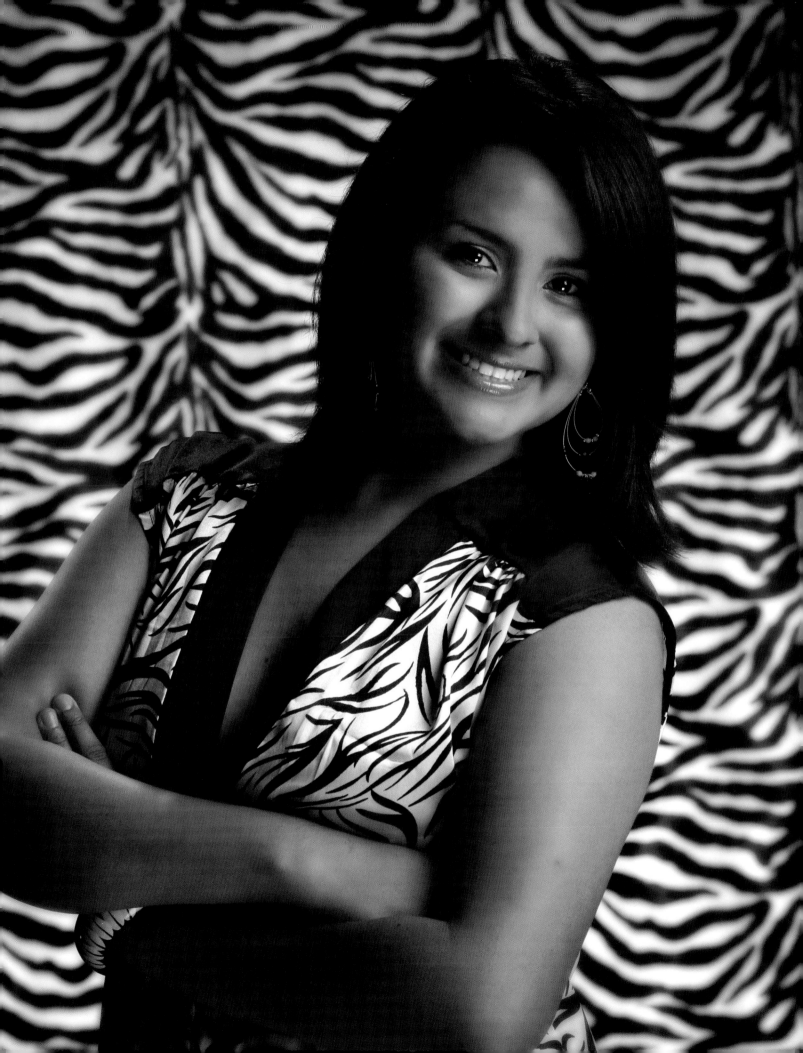

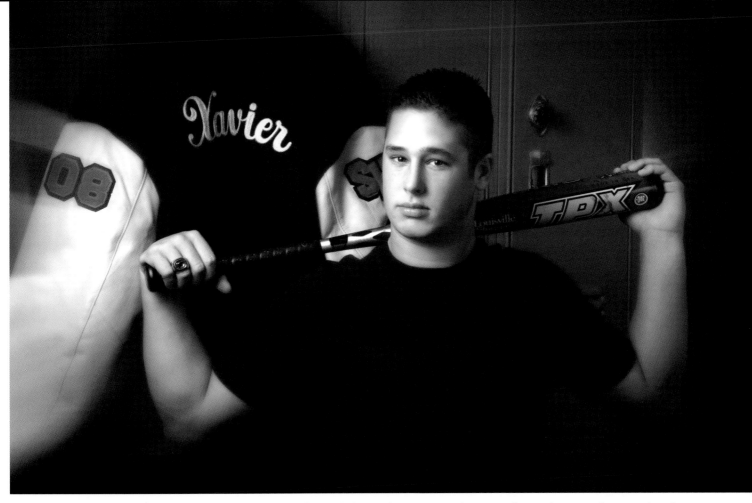

ABOVE AND FACING PAGE—*Don't leave your clients out of your lighting decisions. Finding out what styles actually appeal to them (rather than just what* you think *they'll like) can make a big difference in your bottom line.*

ket (high school seniors and teens) and select the lighting ratios and angles that you and they like the best. Am I telling something completely different than you have been told throughout your photography training? Does it seem like a strange idea to ask the people who make up your customer base to decide on a style/technique of lighting? It shouldn't. Unless you are a high school senior or teen, how can you select anything that is supposed to be suited for them? I talk to my target demographic before I do *anything.* (My seniors helped me pick out the color and style of the Harley Davidson motorcycle I bought for the studio. They helped me select an exotic car [the Viper] and then finally the color of that car. I also ask my seniors their opinion on everything from mailers and displays to products and framing.)

Once you and your test group decide on the main-light position that provides the best look, remove all the other pieces of tape from the floor. After you decide on the best

ratio of lighting for both fair and darker skin, leave just those two marks on the floor (the positions of your reflector or light for fair/dark complexions).

This doesn't provide a "lighting by numbers" system, but it's a starting place for each session. My assistants use these marks on the floor to position the main and fill lights so I start out each session with the lighting in the same spot. From there, I can easily make changes to the lighting for the individual subject—but we always start out from the same spot and using a tested lighting technique.

Developing Your Style

The one lighting rule you should always follow is to avoid using any more lights than is necessary. If one light will work, don't use two just because you can. Yielding to the temptation to use too many lights is one way people make lighting more confusing than it should be (and consequently mess up their lighting style).

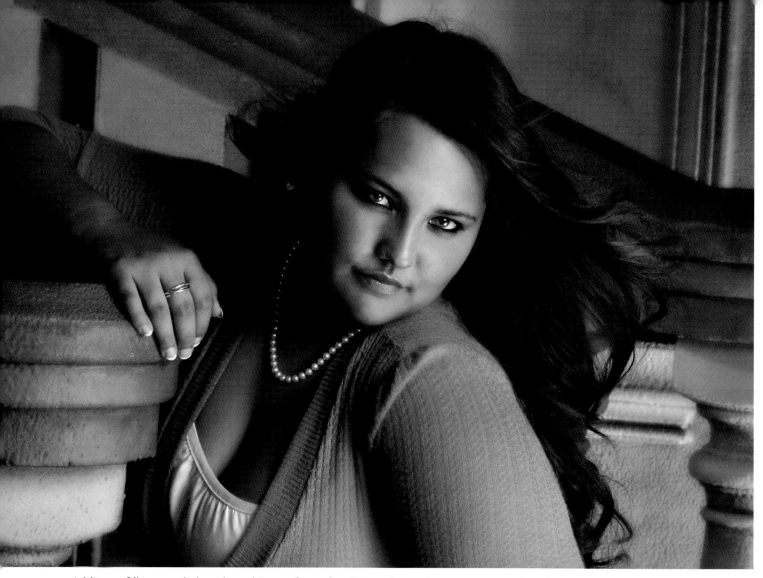

Adding a fill source below the subject softens the skin, reduces the appearance of circles under the eyes, and gives the portrait a more glamorous look with a second lower catchlight.

Having completed the previous testing procedure to set your main and fill lights, you will be able to produce professional-quality lighting for your clients. From this point on, you will start to refine and define your lighting style. If you offer only one style of lighting that you perfect to an amazing degree, you can be successful working with seniors and teens—however, if you master several styles of lighting you will be able to offer more of a variety of looks to your very style-conscious clients.

An Additional Reflector/Light. When using the main light and fill setup we just completed testing, I always work with one additional reflector or light under the subject. This additional light source softens the skin, reduces the appearance of circles under the eyes, and gives the portrait a more glamorous look with a second lower

catchlight in the lower part of the eye and highlights on the lips. If you decide to add this reflector or light, just test it to determine its optional position/setting in relation to your already-tested lights. I usually work with this light 1 to 1.5 stops less than the main light.

This type of lighting makes up 90 percent of the images I create. I also work with other styles of lighting, which make up the other 10 percent of my images. These are discussed below.

Butterfly Lighting. To create butterfly lighting, the main light is placed above the camera with a reflector or secondary accent light under the camera. The best ratio for the lighting will depend on the facial structure of the person you are photographing and the desired look. At times, I have the lower light (or reflector) at almost the

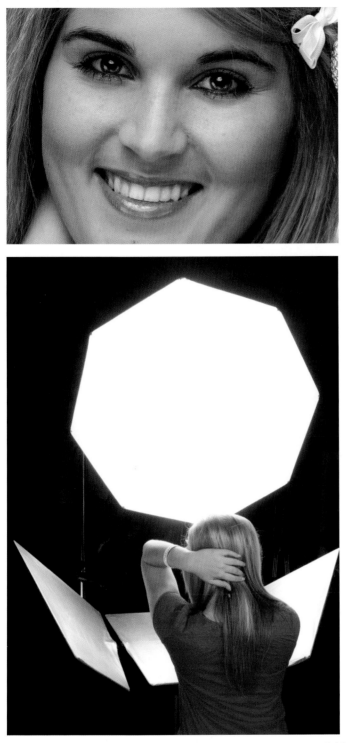

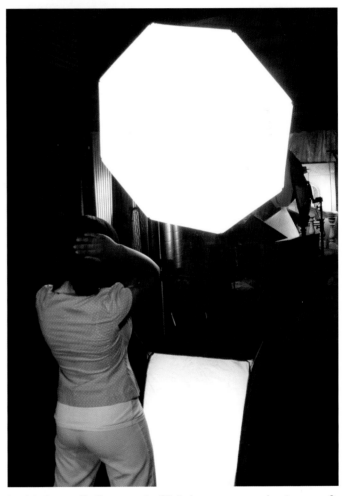

This butterfly-lit portrait was created using a Westcott Trifold reflector below the subject.

In this butterfly-lit portrait, fill light was created using a softbox on the floor.

same setting as the upper main light. For most of my portrait clients, I have the upper main light about a stop more than the reflector/secondary floor light.

For this lighting style to be effective, you need to ensure that there are obvious catchlights in each eye at both the 12 o'clock and 6 o'clock positions (or relatively close to those positions). The one mistake that I see many photographers make is placing their lights too close to the subject's head—basically with one light almost on top of the subject and the other directly underneath, which produces

LIGHTING WITH VARIATIONS

Another lighting check that I always do occurs when I go through my posing variations (see page 75). When I go into the first pose myself, I look directly at the camera. If I can't see the main light in my peripheral vision, the light is positioned too far to the side (too far from the camera position) or too high. With my lighting style, I know that if I see more than just the edge of the main light in my peripheral vision, the light is not at the correct angle. While this check isn't as precise as the markings on the floor, it is my last chance to check my lighting. (This technique also works on location and outdoors.)

a freakish horror-movie lighting effect. Both the main light (over the camera) and the lower light/reflector should be in front of the subject, not above and below the subject.

Ring Lighting. The next lighting style is one I noticed becoming popular in commercial photography, and even television commercials, six or seven years ago. They used a large ring light, similar to the ring light used for macrophotography but three, four, or five feet in diameter. While these were initially very expensive, Alien Bees eventually released a small model that was around $600. At that point, I bought one. It is smaller than I would have liked it, but it works well for the price.

The ring light, whether it's a larger model or a smaller one, works on the same principle as the small "around the lens" macrophotography version; you position the camera in the middle of the ring. The lighting effect can be beautiful, but like butterfly lighting it is not for everyone.

I call these two styles—butterfly lighting and ring lighting—my "pretty people" lights, because it will make pretty people look stunning. If, on the other hand, you try it on a girl who has a large nose, no cheekbones, or otherwise looks like Ichabod Crane . . . well, things can get ugly fast.

Spotlights. Spotlights have the unique ability to draw the viewer's eye to the main area of interest in a portrait, normally the face. When using a spotlight for the main-

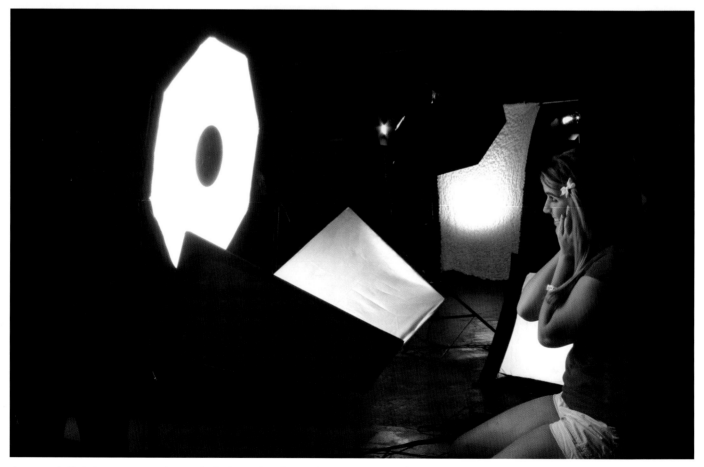

A portrait lighting setup with a right light and trifold reflector

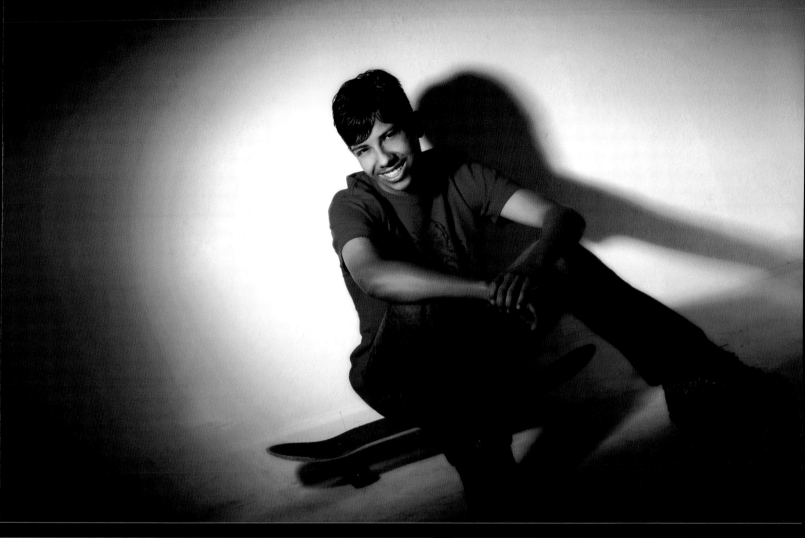

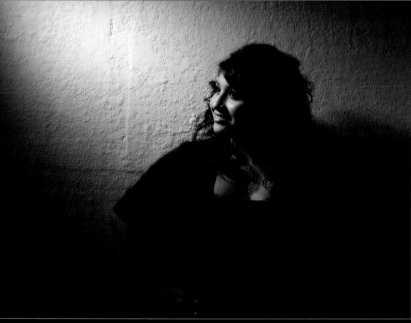

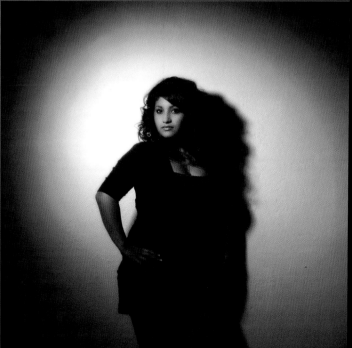

Spotlights have the unique ability to draw the viewer's eye to the main

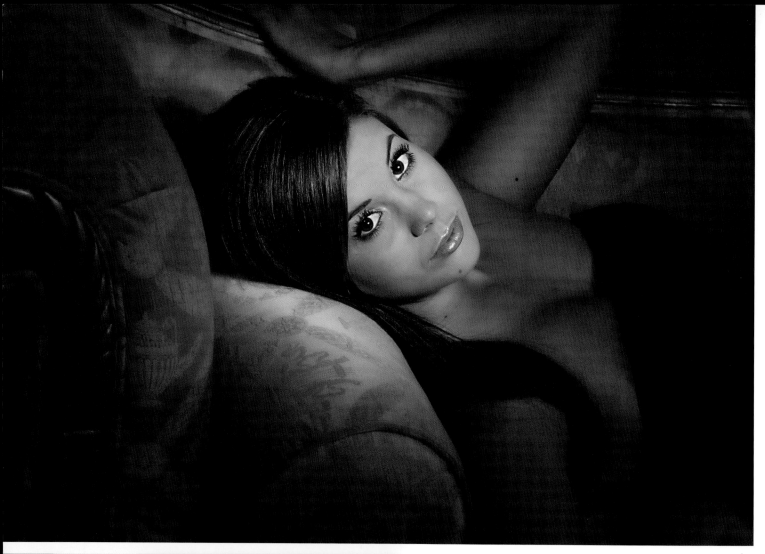

The diamond light highlights the important planes of the face.

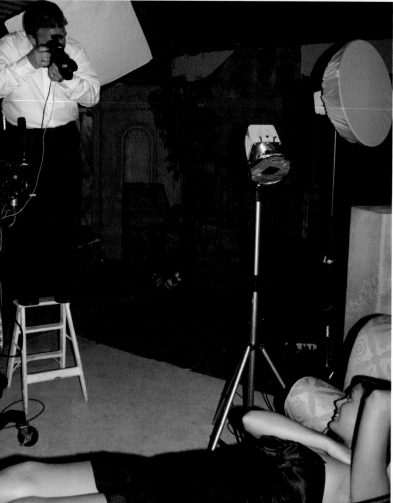

light source, you have to test the amount of fill used so that you soften the harshness of the look but do not void the effect of the spot.

One of my favorite ways to use this light is simply to pose the subject leaning on a white wall with a single grid spot illuminating the subject and background. Whether this shot is taken as a full-length or head-and-shoulders portrait, the look is striking and yet simple. It's not for everyone, but it's a consistent seller.

Diamond Light. The desire to accentuate my subjects' eyes led me to use what I call a diamond light. Because the important points of the facial plain form a diamond shape, I cut out a diamond in a black sheet of paper, put it on a mount for a projection box, and project the diamond-shaped light pattern onto the face at a slightly greater intensity than the standard main-light source. If the pro-

jection box is focusable, make sure the diamond pattern is out of focus so there are no distinct lines from the gobo. The effects are beautiful. (*Note:* A few years later I was watching a show on television and saw a *Playboy* photographer using the same technique to add a glamorous look to the face of the young lady. So much for my "original idea." Photographers have probably been using a variation on this lighting idea since before I was born!)

Parabolics. Parabolics, essentially large reflector dishes, have been used in portrait photography for decades. If you can imagine combining the light from a softbox with the light from a spotlight, you would end up with something close to the lighting produced by a parabolic. The light is harder than the light produced by a soft light source, but it's also more controllable.

I often use this type of lighting when I am going to diffuse an image. Many times, when photographers diffuse an image, they do nothing differently in their lighting and wonder why their images look "mushy." By increasing the contrast of the image, more of the fine details are preserved when the shot is later diffused.

I also use parabolics for corrective lighting, something I learned by studying the lighting styles of a photographer by the name of Marty Richert. He used parabolic lighting, combined with barn doors and gobos, to block portions of the main light from hitting areas he didn't want the viewer to notice. He used the same technique to tone down lighter areas that were closer to the main light and would record too brightly in the final photographs. This kind of previsualization and control is what it means to be a true professional photographer and a master of your craft. Guys like this produced results in their original images that many photographers today could only re-create in Photoshop.

When I work with a parabolic as a main-light source, I typically use a flash for fill. With the added contrast of this type of lighting, reflected fill isn't always sufficient to open

A parabolic fitted with barn doors was the main light for this portrait.

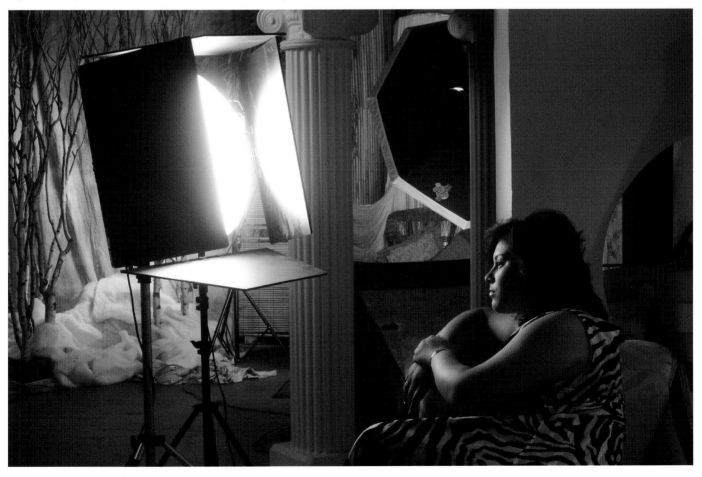

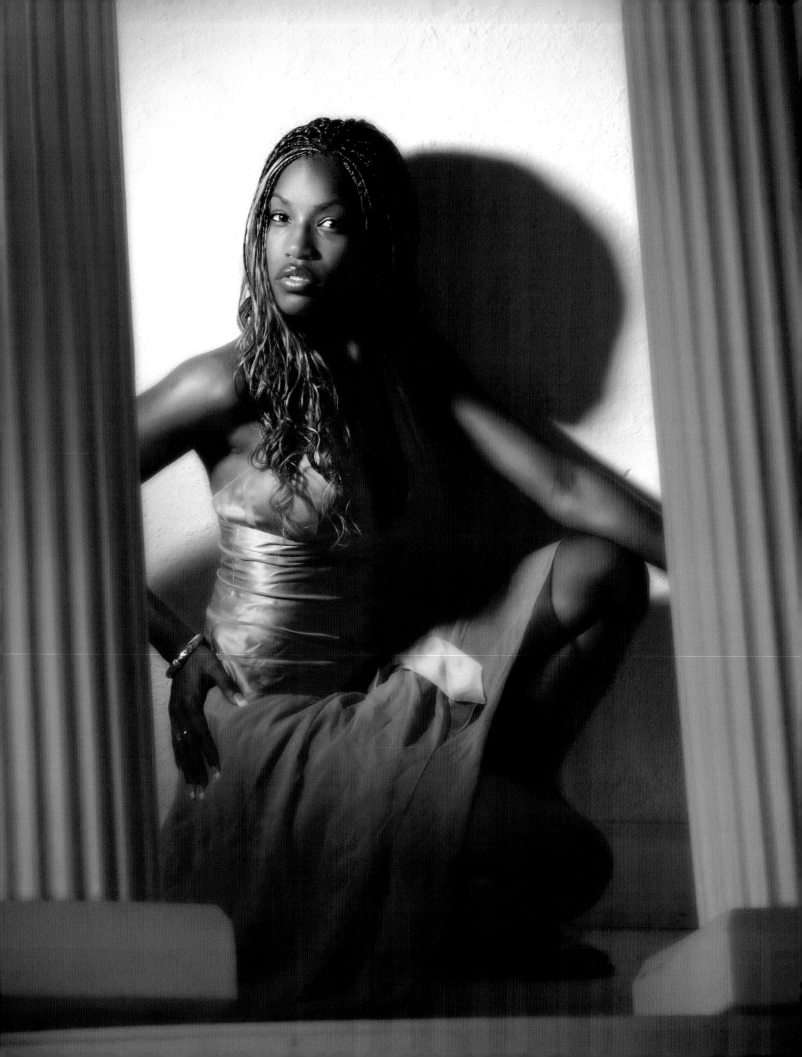

up all the little shadows in the nooks and crannies of the face. If you are like me, you will also find that your fill needs to be powered up a little more (producing a lower lighting ratio) than it would be with a softer source. As you test this type of lighting, be very careful about getting proper lighting on the eyes, using your fill light to soften and control the contrast.

While some younger photographers might think this style of lighting has an "old school" look, in this business you quickly find that what was once old becomes new again very quickly. As a result, many of my younger clients find this style of lighting very "classic Hollywood."

Background Lights

When designing a lighting setup, don't limit your attention to the lights on the subject. The direction and angle of any background light(s) also will change the appearance of the background and help direct the eye of the viewer.

When working with a set that you must illuminate, placing the background light directly behind the subject minimizes the contours and textures of the set behind the subject. If, instead, you mount the light above the set and angle it downward, it brings out the textures of the set and creates more contouring on the various elements.

The same is true for lighting a painted or solid-color background; the way in which you light it will change its appearance and determine the area of the portrait the viewer will notice. If you use a soft background light, the background will be evenly lit. This is a look I don't care for. I prefer to use a standard silver parabolic to focus a beam of light on the desired area of the background. The width of this beam can be increased or decreased by moving the light closer or further away. I typically use the parabolic in a lower position, then angle it upward. This creates a small area of lighter tones for separation around the subject, then fades to a darker tone around the subject.

The background light can also help direct your eye toward or away from certain body parts. For example, imagine a woman in a black dress is placed in front of a black

RIGHT AND FACING PAGE—*A single background can yield a variety of looks when the lighting on it is changed.*

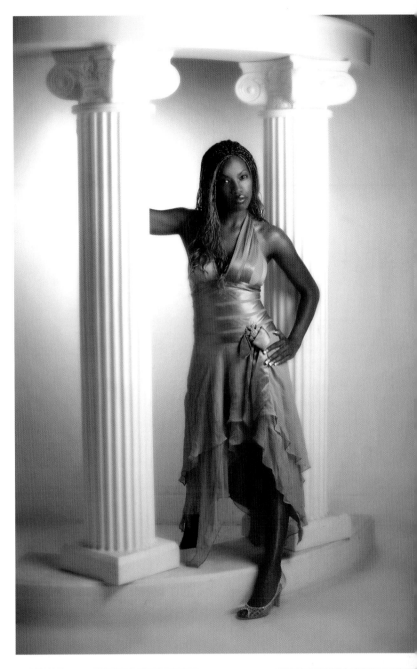

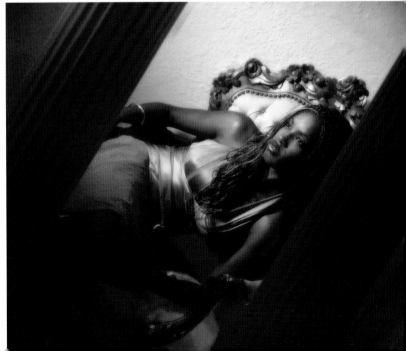

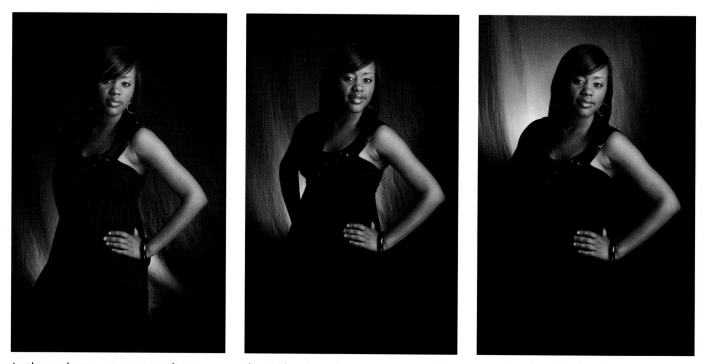

In these photos, you can see how you can direct the viewer's eye to or away from a certain area of a client's body. With the background light low, it draws the eye to the hips and thighs, which is good for some but not for most. As the background light is elevated, the eye is drawn to the waistline. Finally, with the background light at shoulder height, the focus is the area of the shoulders and head, with the body blending into the background.

background. This woman has a small waistline that you know she will want to accentuate. By placing the background light at waist level, you can create highlights that will draw the viewer's eye directly to her waist. If, in contrast, you knew the same subject was nervous about the size of her hips or waist, you could place the background light at shoulder height to keep the highlights (and the viewers' attention) in this area. Because there will be little or no separation light on the lower part of the subject's body, the black dress and black background will blend together and disguise her shape in the area of concern.

Final Thoughts

When lighting teen and senior portraits, you have many more lighting options than with most other clients. Just be sure to test each type of lighting you use and develop a consistent and repeatable system of lighting for working with clients. While some photographers might think this would lead to getting stuck in a certain style of lighting, I look at it as a foundation to start building on—a beginning to expand from. Before you start the next chapter, put this book down and start testing!

Posing

Care Enough to Do It Right

Too many photographers regard the self-induced problems of their clients (weight problems, wrong choices of clothing, etc.) as a nuisance that takes up time and energy. I was the same when I first started in photography, I would think to myself, "That girl has arms like a tree trunk and she brings in nothing but sleeveless tops? What an idiot!" Back then, I resented these clients because I felt that they made my job harder.

What I didn't understand is the way human eyes and brains work to save our egos from having to handle reality when we look in the mirror. You might gain ten or twenty pounds and lose some hair, yet it's not until you see yourself in a picture that you really notice these changes. You think to yourself, "I look in the mirror every day. Where has this fat, old, hairless guy been hiding?"

Knowing this, I tend to sympathize with my subjects' conditions—and it truly matters to me how my clients feel when they see their images. Everyone has a feature or aspect of their appearance that they are self-conscious about. In my efforts to minimize these problems, I work harder in the average session than most photographers—but the rewards of my extra efforts are many.

Sensitively Identify Any Problems

In chapter 3, I mentioned that one of the "constants" we must deal with when creating portraits is your subject's appearance. Posing, more than any other single factor, will minimize a subject's flaws and make a profound difference in their appearance in the final portrait—and in your total sales. Therefore, it's important to identify any appearance problems or concerns that need to be addressed so that you can design flattering poses that are tailored to the individual subject.

IT'S WORTH THE EFFORT

In many of my previous books, I have told stories of some of my clients and their emotional reactions to the images I create for them. As I was writing this book, I had one of the most rewarding moments a photographer can have. It was in the middle of the summer, which is a very busy time during which I see up to nine seniors a day. I was photographing a young man, who had both his father and mother with him during his session. I recognized the father—he had obviously been in with an older child for their senior portraits—but I couldn't remember when or who it was. He was a large man, at least 6'4", and he looked none too happy as he waited for his son. I was photographing his son with some personal props he had brought in and I was going back and forth making sure everything was perfect for the shot. After I finished capturing all the images and the young man was done, this father walked up to me, shook my hand, and said, "I have been in here twice and you have made me cry each time." I looked at the father's face and there was a tear rolling down his cheek. That is why I work harder. That is why I always say it's not about us, it's about them.

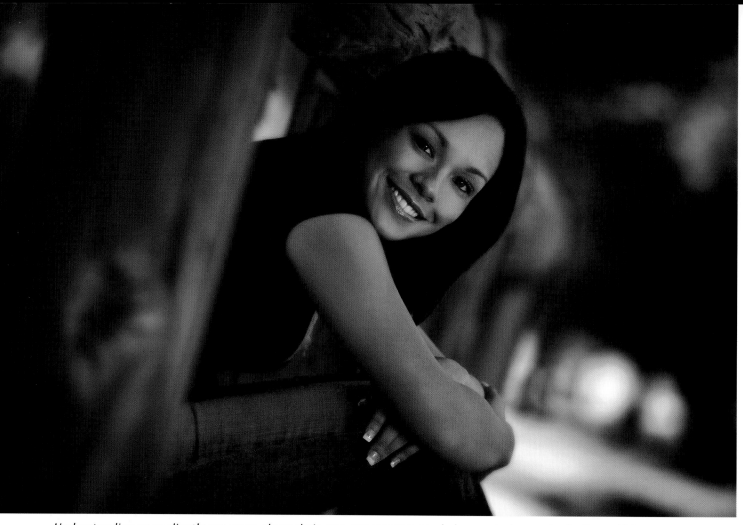

Understanding your client's concerns about their own appearance can help you design portraits they will love.

Most teenagers will not come right out and tell you what they consider to be problems with their appearance. They won't write it down on a questionnaire. The majority of the time, the mothers of the seniors are the ones who alert us to issues with their sons' or daughters' appearances—and even this doesn't happen as often as we would like.

To encourage clients to tell us if there is a problem—without making them feeling embarrassed or awkward—we ask questions to which the client only has to answer "yes" or "no." We phrase these questions to make it clear that lots of other people worry about the particular issue we're discussing. For example, a typical situation occurs when senior girls bring in sleeveless tops (something we specifically recommend against in our consultation materials). The minute I see them, I explain, "Sleeveless tops are fine." This doesn't make the senior feel like an idiot for not following the guidelines. Then I continue, "The

only problem is that a lot of ladies worry about their upper arms looking large or hair showing on the forearms. Does that bother you?" Either she will smile and say "Yes" or she will say "No." By phrasing your question carefully, you can make it easy for them to voice their concerns without being embarrassed.

The best way to handle a possibly embarrassing situations is to give the client two options, so no answer is needed. We do this with the "barefoot" issue. Rather than ask if a girl hates her feet, we explain, "With a casual photograph like we are doing it looks cute to go barefoot. If you don't mind, you can come out of the dressing room barefoot, but if you'd rather not go barefoot, you can keep your shoes on." When the girl comes out of the dressing room, not a word needs to be said.

Basically, it is not so much *what* you say to clients that is important, rather it is the *way* you say it. For every problem and potentially embarrassing situation there is a way to

handle it without making yourself look unprofessional or seeing your client turn red.

For example, when I see a heavier girl with a lot of boxes of shoes, I know I am going to have a problem and I need to say something the minute I show her into the dressing room. I first explain, "Many ladies go on a shopping spree to buy a matching pair of shoes for every outfit. Since they bought them, they want them to show in their portraits. The problem is that when you order your wallets for family and friends, the full-length poses make it very hard to really see your face that well." (This gets the girl to accept that not all the poses should be done full-length.)

Then I continue, "Most women also worry about looking as thin as possible. The areas that women worry about the most are their hips and thighs. This is why most of the portraits are done from the waist up, not to show this area." Next I ask, "Now, are there any outfits that you want to take full-length, or do you want to do everything from the waist up?" She will usually think for a second and say she wants everything from the waist up. This avoids telling her she can't take full-lengths, or being brutally honest and telling her she shouldn't take them.

Posing Styles

Types of Poses. Within a single session you may use a variety of posing styles. This is a business decision you must make. But to learn posing you need to be able to distinguish between the various types of posing and know what type of situation each is suited for.

Traditional Posing. In senior portrait photography, traditional posing is the type used in yearbooks. It reflects accomplishment, respect, and a classic elegance. Whether these portraits are taken in a head-and-shoulders- or full-length style, the posing is more linear, with only subtle changes in the angles of the body. The expressions should be subtle as well; laughing smiles are definitely not appropriate in these images. But at the same time, serious ex-

LEFT—*Traditional poses have a classic elegance.* RIGHT—*Casual poses show people as they are when they're relaxing.*

HIDE THE STOMACH

If the senior/teen wants a full-length pose but doesn't feel like they want to show their midsection, have them lay on their stomach. Then, pose the hands, arms, and legs to complete a natural, resting look.

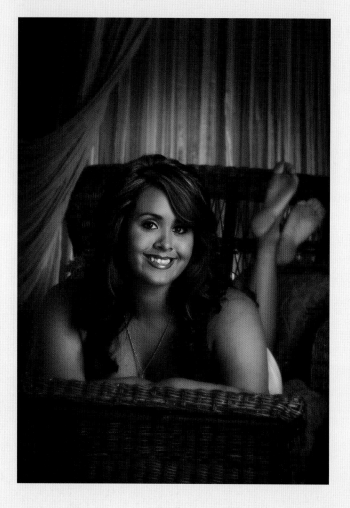

pressions need to be relaxed. Most people taking traditional portraits aren't comfortable doing so and, therefore, have a tendency to scowl; this needs to be avoided.

Casual Posing. Casual posing is a style of posing in which the body is basically positioned as it would be when we are relaxing. In senior portraiture, these are the images parents and grandparents will immediately love—but teens will like them too, because they look natural and casual. Casual poses are resting poses. The arms rest on the legs, the chin rests on the hands. The back is posed at more of an angle. It is common to use the ground to pose on, lying back on the side or even on the stomach.

The purpose is to capture people as they really are—or at least like we would like to think of them. Most teens of today are actually curled up in their pajamas texting or playing video games when relaxing. We are looking instead for the television version of how seniors/teens look in casual situations. This might mean you pose them curled up on the sofa while reading a book (like that's going to happen!), lying on a blanket enjoying a picnic in a beautiful park setting ("Ants, dirt, and sun? Forget it!"), or lying on the floor of the living room watching television with their parents ("Television and parents are so *yesterday!*"). These are the "casual" moments parents envision when they think of their kids—and these are the most ordered (although not always the most requested) poses.

Glamorous Posing. Glamorous poses are designed to make the subject look as appealing and attractive as possible. I am not talking about boudoir photography or the type of glamour images that achieves its look by having the client in little or no clothing. You can pose a fully clothed human being in certain ways and make them look extremely glamourous and appealing. If you finish the pose with the right expression, often with the lips slightly parted, you will have made the client's romantic interest very happy.

A few years ago when we started taking extreme close-ups, a popular "glamour" style, I photographed a senior girl in a strapless dress, which meant no clothing was visible in the close-up image. I had done hundreds of these images before with bare shoulders and never thought a thing about it—until this girl's father yelled out in the viewing station, "It looks like she ain't wearin' nuthin'!" (yes, he said it just like that). The mother and senior were completely embarrassed, but it did bring up a good point. Now I always ask if Dad will have a problem with bare shoulders; if they think he might, we select something else.

Almost every girl, given the right makeup, clothing, and photographer can look like a cover girl—but this shouldn't mean making her look like someone else. I once had a mother come in with her senior and talk about a session she did for her husband at a mall glamour studio. She spent quite a sum of money and bought a very large wall portrait of herself. When she gave it to her husband he

looked completely speechless. When he finally spoke, he said, "This is absolutely beautiful—it looks nothing like you!" That was a major slap in the face. While he didn't mean it as harshly as it came out, it's a good reminder that you don't want to make someone look so different that they are unrecognizable to their family.

A Direction for the Session. The purpose of defining each type of posing is to have a direction for the session. This is the point at which a photographer's own style and experience take over. For example, many of my traditional poses are much more glamourous in their look than what the average photographer would consider traditional. This is because, as human beings, I think we all want to appear attractive. People who insist they don't care about how they look are the same people who say they don't care about money—and I think that people who would say things like that would lie about other things, too.

The Style Breakdown. It's important to determine to whom portraits will be given when deciding on styles. Not too many grandmothers want to see their grandson with his shirt off and a barbell in his hands; not too many of the senior's friends will want a wallet-size print of their friend in a cap and gown. For most sessions, the portraits will be going to different people with different tastes, so I use a 20/20/60 split. This means that 20 percent of the images are a more traditional or classic style that grandmothers and aunts typically want to see. Another 20 percent of the images are tailored to the teen's tastes, which means they reflect that client's interests or, if they choose, a fashion/glamour style. The remaining 60 percent of the images are those casual, "slice of life" images that show the senior as they really are. These casual images usually constitute the largest part of the senior's portrait order.

Posing Fundamentals

Once you have determined the style of the pose you want to create, you can begin to position the subject to make them look their best.

Glamorous poses should make the subject look extremely attractive, but never sleazy.

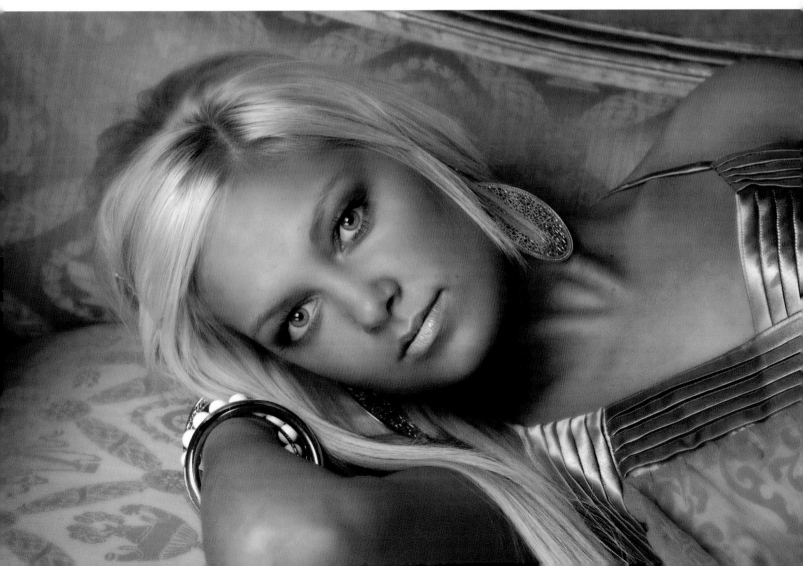

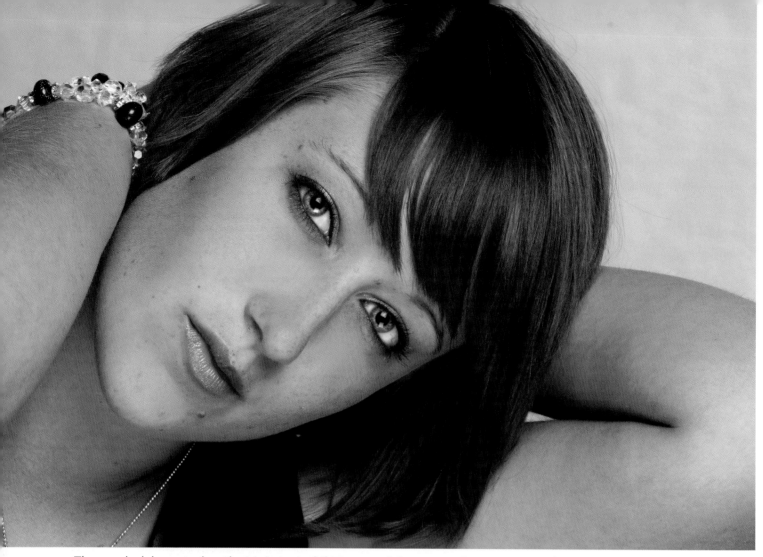

The eyes look largest when the iris is toward the corner of the eye opening, not centered.

The Face. We will start off with the face, because the face is the most important part of any portrait. There are portraits that have the face in silhouette or obscured from view, but these are usually created as artistic exercises for the photographer, not as portraits that would be salable to the average client.

The Eyes. As you might imagine, the posing of the face is linked to the lighting. You can create the most stunning pose in the most stunning scene, but if the face (particularly the eyes) is not properly lit and properly posed, the portrait will not be salable. The eyes give life to the portrait, and it is critical to see catchlights in them. They attract the viewer's gaze to the subject's eyes.

There are two ways to control the position of the eyes in a portrait. First, you can change the pose of the eyes by turning the subject's face. Second, you can have the subject change the direction of their eyes to look higher, lower, or to one side of the camera.

Typically, the iris should be positioned toward the corner of the eye opening. This enlarges the appearance of the eye and gives the eye more impact. This is achieved by turning the face toward the main light while the eyes come back toward the camera. This works well for all shapes of eyes, except for people with bulging eyes (where too much of the white will show and draw attention to the problem).

The Tilt. According to traditional posing theory, a woman is always supposed to tilt her head toward her higher shoulder and a man should always tilt his head toward his lower shoulder. The real rule of tilting the head, however, is that there is no rule. You don't always do *anything* in photography; you don't tilt toward the high shoulder and you don't tilt toward the low shoulder, you

should tilt the subject's head toward whichever shoulder makes them look their best in the pose.

The Neck. The neck really isn't posed and it really isn't part of the face, but it can be a problem spot if your senior portrait client is at all overweight. The best way to handle the neck area is to cover it up with clothing or with the subject's arms or hands. If it isn't possible to conceal the area, have the client extend their chin out to the camera and then lower their face, basically bowing their neck (which is why this pose is commonly referred to as the "turkey neck"). This will stretch out the area and help to eliminate a double chin.

The Shoulders. The line of the shoulders shouldn't form a horizontal line through the frame. A diagonal line makes the portrait more interesting. It also makes the subject look less rigid. The shoulders of a man should appear broad and be posed at less of an angle than the shoulders of a woman. Women's shoulders can be a very appealing part of a portrait if posed properly, but it is a good idea to

The subject's shoulders should be at an angle, never in a straight horizontal line across the frame.

LONG HAIR

When photographing a woman with long hair, I look to the hair and not the gender to decide the direction the head will be tilted and the direction in which the body will be placed. Long hair is beautiful, and there must be an empty space to put it. A woman's hair is usually thicker on one side of her head than the other. The tilt will go to the fuller side of the hair and the pose will create a void on the same side for it to drape into. This means she will sometimes be tilting toward the lower shoulder.

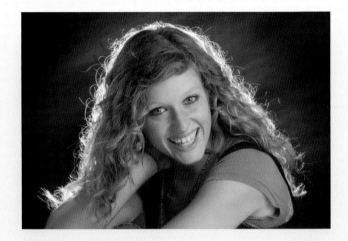

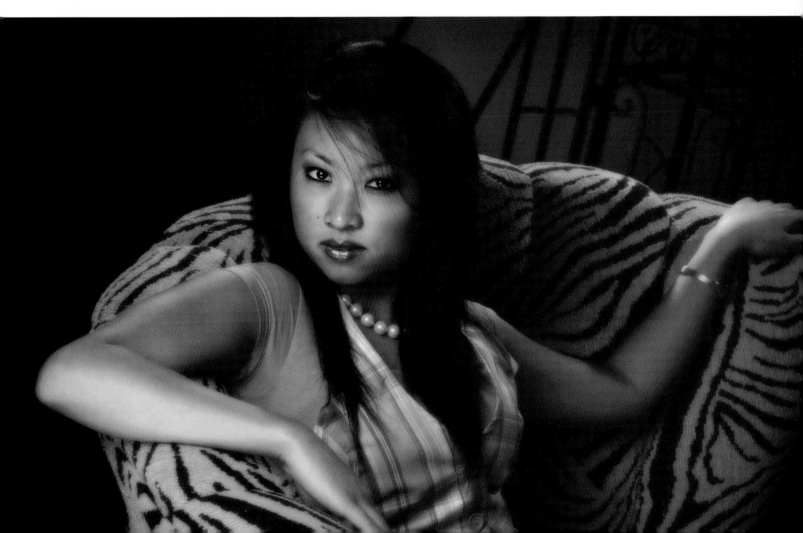

OBSERVE THE DETAILS

The key to good posing is being observant. Many photographers are in too much of a hurry to start snapping pictures. I tell my young photographers to take one shot and wait for that image to completely download and be visible on the screen. At that point, I want them to study the image for at least ten seconds. By forcing them to take the time to notice problems in posing, lighting, and expression, the number of obvious problems have gone down considerably.

To learn how to pose the arms, watch people as they are relaxing. They fold their arms, they lean back and relax on one elbow, they lay on their stomachs and relax on both elbows, or they will use their arms to rest their chin and head. (*Note:* Any time weight is put onto the arms [by resting them on the back of a chair, the knee, etc.] it should be placed on the bone of the elbow. If weight is put on the forearm or biceps area, it will cause the area to appear larger than it actually is.)

Posing the arms carefully also gives you the ability to hide problem areas, such as the neck, waistline, or hips. I look at the client once they are in the pose to see if there are any areas that, if I were them, I wouldn't want to see. If there is a double chin, I lower the chin onto the arms to hide it. If I see a not-so-flat stomach, I may extend the arms out to have the hands around the knees.

have them covered with clothing if the subject's weight is at all an issue.

The Arms. The arms should not be allowed to just hang limply at the subject's side. They should be posed away from the body, creating some space between the torso at the arms to better define the waistline. Having the subject rest their hands on their hips or tuck them in their pockets will automatically kick out the elbows and create just such a pose.

The Hands. The traditional rule ("all joints bent") results in hands that look a little on the unnatural side. Your subject tends to look like a mannequin from the 1960s—and when you have the hands posed in such a way, it can

LEFT—*The arms shouldn't just hang at the sides—give them something to do. Here, the arms loosely frame the subject's face.*
RIGHT—*Leaving space between the arms and the torso give the waist a slimmer line.*

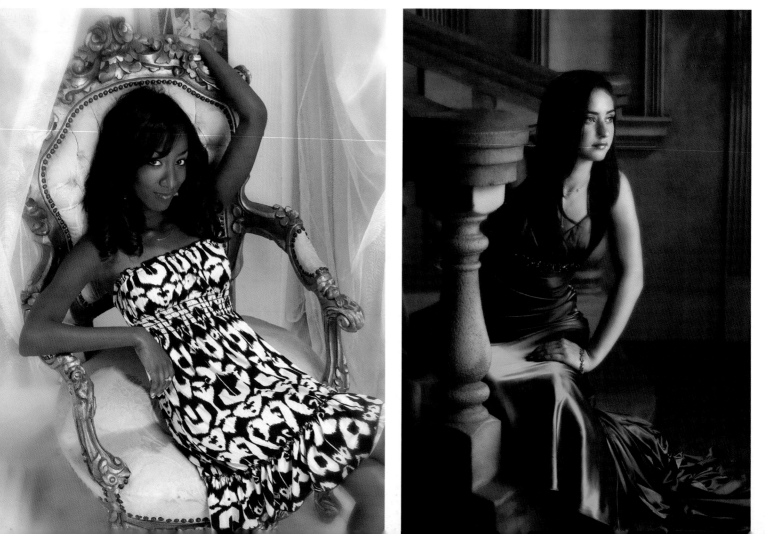

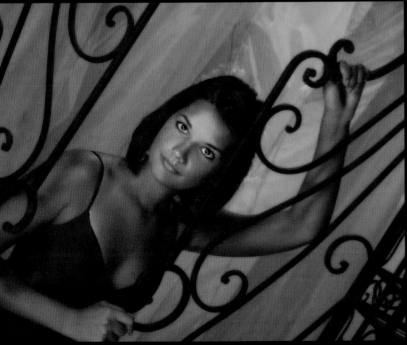

To look natural, hands should either rest on something or hold something. They should never dangle down lifelessly.

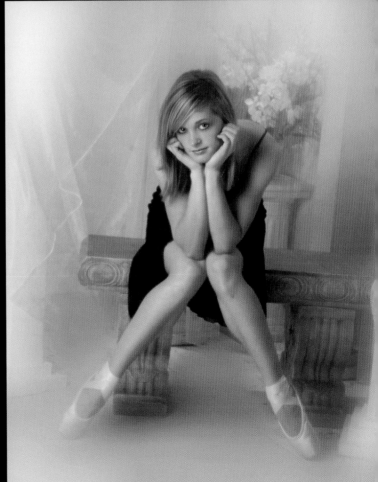

draw attention away from the face, the intended focal point of the portrait.

Generally, the hands photograph best when they have something to hold or rest upon. They photograph worst when they are left dangling. The hands are one area of the body that clients usually pose very well on their own, if you explain where they are to place them or what they are to hold. If you watch people relaxing, in fact, you'll see that they tend to fold their hands or rest them on their body—instinctively avoiding the uncomfortable and unflattering "dangling" positions.

Place the body and arms where you want them, then find a place for the hands to rest, or something for them to hold. Following this rule simplifies the entire process, allowing you to achieve quick and flattering results while avoiding the very complex process that many photographers go through when posing the hands.

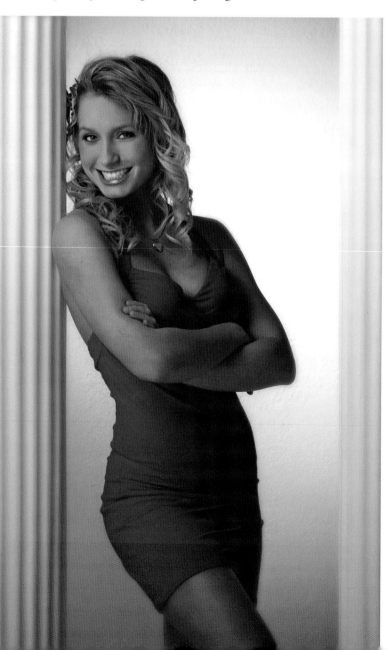

Fists. Guys don't always have to have their hands in a fist—and if they do, it should be a relaxed fist that doesn't look like they are about to join in on a brawl (if the knuckles are white, the fist is too tight).

Women should never have the hand in a complete fist. If a woman is to rest her head on a closed hand, try having her extend her index finger straight along the face. This will cause the rest of the fingers to bend naturally toward the palm, without completely curling into it. Even the pinky won't curl under to touch the palm.

The Waistline. The widest view of the waistline is when the body is squared off to the camera. The narrowest view of the waistline is achieved when the body is turned to the side. The more you turn the waist to the side, the thinner it appears—unless there is a round belly that is defined by doing so.

A common problem with the waistline occurs when the subject is seated and folds of skin (or stomach) go over the belt. Even the most fit, athletic person you know will have a roll if you have them sit down in a tight pair of pants. There are two ways to fix this problem. First, have the subject straighten their back almost to the point of arching it. This will stretch the area and flatten it out. The second solution is to have them put on a looser pair of pants. (*Note:* Many photographers who lack an eye for detail also create the appearance of rolls simply by failing to fix the folds in a client's clothing around their waistline.)

Hips and Thighs. Unless you are a woman (or live with a woman), you never will realize how much women worry about this part of their bodies.

The first basic rule is never to square off the hips to the camera. This is obviously the widest view. In standing poses, rotate the hips to show a side view, turning them toward the shadow side of the frame if weight is at all an issue.

Just as the arms shouldn't be posed next to the body, legs (at the thighs) should never be posed right next to each other in standing poses. There should always be a

Turning the shoulders, waist, and hips so that they are at an angle to the camera creates a slimmer view of the entire body.

slight separation between the thighs. This can be done by having the subject put one foot on a step, prop, or set. Just turn the body toward the shadow side of the frame and have the subject step forward on the foot/leg that is closest to the camera. Alternately, you can simply have the subject turn at an angle to the camera, put all their weight on the leg closest to the camera and then cross the other leg over, pointing their toe toward the ground and bringing the heel of the foot up. This type of posing is effective for both men and women.

More can be done to hide or minimize the hips and thighs in a seated pose rather than a standing pose, but there are still precautions that need to be taken to avoid unflattering effects. If you sit a client down flat on their bottom, their rear end will mushroom out and make their hips and thighs look even larger. If, on the other hand, you have the client roll over onto the hip that is closest to the camera, their bottom will be behind them and most of one thigh and hip will hidden. Again, the legs must be separated, if possible.

When you separate the legs, in this or any other pose, you need to make sure that the area between the legs (the crotch area) isn't unsightly. This problem commonly occurs when you have a guy seated with his legs apart, then have him lean forward and rest his arms on his knees. The pose works well because this is the way guys sit—and it sells well because it looks comfortable. The problem is that the crotch area is directly at the camera. In this situation, you can use the camera angle and the arms to hide or soften the problem area.

The Legs. The calves and ankles are not a problem for most guys, but they can be a real issue for many women. The "cankle" (or the appearance of not having an ankle, but the calf of the leg just connecting to the foot) is a look that many women have and most could live without. This is best handled by suggesting pants, looking for tall grass to camouflage the area, or taking the photographs from the waist up.

The first advice I give to our young photographers about posing the legs is to pick what I call an "accent leg." Usually, the accent leg is determined by the pose and the direction of the body. This works in both standing, seated,

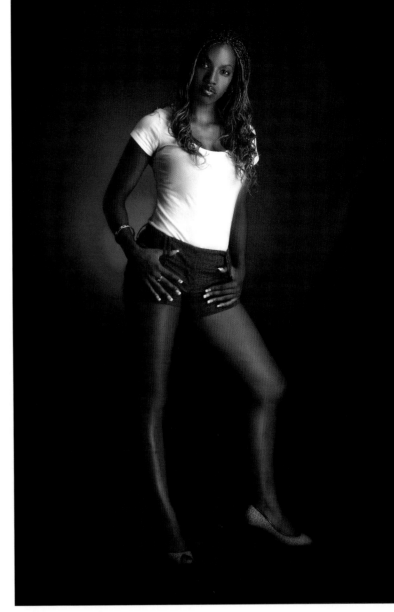

Creating some separation between the legs makes for a slimmer look. High heels further lengthen and tone the legs. Here, the subject's left leg is the accent leg.

and reclining poses, leaving the other leg as the support or weight-bearing leg. If you use this strategy, you will have cut your work in half since you'll only need to pose one leg instead of two.

LEG POSING INSPIRATION

When looking for new posing ideas that include the legs, peruse some fashion magazines. These are the images that set the standard of beauty for your senior portrait subjects. Teens don't want to look like mannequins, they want to look like the girls on the covers of these magazines. If they don't have legs like those girls, however, suggest that they wear pants.

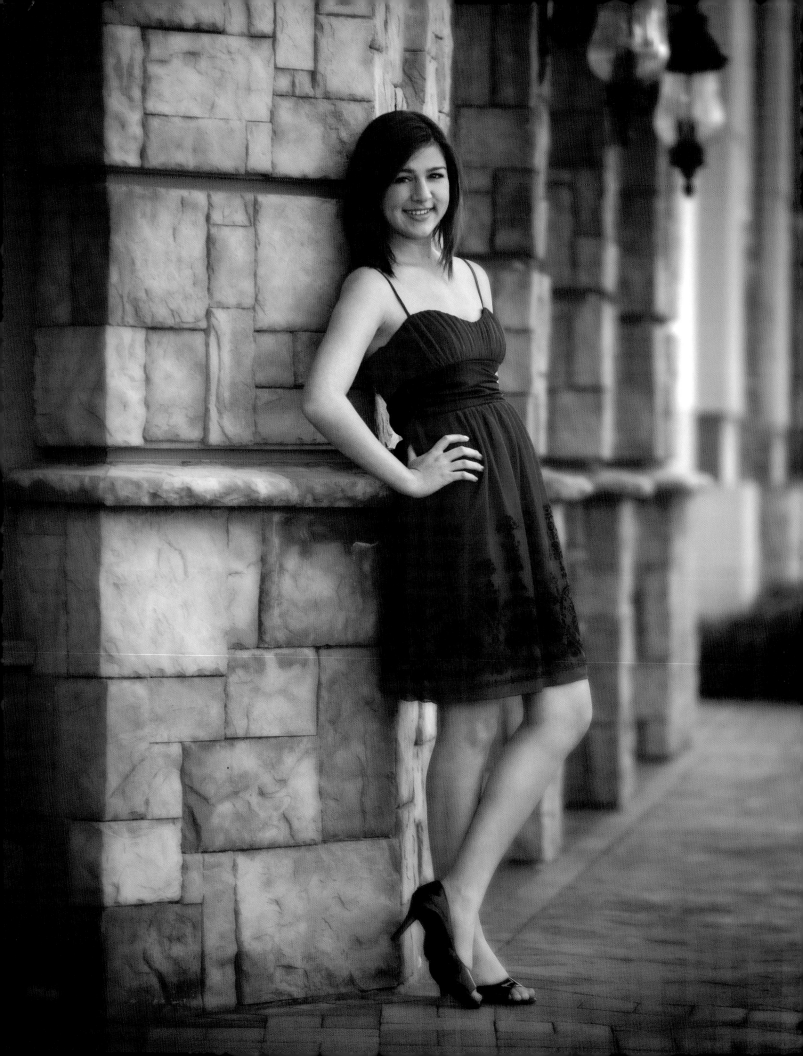

Take the classic "James Bond" pose. In this stance, the weight is put on one leg and the accent leg is crossed over with the toe of the shoe pointing down. Even if you just have the accent leg turned to the side (one foot pointed toward the camera, one pointed to the side) it produces a more interesting, more flattering pose.

In a seated pose, at least one leg should extend to the floor in order to, for lack of a better word, "ground" the pose. The body needs to be grounded. Have you ever seen a person with short legs sit in a chair where their feet don't touch the ground? While this is cute for little kids, a pose that is not grounded looks odd for an adult. In a seated pose where one leg is grounded, the other leg becomes the accent leg. The accent leg can be "accented" by crossing it over the other, bending it to raise the knee, or folding it over the back of the head (just kidding)—but you need to do something with it to give the pose some style and finish off the composition.

There are literally hundreds of ways to make the legs look good—in fact, it's easier to isolate what *not* to do. The following are the deadly sins of leg posing:

1. In a standing pose, never put both feet flat on the ground in a symmetrical perspective to the body.
2. Never position the feet so close together that there is no separation between the legs/thighs.
3. Never do the same thing with each leg (with a few exceptions, like when both knees are raised side by side).
4. Never have both feet dangling; one must be grounded.
5. Never bring the accent leg so high that it touches the abdomen.
6. Never expect one pose to work on everyone.

Rule number six is especially important. Because of how flexible clients are (or are not), as well as how their bodies are designed, no single pose—no matter how simple it is—will make everyone look good. This is the golden rule of posing: when a client appears to be having a problem with a pose, scrap it. Don't struggle for five minutes trying to get it to work.

FACING PAGE—*In this simple, classic leg pose, one leg bears the subject's weight, while the other is crossed over with the toe pointed down.* ABOVE—*In seated poses, at least one foot should touch the floor to make the subject look grounded.*

The Feet. While casual poses typically look good with bare feet, many people hate the appearance of their feet. I never knew how much feet were hated until we started shooting seniors with bare feet. I would tell each senior who was taking more relaxed poses to kick off their shoes and socks—and I would see a look of horror come over their face. The subject would usually explain they hated their feet. Based on their reaction, I expected to see feet with seven toes.

When it comes to this area, clients don't want their feet to appear large or their toes to look long. Also to be avoided are funky colors of toenail polish, long toenails (especially on the guys), or (if possible) poses where the

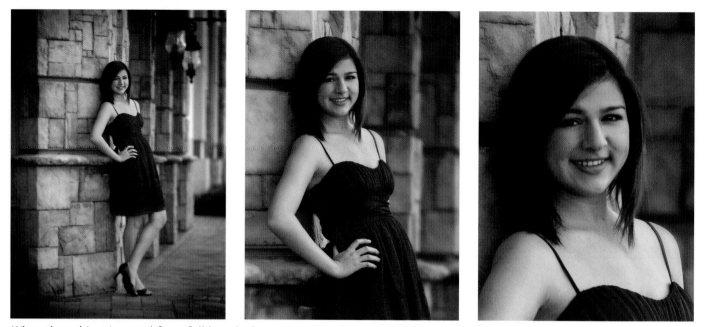

When the subject is posed for a full-length shot, you can easily zoom in (or move closer) to create a three-quarter-length portrait and a head shot—without having to reposition the subject. This helps you maximize the variety of images and minimize the time spent posing.

bottom of the feet show. If the bottom of the feet are to show, make sure they are clean.

Bare feet can be made to look smaller by pushing up the heels of the foot. This not only makes the feet look better, but also flexes the muscles in the calves of the legs, making them look more shapely. Muscle tone in the legs is determined by the muscle that runs down the outside of the upper and lower leg. Flex that muscle and the legs appear to be toned. (If the feet are showing with open-style shoes, the higher the heel, the smaller the foot appears.)

The subject's tension may become visible in their toes. If a person is nervous, their toes will either stick up or curl under. Neither one is exactly attractive. Just like the fingers, toes photograph better when they are resting on a surface.

Pose Every Image as a Full-Length Portrait

I suggest that you create every pose as if you were taking the portrait full length. This achieves two things. First, it speeds up the session by allowing you to go from head-and-shoulders, to three-quarters, to full-length shots with a quick zoom of the lens. Second, posing the entire body every time gives you practice in designing full-length poses.

This approach also makes the client feel complete. A certain look comes over a subject when they are posed completely and know they look good. If you don't think this is true, imagine how you would feel in an elegant dress with your arms and shoulders posed properly but your legs in some terribly awkward stance. It's like being dressed for success and looking good—right up until someone tells you your fly is open. Just take my word for it: pose the entire body; it's good for you and the client.

Demonstrate the Pose

Demonstrating poses will help your client to relax. Just think of yourself doing any new task. You feel kind of nervous—especially if you have the extra pressure of wanting to look your best and do this task at the same time. Wouldn't you appreciate a person to guide you through the task and demonstrate how to do it as opposed to telling you to "go stand over there and do this"? We always need to put ourselves in our clients' shoes.

Male photographers hate this. I have heard it all—"How am I supposed to pose like a girl?" or "I feel really dumb!"—but I don't care how they feel. Until you can pose yourself, feel the way the pose is supposed to look, and demonstrate it to a client, you will never excel at pos-

ing. Yes, you get some pretty strange looks when you're not a petite man and you're showing a young girl a full-length pose for her prom dress, but that is the best learning situation I, or any other photographer, can be in.

No matter how silly you might feel demonstrating poses, it is the most important part of the learning process. You can look at all the poses shown in this book, get clippings from magazines, and go to seminars, but until you practice them daily in the same situation as you will actually use them, designing flattering poses will always be a challenge to you.

Work with Variations

When I was first learning posing, I had such a hard time with it. I would sit someone down and my mind would race, trying to figure out how to make the subject look comfortable and yet stylish. I would go to seminars and look in magazines to get posing ideas, but it seemed that when a paying client's session started the ideas went right out of my head.

We live in a world that has us looking for immediate solutions to long-term challenges. I see my sons trying to learn something new, and they get frustrated because they don't master it in the first five minutes. Whether it is lighting, learning digital, or especially posing, you won't get it the minute you put the book down. That would be like picking up a book on karate and thinking that when you finished reading it you would be a black belt. Posing is a learning process and, like all learning processes, it takes time and practice.

I realized, early on, that if I was going to become effective and comfortable with posing, I needed to practice often and in the same situations that I would be needing to use this skill. I needed to practice under the pressure of

Demonstrating poses might make you feel silly, but it puts your subject at ease. It's also much quicker than trying to describe poses, so it greatly streamlines the posing process.

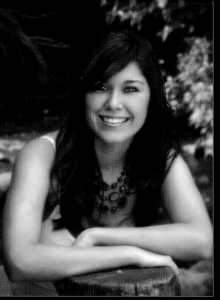
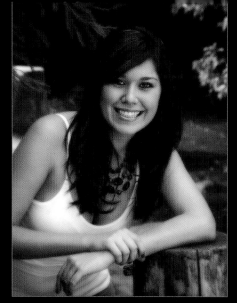
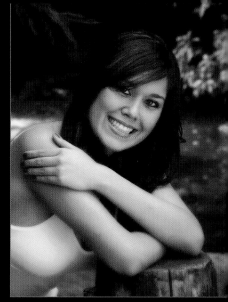
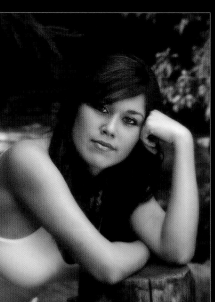
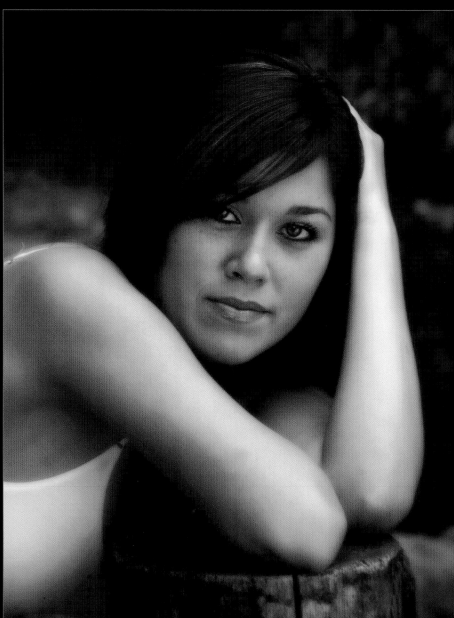
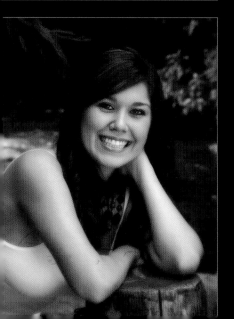

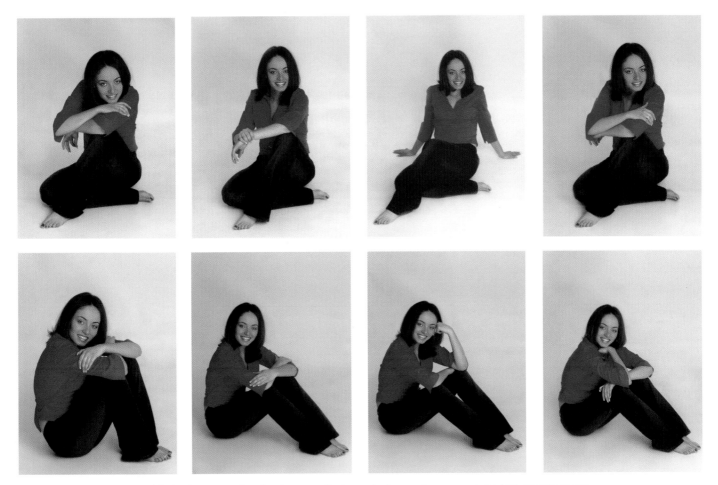

ABOVE AND FACING PAGE—*Variations are simple changes that can help you turn one pose into many poses.*

a session, not as I was fooling around shooting a test session of someone I knew. I also knew that I didn't have ten years to get good at posing my clients—I needed to get as many poses down as I could, and do it as quickly as possible. This led to what I call variations.

Variations are simple changes you can make in a single pose to give it a completely different look. You start out with a basic pose, then come up with a variety of options for the placement of the hands, arms, and/or legs. This takes one posing idea and turns it into five or ten different poses. I make every photographer in my studio (including myself) do this for every session. It provides good practice because it teaches you how to maximize each pose. It also gives your client the most variety from each pose they do.

Using variations keeps each of your poses in your mind, so no matter how much stress you feel, the poses are there. It's just like multiplication tables—once they stick in your mind, you'll never forget them. This is an important fac-

tor, since I have ten shooting areas in our main studio and often need to go as quickly as I can from one shooting area to another, working with up to four clients at a time. As you can imagine, this requires some real speed at posing demonstration. I assist each client into the desired pose and refine it—then I'm off to the next client!

Be Tactful
Photographers don't usually spend a lot of time thinking about how to talk with their clients about posing without offending them. While watching photographers work with clients, I have heard posing instructions like, "Sit your butt here," "Stick out your chest," "Suck it in just before I take the picture, so your belly doesn't show as much," "Look sexy at the camera," and "Show me a little leg." I am sure the women who were instructed in this way didn't feel very comfortable with or confident about their chosen photographers.

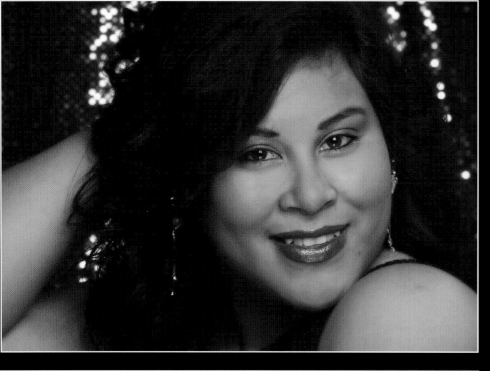

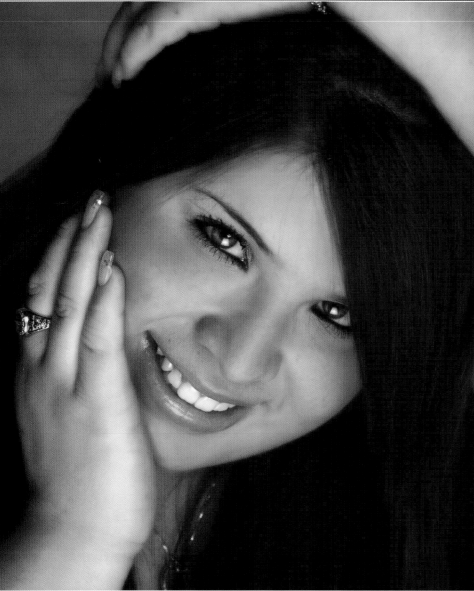

As these before-and-after images show, posing is one of the most powerful tools at your disposal for making your subjects look their best.

Whether you are discussing a client's problems or directing them into poses, there are certain words that are unprofessional to use in reference to your clients' bodies. In place of "butt," choose "bottom" or "seat." Never say "crotch," just tell the client to turn his or her legs in one direction or another so that this area isn't a problem. Instead of "Stick out your chest," say "Arch your back." Replace "Suck in your stomach" with an instruction to "Breathe in just before I take the portrait." To direct a client for a "sexy look," simply have the subject make direct eye contact with the camera, lower her chin, and breath through her lips so there is slight separation between them.

No matter how clinical you are when you talk about a woman's chest, if you are of the opposite sex, you will embarrass them. The only time it is necessary to discuss that part of the anatomy is when the pose makes the woman's bust appear uneven. When this situation comes up, I just explain to the subject how to move in order to fix the problem—without telling her exactly what problem we are fixing. Once in a while, we have a young lady show up for a session wearing a top or dress that is really low cut. In this situation, you need to find an alternative. If there is way too much of your client showing, you may explain that this dress is a little "low cut" for the type of portraits she is taking.

Refine the Camera Position

Once I make my final decisions about posing and adjust the lighting, there are still more choices to make. Do I take the image at a normal height? Should I raise or lower the camera? Should I have the camera straight? Or tilt it to distort the vertical and horizontal lines? Each of these decisions will have a significant impact on how the pose is perceived in the final portraits.

With seniors, it is very popular right now to shoot from a very elevated angle, with the face raised to record properly. This is a perfect way to record a larger facial size (which moms like) along with more of the body and outfit (which seniors like) in the image. Lowering the height of the camera can also be effective, especially when trying to make the client look taller.

More than any other market, seniors demand portraits that are different and unique. An easy way to turn a simple portrait into one that is more dramatic is to tilt the camera to throw off the vertical and horizontal lines within the frame. It takes some time to learn how to tilt the camera effectively to match the flow of the image—and this is something that kids will appreciate more than parents and grandparents, so a little goes a long way. (*Note:* When you look at the file you have tilted and you can't decide whether it should be cropped vertically or horizontally, you have tilted the camera too much.)

Final Thoughts

Finding poses that clients like—and that sell well—should never be a problem. What *can* be a problem is remembering them when you are working under the pressures of a paying client's session. To help things run smoothly, we keep small sample books in the front of our studio. From these, client can select their favorite backgrounds and poses. This gives us a solid point of departure for each session. And when I get an inspiration and come up with a new pose, I make sure it gets into the sample books immediately so it's not lost.

Practice is the key to posing beautifully and efficiently.

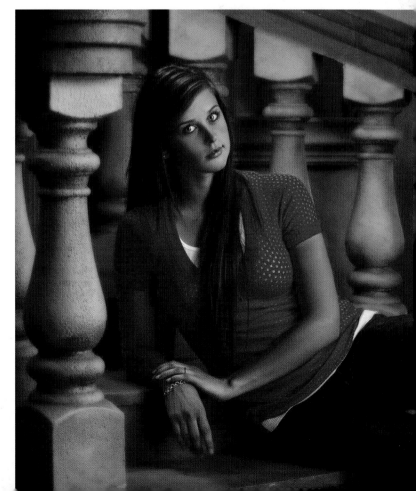

Outdoor and Location Portraiture

Let me start off by saying one simple thing about working outdoors or on location: either learn to do it correctly or stay in the studio. I am not arrogant enough to think I am the final authority on portraits taken on location (of course, after writing three books on the subject, I'm probably at least in the top fifty!), but I've seen all too many photographers wandering around parks without a

clue as to what they should be doing. So, here are my basic rules for working outdoors and on location.

The Rules

Rule 1: Don't Use On-Camera Flash. Never ever use on-camera flash for outdoor portraiture. I have said it for years: if you wouldn't use a particular light source in the

Even portraits made outdoors should have studio-quality lighting.

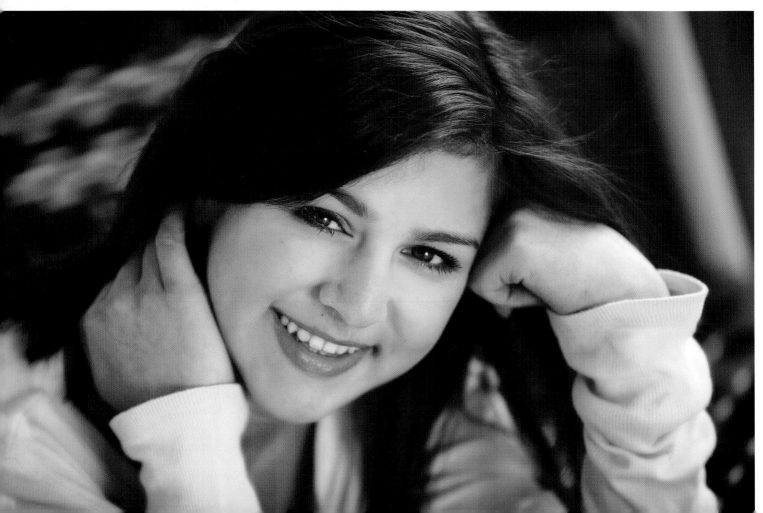

studio, why would you use it outdoors? I see local photographers, who are quite proficient in the studio, wandering around outdoor locations—going from spot to spot, paying no attention to the natural light and thinking that their little TTL on-camera flash will make everything okay. Don't make this mistake.

On those rare occasions where flash is critical, you should use the same flash you use in the studio. Using an on-camera flash outdoors is like leaving your professional camera in the studio and taking a point-and-shoot consumer camera to the session. Sure, I guess it's easier—but convenience is not an excuse. You should care enough (about your clients and about your own reputation) to go the extra mile and deliver images with studio-quality lighting whether or not you're working in the studio.

Rule 2: Work with the Natural Light or Overpower It. You have two choices when working on location: work with natural light (learn to evaluate its quality and direction) or use a light source to overpower the natural light and use the natural light as fill.

You're probably thinking, but what about flash fill? Well, in my experience, no photographer (no camera metering system, either) is good enough to properly fill in the delicate light that exists outdoors. Using a professional flash to overpower the existing light will give you better results—and better control over the light on your background. We'll cover this in greater detail later in this chapter.

Rule 3: Learn to Work in Less-than-Ideal Lighting. The vast majority (about 99 percent) of paying clients won't want to be photographed when the outdoor lighting is ideal (right after sunrise and just before sunset). It's a mistake to think otherwise. Today's clients are stressed out, overworked, overscheduled, and used to receiving excellent customer service. With very few exceptions, they are not going to get up before the sun rises or stay out after dark because you say the lighting is perfect at these times. This reality is the reason that some studios don't photograph many clients outdoors; the photographer doesn't want to be inconvenienced by the poor lighting at the times of day that clients find convenient for their sessions.

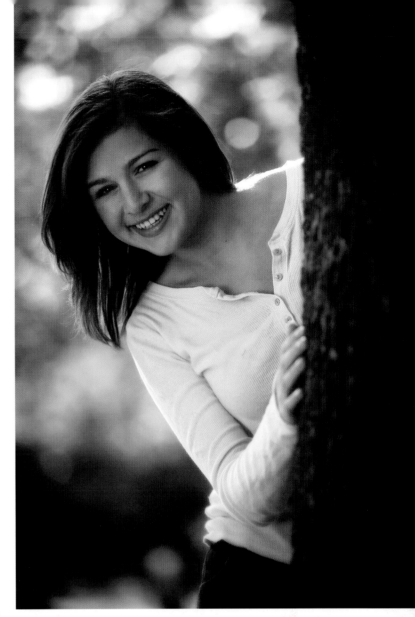

Booking an entire day of sessions at a single outdoor location makes it possible to offer them at the same price as studio sessions—and reap the rewards of the higher sales that location sessions typically bring in.

Rule 4: Be Smart about Scheduling and Travel. Another reason—aside from lighting—that outdoor sessions don't work for most studios is that they tend to take a senior, at dawn, to a distant location. To compensate, they charge a small fortune for travel or hope that the order size will make up for the time in travel. Neither idea works. If you charge a high sitting fee for outdoor sessions, no one will book them. And while orders that include outdoor portraits do tend to be larger, they are not so much larger that they will cover an hour of travel (usually the *minimum*) to and from a place worth using for photographs.

Instead, we set up entire days at selected outdoor locations. This cuts down on the travel time and costs, but it means I have had to learn to photograph at *all* times of day, not just the ideal times. Using this strategy, our seniors get the great outdoors for the same cost as a session inside the studio. As a result, our clients are excited to book location sessions and we actually get to keep the additional profit from the higher sales that result from these sessions.

Rule 5: Make the Most of Your Locale. You don't need an outdoor shooting area to do outdoor portraits. So many photographers dream of the day when they will be in a position to have an outdoor portrait garden at their studio, but there are good reasons to channel this energy into other endeavors.

First of all, it is expensive to put in an outdoor garden of any size—and this is a price that you will probably never recoup in your use of the outdoor shooting area. Second, unless you have a few acres in your backyard garden studio, it is hard to get the feeling of depth that is possible in

a larger public park or natural outdoor area. Third, most backyard shooting areas are only usable at certain time of day because they lack the mature trees necessary to provide shade at all times. In fact, some the worst outdoor portraits I have ever seen came from otherwise good photographers who tried to make their portrait garden work for sessions throughout the day.

In contrast, it costs me $24 for a one-year pass to our local park. This is five minutes from the studio and consists of 160 acres of land with lakes, creeks, and wooded areas—things you can't find in almost anyone's backyard. Is there a similar park in your area? If so, it could save you a lot of money and help you create even more attractive portraits.

Lighting Control

I could easily fill many books on the subject of outdoor photography and the coordination of all the elements in the average scene to create a certain look or style of portrait. However, I feel that the two most important factors in outdoor photography are learning how to photograph "properly" at any time of the day and finding usable backgrounds (and learning how to modify the midday backgrounds to make them usable for portrait sessions). What I've provided below is a condensed version of my approach to lighting and background selection, focusing on working at those "inconvenient" times of day when the available light makes our jobs a little harder. For a more detailed look at working outdoors, I recommend my book *Jeff Smith's Lighting for Outdoor and Location Portrait Photography* (also from Amherst Media).

Find Pockets of Shade. When working outdoors in the middle of the day, I first look for pockets of shade that I can place my subject within—large trees and patio-type structures are the most common places to find this. Once I find a shaded area, my next concern is the light direction. I have to be honest; most of the time, the natural light is completely wrong to function as the main light. Therefore, I pose the subject with the sun behind them.

LEFT AND FACING PAGE—*Shooting in a local park offers me larger and more diverse setting for outdoor portraits than I could ever have in a backyard portrait park.*

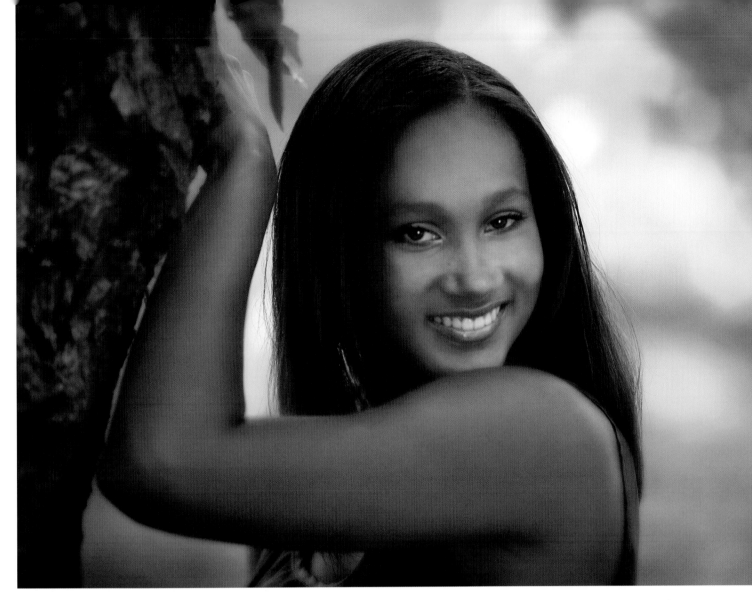

If any light does filter down to the subject, it creates hair/separation lighting on them.

Create the Main-Light Source. With the natural light coming in from behind the client, I then need to create a main-light source. To do this, I use white/silver reflectors. If you haven't tried this approach, you don't know what you are missing. Using flash outdoors is like shooting a gun while blindfolded. You can't see the effects of the light from the flash unit on the subject—and if you think the preview on the back of your camera will help, forget it.

With a reflector, what you see is what you get. Typically, I have my assistant stand in the same place I would position my main-light source in the studio. Since the sun is at the subject's back, the assistant will simply find a sunny spot filtering through the trees, then use the reflector to bounce that light. We use the reflector at the same height as the main light would be placed. If the reflector is placed at ground level and angled up toward the subject—as you often see photographers using it—the result is freakish, horror movie–style lighting.

The light source should be placed in relationship to the elevation of the subject and the angle of their face. To do this, find a beam of light and use the reflector to aim it over or to the side of the subject's head. The beam should be several feet away from the subject. Then, start bringing the beam of light closer to the subject until (from the camera position) you see bright catchlights in their eyes. At this point, you have a usable main-light source.

Working with reflectors takes some getting used to, but after a few days most of my assistants get the hang of it and can easily control the direction and intensity of the light on the subject. You accomplish this control by learn-

ing to feather the light. This simply means directing the center of the beam of light slightly away from the subject. This lets you use just the softer light at the edge of the main beam.

Most of my outdoor images are created using only one reflector and natural light. As photographers, we tend to enjoy complicating even the most simple processes—but, really, there is no need. On some rare occasions, it's necessary to add additional reflectors to accent the hair or add a highlight to the shadow side of darker skin. That's always an option, but in most cases—if you can see the direction of the light and the effects of the natural light on the subject—it just isn't necessary.

Background Control

Years ago, I studied with an excellent portrait photographer named Leon Kennamer, who perfected the idea of subtractive lighting and controlling all the natural light on

Lighting with a reflector on location is simple and versatile.

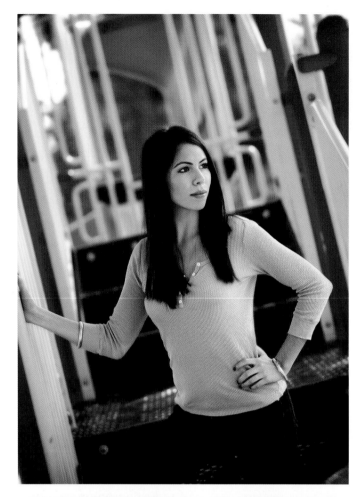

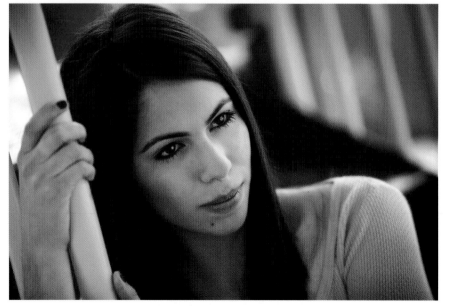

a subject. He used black panels to create shadow, then added a translucent panel overhead to soften the light from above. His work was amazing—but there was one shortcoming: it worked best when the outdoor lighting was already pretty good.

Finding the Right Exposure Balance. If you work outdoors during the middle of the day, softening and controlling the main-light source isn't your biggest problem. The most pressing issue is finding a background that isn't burned up (greatly overexposed) by the midday sun. In fact, under these conditions, using subtractive lighting techniques makes the problem worse, because you are *reducing* the overall quantity of light. During the midday hours, you need to *increase* the quantity of your main-light source. Raising your exposure is what makes it possible to find usable backgrounds—backgrounds that are, in terms of exposure, in better balance with the lighting on the subject. This is why I use a reflector as a main-light source with the ambient light as the fill source.

Finding backgrounds during the middle of the day is different than at "ideal lighting" times of the day. As noted above, the first step is to find a pocket of shade to pose the subject in. Once you figure out the placement of the subject, you can start walking around them to find a usable background. Look for an area that is not in direct sunlight; to be usable, the background must be in shadow or backlit. Sometimes, the background will be quite a distance away. Many times, I will place the subject in the shade of a large group of trees and her background will be another group of large trees located fifty to two-hundred feet away.

Camera Height. During the midday hours, the elevation of the camera relative to the subject becomes very important. In the middle of the day, the ground is typically unusable as part of your background—at least if any part of it is in direct sunlight. To compensate, I will either look for a elevated place to pose the subject or adjust the camera position/height to avoid showing the sunlit ground. I also look for an area that has the foreground in shade. I can use this to hide any areas of the ground that are burned up by the harsh sunlight.

Look for Even Lighting. As I noted earlier, using flash can help; increasing the amount of light on the subject can

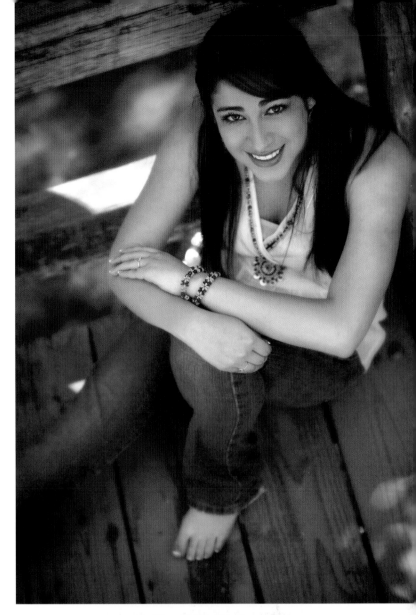

An elevated camera angle allowed me to make use of the shaded stream as the background for this image.

CLOTHING FOR OUTDOOR PORTRAITS

To create images outdoors that have a sense of style or visually make sense, I use the same controls as I do in the studio—with the exception of the client's clothing. In the studio, we have a variety of sets and backgrounds to handle the odd choices that clients often make. However, if you are in a wooded area and your client shows up in an outfit with a very dramatic pattern or bright colors, your portraits won't have the look that they want. Therefore, we stress to clients how they must dress to ensure their portraits will look beautiful. For the typical park location, we suggest jeans, jean skirts, cotton blouses, summer dresses, and anything else very casual.

bring them into balance with a brightly lit background. However, this only works if you can find a background that is *consistently* lit. In outdoor settings, the average scene has dark, shaded areas as well as areas that are burned up by sunlight. If you use flash and meter for the bright areas, the areas in the shadows will record as nearly black, giving the portrait an unnatural look.

Indoor Location Sessions

Years ago, I worked only at outdoor locations—basically parks, river locations, or my client's own property. I have found, however, that many teenagers like to be photographed at indoor locations—either at their homes or at public buildings like museums, old theaters, or even city hall. When I select an indoor location, I look for the same qualities and photograph the same way as I do at an outdoor location.

Using Window Light. If I am going to photograph indoors, I must have large windows to work by. I hate seeing indoor portraits photographed with flash. A room has a certain look provided by the natural light sources (windows and doorways) and the artificial light sources (track lights, pot lights, lamps, etc.). The way an interior looks to the eye is the way it should look in your portraits. In most cases, if a portrait photographer uses flash for an interior it looks unnatural, because they don't integrate the natural light patterns of the space. So you can either intern with a photographer who specializes in photographing interi-

ors (for magazines, not real estate agents) or you can seek out locations that are primarily lit by very large windows and use the light from these to light the subject.

Basic logic tells you that the main light will be the window in these situations. However, since you can't move the window, you'll need to position the subject in such a way that the window is in the main-light position relative to them. The side of the subject opposite the window will then be the shadow side of the image. If this is too dark, add a reflector to create fill light. (*Note:* If the room has light-toned walls and many windows, you may have the opposite problem: a shadow side that is too light. In this case, you can add a black card to subtract some of the light from the subject's shadow side—just as you would outdoors when your main-light source is too large.)

Shutter Speed and ISO. When working with window light, some photographers worry about blur resulting from slower shutter speeds or the decreased image quality that can occur as you raise the ISO settings. When I work away from the studio—indoors or out—I typically use an ISO setting of 400 and leave my f/2.8 lens wide open—yes, wide open! Photographers often stop down their lenses by two stops from the maximum aperture to achieve the best edge sharpness, then turn around and soften and darken those edges in postproduction. To me, that seems kind of counterproductive. Outdoors, with my lens at f/2.8, I normally work at a shutter speed of $\frac{1}{500}$ second or faster. Inside, I typically work at around $\frac{1}{250}$ second—definitely fast enough to allay any concerns about blur.

Keep Your Focus on the Subject. Whether working outdoors or in a beautiful interior location, photographers often get caught up in the size and scale of the location and all the beauty in their surroundings. However, while photographers like full-length poses that show all the beautiful surroundings, clients only buy photographs in which they can clearly see the face and the expression. This doesn't mean that I don't do full-length poses or show the location—I just look for ways to compress the body and condense the scene so I include as much as possible of the location while keeping the facial size as large as possible.

To compress the body, I often pose the subject in seated, kneeling, or lying positions that have the face closer

Working at an indoor location, a large window functioned as the main light. Reflectors were then added for subtle fill.

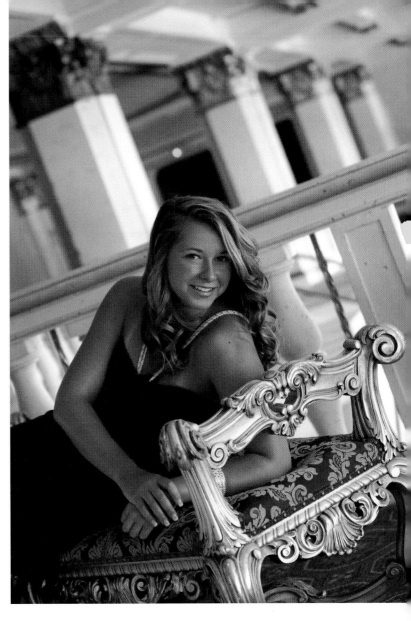

to the camera than the body, which recedes into the background. This allows me take many full-length poses while avoiding any complaints from parents that they can't see the face clearly. To condense the background, I look for the most appealing parts of the entire scene and use just those smaller, more beautiful spots. You can condense a background, getting more into less space, by better selecting the angle from which you photograph the background, as well. A row of columns and their ornate tops make for a huge background area; by bringing the subject closer to the columns, however, you can capture their essence and beauty while keeping them at a reasonable scale in relation to the subject.

Final Thoughts

Whether at a lovely forest or a beautiful home, I think some of the most engaging portraits are taken on location. While I love my Viper and Harley for senior portrait props, when working in the studio you can never match the depth and sense of realism that is possible with portraits taken on location. Here's another factor: in the studio, we photographers tend to have our toys; when we go to a location, we give the senior a great opportunity to show theirs. That's the subject of our next chapter.

CHAPTER SEVEN
Adding Props

The one thing that you quickly realize when working with clients of high school age is that they are all individuals. While some photographers have you believing that every girl wants to look like a pinup model and every guy wants to show off his ripped abs and bulging biceps, it really isn't that way. We have many girls who want to do the same painted-background session that their mothers did thirty-some years ago. We also have boys who absolutely do not want to be photographed for anything other than the yearbook.

These varying tastes will need to be evaluated and accommodated for in all of your sessions—and they'll be par-

BELOW AND FACING PAGE—*The different props teens bring to their sessions show you how diverse your clients really are.*

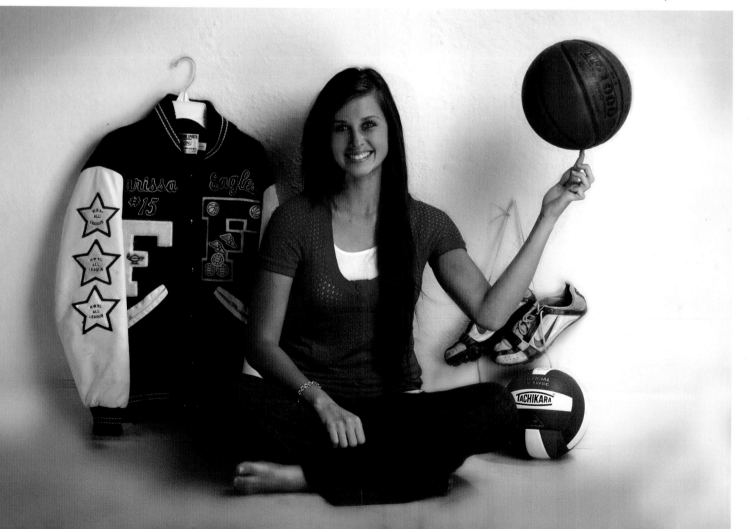

When using large props, it's especially important not to allow the prop to overwhelm the subject.

ticularly obvious when clients bring their personal props to the shoot.

Personalize with Props

I love when seniors bring in their own personal props. We have photographed everything you could imagine—from guitars, to enormous snakes, and everything in between. To encourage seniors to bring in their personal props, we don't charge a fee for including them and we mention it in all of our information and phone conversations. (*Note:* I should mention that even with a great deal of advertising, reminders, and no extra fees, the majority of our seniors do not include these items. Probably one in twenty brings something other that the typical letter jacket or cheer uniform. In other areas it may be more popular, but for our seniors it isn't a major factor.)

Keep the Focus on the Person

When we include a prop in someone's image, we keep the focus on the person, not the prop. I, like most senior portrait photographers, went through the years of lighting

props (like mid-swing baseball bats) on fire and creating what were basically portraits of props with people in them. Today, however, I prefer a simple approach. I like to think we are showing a little of the senior's personality, not creating an episode of "When Photographers Have Way Too Much Time on Their Hands." First and foremost, the focus of any portrait must be the person, not the stuff they bring in. When your eyes are drawn to anything in the portrait before you look at the person's face, you really don't have a portrait of the person; you have a portrait of the stuff the person brought in.

The Size of the Prop

The way in which we photograph a senior with a prop depends on what the prop is and its size. Smaller props are photographed in head-and-shoulders or waist-up compositions so they are visible. These props would be things like books, a football/soccer ball/basketball, or small stuffed animals.

While some props are perfect to hold, like a guitar or other musical instrument, others are better displayed in the background or on the floor where the subject is sitting. Posters, paintings, jerseys, and uniforms fall into this category. These types of items fill the space around the subject to become the background/foreground.

The next groups of props are the large ones—the quads, motorcycles, cars, trucks, buildings, etc. When I photograph these props, I minimize their visual weight by turning them into background elements. I do the same thing when I photograph seniors and teens with our studio's Viper. If I were to put the subject inside the car, there would be a photograph of a huge car with a person's head sticking out of it—not a real strong selling point. If, instead, I bring the person in *front* of the car, I can make the Viper fall into the background so the person remains the focus of the portrait. This is the same idea I use when photographing people with the Harley; the motorcycle either becomes the background or we isolate only a portion of

Showing only part of the prop can help keep the attention on the subject of the portrait.

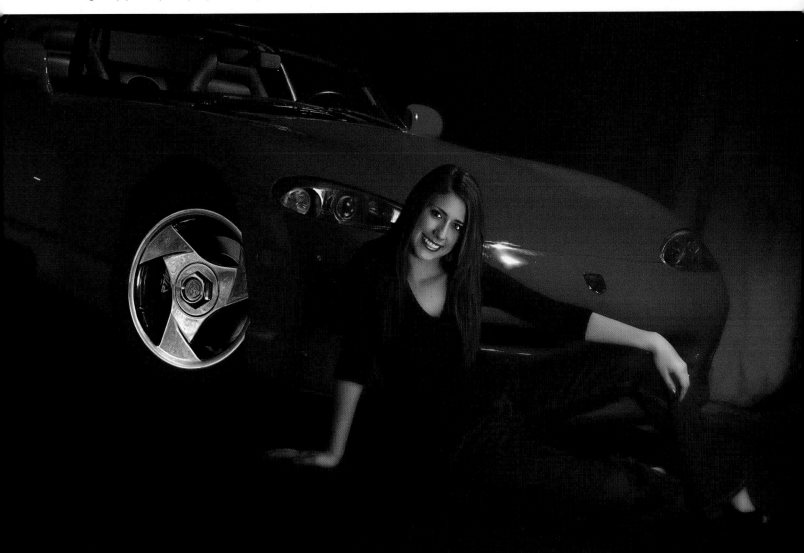

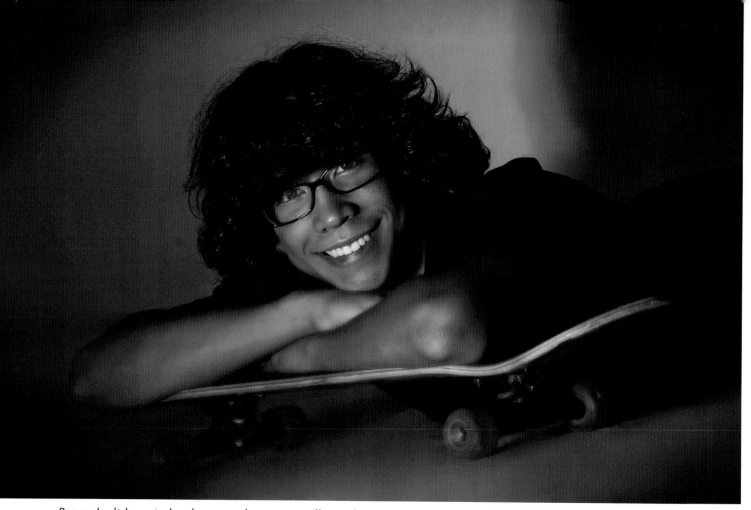

Props don't have to be shown as they are usually used. Here, a creative pose allowed the skateboard to be incorporated into a casual head-and-shoulders portrait.

the bike to form a foreground/background element in a head-and-shoulders pose.

While we have modified our studio to allow the Viper to be moved in and out, I don't want to take the time to bring in seniors' own cars and trucks—not to mention the fact that summers in Fresno are incredibly hot and the air conditioning has to work hard enough to keep the studio cool without large doors opening and closing all day.

When a senior wants to use a prop that is too large to get through the front door, we set up an appointment at one of our outdoor locations. Many seniors want to be photographed with their car or truck, and this is done outdoors. Since we live an area that has many farms and ranches, it is also very common for seniors to want to be photographed with horses or other livestock. The idea is always the same with these additions: reduce the apparent size of the larger prop by putting it into the background or capturing just the most important part. Horses are a

good example. Not only are they huge, but horse owners are always very fussy about the placement of the legs and the position of the horse's body. The best way to avoid investing undue time in horse posing is just to photograph the head of the horse. Of course, even this is hard enough, because horse people want both ears up and forward.

Final Thoughts

Whatever your subject might bring in, you need to find a way to position it somewhere in the frame where it will be noticeable but not overpowering. When you see the variety of props that come in with seniors, you'll really begin to understand how diverse this market is. Your first senior will want to be photographed with a Bible, the next will have gothic props; one senior will bring a new BMW or Corvette, the next will wheel out an old tractor—you never know.

Finishing the Portraits

I believe that the enhancements done to each ordered portrait are a part of the creation of each of my images. That being said, though, I also feel strongly that you must get the image recorded properly in each file so that only minimal retouching, with little or no significant correction, is needed. At first, that may sound like I'm contradicting myself—but let me explain.

Enhancement is a part of the creation process. It helps give your images a consistent look that lets them be identified as being your style and your work. However, corrections should only need to be done when it is impossible to correct problems in the camera room. No matter how good you are at corrective lighting and posing, for example, you can't hide braces or make a face attached to a three-hundred-pound body look thin enough. These issues require corrections. You should not, however, waste time making postproduction corrections for things that can be concealed just by having the client wear the right clothes, or taking a few seconds to refine a pose and tweak the lighting.

Delegate Postproduction

I am going to make a bold statement here: if you retouch and enhance your own images, you're making a serious mistake—at least from a personal and business standpoint. Behind the camera, I can generate a lot of money for my business. At home, I can be a father to my children and a husband to my wife, enjoying times that money cannot buy. When I get behind a computer, I have just replaced a $12/hour employee. I'm either sacrificing my business profit or my home life, and that's stupid.

I go to conventions and seminars and hear photographers talking about the four-minute slideshow they personally spent twenty-three hours designing for this program. All I can think is, "Why??" (And as that same speaker continues, don't be surprised if he mentions that he has just said goodbye to wife number three and can't figure out why he can't find a good woman.) What can be accomplished on computers is amazing—so hire some talented young people and pay them to create it for you. You have three jobs in your business and in your life: take pictures, train your staff, and spend time with your family and friends.

Standardize Your Procedures

As we all know, there are many ways to accomplish the same job in Photoshop—however, each technique for accomplishing a particular job will create a certain look. If you have two different people retouch the same image, giving them no instructions, you will typically end up with images that look like they were photographed by two different photographers. To ensure consistency, you need to define a step-by-step method of enhancement that each and every person working on your images will follow.

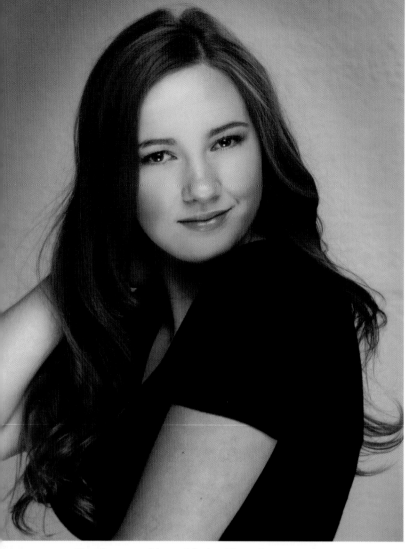

Simple retouching with the Clone Stamp tool gives every subject's skin a flawless appearance.

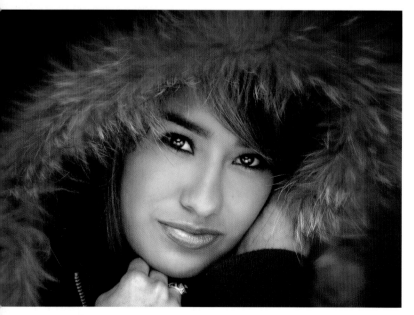

The Dodge tool is used to brighten the eyes and bring out the eye color.

What strategy you use to enhance your images is a personal decision.

Our Approach to Enhancement

The Skin. As photographers move toward automated types of retouching that use diffusion to soften the skin, I feel like we are seeing more and more "plastic" people. They don't have any texture on their skin, so they look a little too perfect. I prefer retouching each ordered image by hand, using the Clone Stamp tool on a low opacity setting to retouch acne, reduce wrinkles and dark areas, and slightly soften the overall texture of the skin. While there are other tools and other methods, this is the look I prefer and how each image from my studio is produced.

The Eyes. Once the skin is retouched, we then enhance the eyes. We use the Dodge tool to define the catchlights and bring out the eye color. The hardest part of the eye-enhancement is making sure the enhancement looks natural in each eye. Many who are new to Photoshop will enhance the eyes to make each identical in color and to match the size of the catchlights. The perfect enhancement, however, is one you don't notice—one that uses the light patterns that already exist in the original image.

Shadowing. The next thing our retouchers look at is the shadowing. If I decided to work with a higher lighting ratio to thin the face using a very dark shadow, the retoucher will look at the shadow side of the nose and other shadow areas to see if they need to be lightened. If needed, they will use the Clone Stamp tool at a low opacity to soften the shadow slightly and not remove it.

And That's It! This is our basic retouching that is done on each image—and that's it. How can we get by with so little enhancement while other photographers aren't? I work on fixing obvious problems in the studio, not on the computer. I shoot with digital the same way as I used to shoot on film. Just because you can make difficult correction and enhancements on the computer doesn't mean you should. With film, we were able to do only negative retouching, with any additional correction being done as artwork on each individual print. When you grow up shooting this way, you are very careful about what you create; mistakes that digital photographers now make every

day (then waste time fixing in Photoshop) used to cost film photographers a fortune. (Of course, the digital photographers of today pay a price, too—typically their personal lives.)

Our Approach to Correction

Look for Simple Fixes. Because we are a higher-priced studio, our retouchers do also look at each image to see if there are any simple corrections—things that could be done in a matter of seconds—that would greatly enhance the image. For example, because of the amount of traffic in our high-key area, there are always little marks on the floor that can be easily eliminated with a simple brighten and blur action.

For Heavy Subjects. *Liquify.* For very heavy subjects, the retouchers look at the face and body to find obvious bulges or areas that could quickly be thinned down. Two effective ways to handle problems of weight are using the Liquify filter (Filter>Liquify) to flatten bulges. Simply select around the bulge. Then, choose the Forward Warp tool from the upper left-hand corner of the dialog box. Then, adjust the size of the brush as needed and push in the bulge.

Stretching. The second technique is very effective for thinning a person, especially in the face. You simply go to Image>Image Size, turn off the Constrain Proportions box, and increase the size of the image to stretch the face slightly from top to bottom. (*Note:* This direction will obviously depend on the orientation being vertical or horizontal, as well if a vertical image is rotated to its proper angle or left on its side as it was captured.) There is no secret number to stretching the image; just make small incremental increases until you start to notice it has been stretched, then step backwards until you don't notice the effect. This only works when all parts of the body that are seen are vertical. If the subject has their arms crossed, the arms would be running horizontally through the frame and stretching the image would make them appear larger.

Vignetting. The final effect we use is to vignette the majority of images, which is nothing more than darkening the edges of low-key photographs and blurring the edges of high-key photographs. Vignettes hold the viewer's attention by softening or eliminating lines that lead outside of the frame. Vignettes aren't used on every image, but they give a finished look to most of our high- and low-key portraits.

To add a vignette, we simply make an oval shaped selection over the subject with the Marquee tool, which has its Feather setting at 250 pixels. Then, right mouse click over the selected area and click on Select Inverse. At this point, you can darken the selected area for lower-key images or blur the area for high-key images as you see fit.

Clients Pay for Other Corrections

These simple procedures are all that 99 percent of our images need—but there are times when a client has a specific problem that couldn't be corrected in the camera room. If that is the case, the client pays for the correction. For example, if someone doesn't like the glare on their eyeglasses (they insisted on wearing them even after you explained several times that there would be glare), that client is billed for the correction.

Darkening and blurring the edges of the image creates a soft vignette that keeps the attention on the subject.

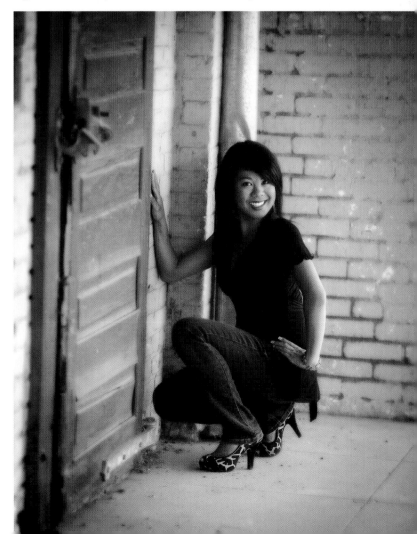

CHAPTER NINE
Marketing

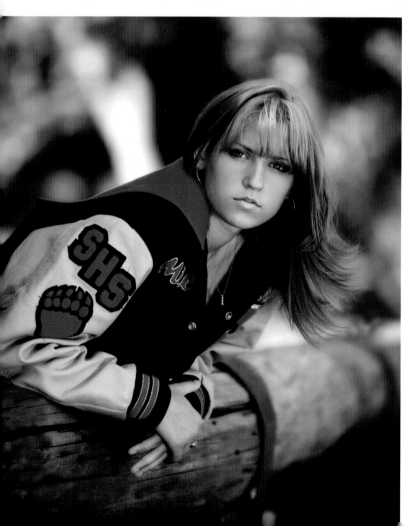

How do you attract senior/teen business to your studio? The answer will depend on many factors. As we have already discussed, a great deal of it will depend on whether your local high schools contract to a specific studio or leave it to students to choose where they go for their senior portraits.

Whatever you do, don't whine about the way your local high schools are set up; there is little you can do about it, so learn to work within the set structure. I've heard stories about photographers getting a state to ban high school contracts for senior portraits—and that's fine . . . but how much time did they spend away from their businesses getting this to happen? And are they any better off now than before? Probably not. If contracts were banned in California, when all was said and done, I think I'd book about the same amount of seniors as I currently do.

That said, let's start off our consideration of marketing by looking at contract photography—what it entails and what advantages/drawbacks you should anticipate.

Contracting

Contracting a high school has many benefits, but there are also a tremendous number of drawbacks. The truth is, many yearbooks wouldn't get published without the help and support of the contracted studio. When and if the day comes that yearbooks are no longer produced, the senior market will change forever—well, actually there won't be much of a market to change!

What to Expect. To get a contract, you must agree to provide the high school with products, services, and—in many cases—donations that help produce the yearbook. This list of products and services can be quite extensive,

The senior portrait market varies by region. If you're getting started in the business, you'll need to research what's going on in your specific market.

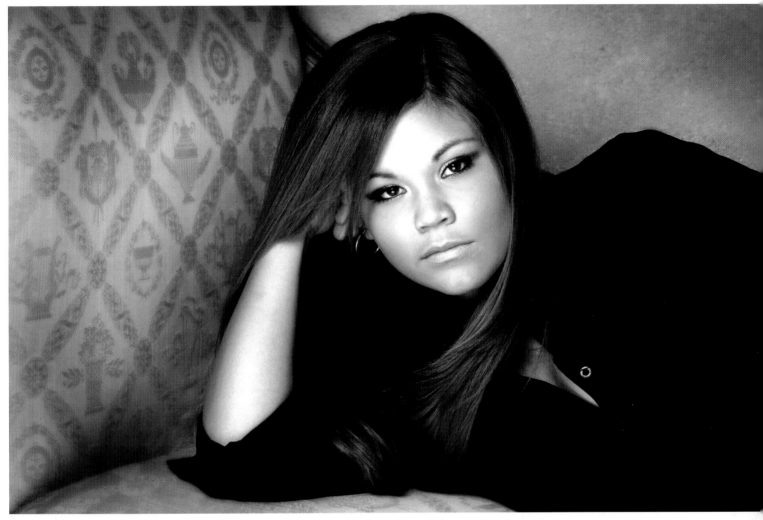

If the local high schools are contracted to another studio, you'll have to offer something unique to win senior clients.

and in most cases it is not based on how many portraits the school's seniors will actually buy. In most contracts, the products, services, and monies provided are, instead, based on what the school feels they need and what the photographer before you was willing to give them. Unfortunately, the more impoverished a high school is, the more the yearbook will need; the more upscale the student population, the less the yearbook will need. (However, many upscale schools will still *ask* for the moon and give the surplus money to another student group, like sports.)

Donations. In many cases, contracted studios provide monetary donations to the school. Is this moral, ethical, or even legal? As a general rule, any company or individual person can donate money, services, or products to high school as long as the students (not a teacher or adminis-

trator) receive the benefit. (*Note:* Check with your lawyer to determine any state laws that might apply to you in this situation.) Also, all money must be paid by check with the name of the group you are donating the money to (*i.e,* "Rolling Hills High School Yearbook"). If you are asked to make a check out (or give cash) to a teacher or administrator, you are in trouble. Money given to a person in exchange for getting a contract is considered a kickback, and in most areas it's illegal. Even if it isn't illegal, it's creepy and unethical.

DONATIONS, NOT KICKBACKS

Not too many years back, a local high school had a safe full of cash given to them by the studio that had done all their yearbook photography. Needless to say, when it was discovered, the entire administrative staff (who knew about the kickback money) was fired and the photographer was banned from working with the high school.

The Value of the Contract. Ideally, contracting is a form of marketing. So, just as you would when placing an ad or doing a mailing, you have to figure out how much you will need to spend on getting these seniors and what your realistic return will be. How many orders can you plan on getting from this high school's contract (figure low; it will always be less than you expect)? How much will this contract cost in terms of your time, the hard cost of products provided, and the donations expected?

Not every contract is worth taking—in fact, there are more poor contracts than good ones. I was once offered a contract for which the high school wanted a lump sum of money donated to the yearbook, plus equipment to use for the duration of the contract. Knowing the make-up of the student population, I passed on the contract because the costs were too high for the expected sales. The contract ended up going to a large corporate studio that did

When you contract, you have to work with every senior at a school. When you market directly, you can work with just the seniors who are a good fit for your style.

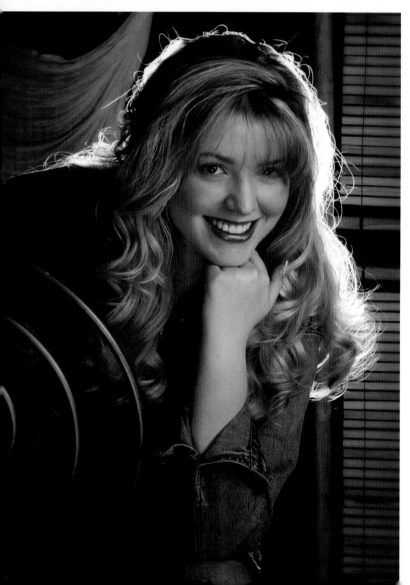

everything for the high school. Eventually, this studio had to increase their portrait prices significantly to try to recoup the high contracting costs. Naturally, the school didn't approve of this, and the studio lost the contract.

Know Who You're Dealing With. When you market directly to get your senior portrait clients you can be selective about accepting bookings. If you get a call from an irate mother loudly demanding that you take her daughter's senior portrait on a Sunday evening, you can politely refer her to another studio that has weekend hours (and doesn't mind working with whacked-out people). When you contract, on the other hand, you have to try to make that mom understand that you don't work on Sundays—and especially not in the evenings. And don't think it ends there. As likely as not, she'll then call the high school and say that you refused to make an appointment and now her child won't be in the yearbook. At this point, all you can hope for is that the school is already familiar with this mom and knows how she is. If you are not lucky, it will turn out that she's the principal's wife.

It sounds like I'm exaggerating, but I'm not. We once had a client call the high school and insist they stop doing business with our company because we wouldn't waive the fee on a bad check she wrote to us. *She* broke the law, but the school was supposed to stop doing business with *us*. They didn't honor her request, but I still had to deal with an uncomfortable phone call from the school asking me why this lady was calling them about a bad check. While 95 percent of the people at any given school are great, the crazy 5 percent (those that you would chose not to do business with if you were marketing to seniors directly) come with the deal. You'll have to try to make them happy.

Understand the Legal Issues. In addition to working with *everyone* at a given school, contracting brings up some legal issues. For example, you must make sure that each student you photograph is included on the list given to the school and on the image CD/DVD supplied to them. A few years back, a local senior portrait photographer contracted with a high school and left five or six seniors off the lists he gave to the high school. He also provided no images, so the yearbook staff couldn't catch the discrepancy and realize that these students were omitted from the

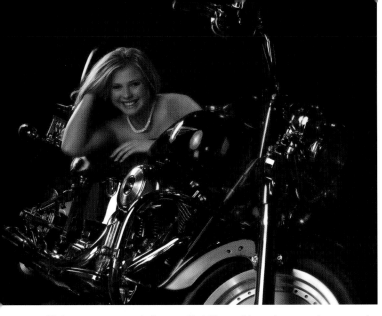

Unique props and the availability of location sessions can be useful in attracting seniors to your studio.

yearbook. The parents banded together and hired an attorney, threatening to sue the high school and the photographer. The outcome was never released—in fact, we only learned about the ordeal because we were the studio they contracted with thereafter.

What's Good About Contracts. Despite the possible problems, I love working with the three high schools with which we have contracts. Our high schools have a caring and understanding staff that appreciates all the work we do for them. Additionally, contracts provide a steady stream of business. Because contracts are a serious arrangement between the photographer and the school, high schools seldom change their photographer if the arrangement is working out well. But again, it is a serious arrangement, so you should not enter into a contract lightly.

Understand the Demographics

Once you find out how each high school is set up, you can come up with figures as to how many seniors are possibly available. In chapter 1, we figured out that (in a contracted school) there are approximately forty-five available seniors in a class of one hundred. That's in an average high school. But what happens if your high school has predominately lower-income students? Beyond this, what is the ethnic breakdown of the student population?

The averages show that poorer students don't buy as many senior portraits as middle- and upper-income stu-

dents. However, in our area, Hispanic students purchase more portraits—on an average—than any other ethnic group of the same economic level. What does this mean? It means that, in our area, if the high school has a high percentage of middle-income Hispanic students, our sales will be better than if it has a high percentage of middle-income white, African-American, or Asian students.

Whether you contract or market to get your seniors, this information is important. As we discussed in chapter 1, girls will make up a larger percentage of the seniors who might have an interest in going to a studio other than the contracted studio (or, if you are contracted to the high school, the girls will account for your larger orders). With that in mind, for us, middle-class Hispanic girls are the cream of the crop. As a result, they get most of our marketing dollars. All other girls come in second place, followed by Hispanic seniors boys, and finally all other senior boys. Marketing isn't cheap, so why not target your message to just those students who will bring the best return?

Understand the Competition

What happens if the photography company contracting with your local high school is pretty good? What if there are already some very large, very successful studios marketing to the local seniors who are interested in an outside photography company? Each of these scenarios will affect the number of seniors who will respond to your marketing plan. If your local high school is contracted by an excellent local photographer, is in an economically depressed area of the country, and there are already three really good studios marketing to get the seniors that don't go to the contracted studio . . . well, you could have a tougher time attracting seniors to your studio.

Fortunately, things are never as good or as bad as we think they will be. There are basically two types of people in the world: pessimists and optimists. The pessimists look at their local situation and say to themselves, "The studio contracting the school is really good and another really good studio sends out mailers to their seniors all the time—I have no chance!" The optimists thinks, "Even though the contracted studio is good and there are many studios already marketing to the local seniors, I am so much better than any of them, I am going to send out three hundred mailers and I will get at least a hundred seniors to respond!" To the optimists out there, good for you. At least you have the right spirit—misguided as it may be. (Read on to get the big picture on direct marketing.)

Direct Marketing

For most photographers, direct marketing is a far more feasible approach to attracting local high school seniors than contracting. There are many ways to get your name in front of seniors, but it will take some trial and error to determine which methods (in your unique market) reach the most members of your demographic for the least amount of time, energy, and money invested.

The Two Rules of Direct Marketing. The first rule of marketing is repetition. No matter how well-designed the promotion, your business name must be received between four and six times for the average person to even remember it. Buying one ad, sending one mailer, or securing one radio spot won't fill your appointment book.

The second rule of marketing applies to advertising, and that is: buy in bulk. Many small studios buy mailers one at a time. This means they're paying a premium price. I know photographers who mail out as many mailers as I do but pay three or four times as much in printing costs because each mailer is handled job by job. When I send in my mailers, they all go in at once and I get a price of about sixteen cents apiece. This means I don't pay much more for a 6x9-inch color mailer than running black & white copies at a copy shop. The same is true for purchasing ads or airtime. No matter what you do, it's going to cost a lot of money—but you'll pay a premium price if purchase one ad at a time. Most of the time, you can sign a contract for so many ads to run over the next six months or a year and pay for them month by month—and doing just that makes more sense for your business.

Methods of Promoting Your Studio. *Web Sites.* Many misguided dollars are spent on web sites. A web site is basically a big brochure. Without a reason to look at your brochure (web site), however, no one will visit it. To encourage our seniors to visit our site often, we post new portraits every month, give away trips, etc. Working to keep your site new and exciting is important—it's the only way to keep clients interested in visiting. Even large e-tailers have to constantly advertise their sites to keep people coming back.

If you're good with computers and can design an appealing web site yourself, it's well worth the time invested. If, however, you have to pay top dollar for a designer, your money will probably be better spent elsewhere.

Giving Work Away. An effective way to get your work in front of your target audience is to give away a few free portraits. To do this, find a person who travels in the right circles and get a wall portrait into their home—it really generates sales. This saved me from bankruptcy in those early years. A few words of advice, though. First, be very careful whom you pick. Make sure you select the leader of whatever pack you're trying to reach. Social events are great places to see the pecking order in a group. You'll

FACING PAGE—*Tight headshots have become a popular style for senior portraits.*

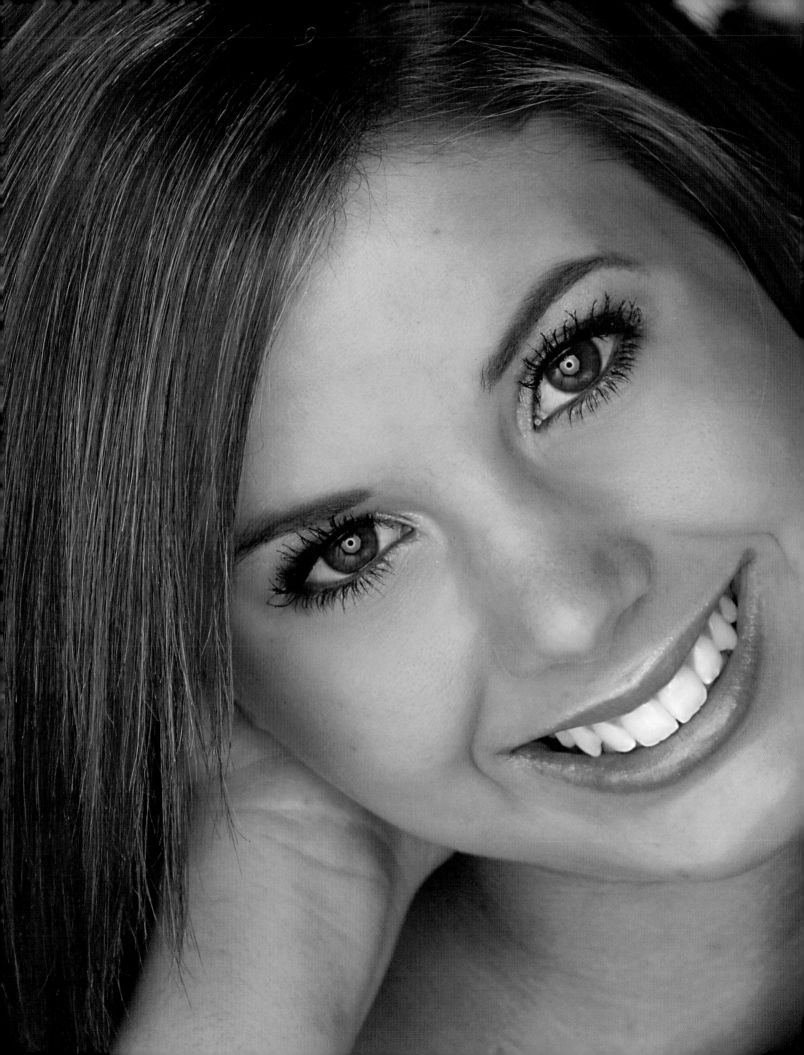

want to give your work to someone who will show it off, someone who seems to thrive in social situations and has many friends. Second, make sure your studio's name and phone number are on every print you give away—no matter the size.

___*Senior Ambassadors.* Whether you call them senior ambassadors, reps, or models they are a part of the marketing program for most senior studios. Think of this as an organized way of giving your work away. Each year, juniors are selected to be photographed as senior models (as we call them at our studio). We select two junior girls per hundred seniors in the high school's student population. (*Note:* We don't choose girls because we're sexist; senior-age guys typically don't respond to our model search—and if they do, they don't show their images around like the girls do.) Each junior is photographed in March so we can include them in all of our advertising. This starts at the end of May—technically, the end of their junior year.

In years past, our models were like salespeople in our local high schools. In exchange for free portrait packages and custom-bound books with all their selected images — and even give a laptop for the model who referred the most clients to us—they collected names and addresses, passed out wallets and wallet cards (wallet image with advertising on it), and did just about anything we asked of them to promote the studio. But things change; fresh ideas soon become aging ideas that every studio does. As a result, our senior models still pass out wallet cards, but they don't collect addresses and aren't expected to be outspoken advocates for the studio.

Recognition should be the single most important factor in selecting your studio models. You want not just the average cheerleader but the most popular cheerleader.

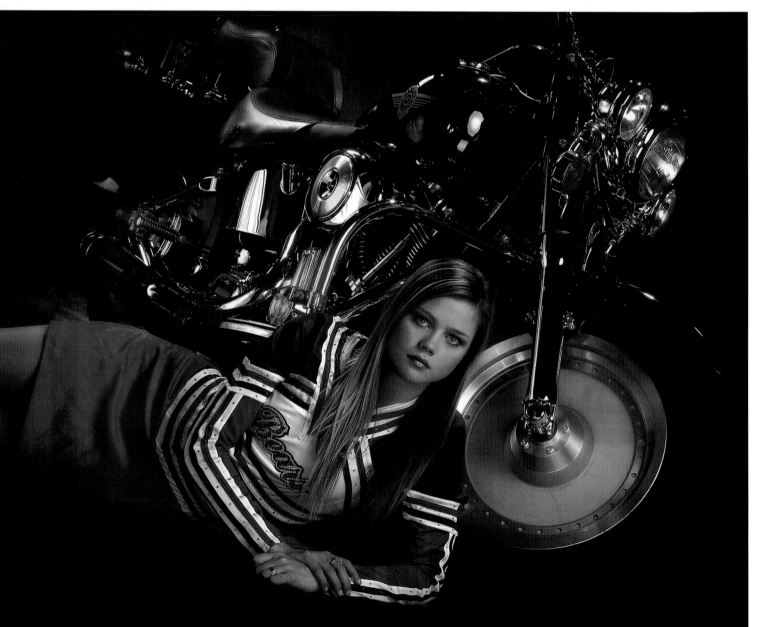

The benefit of this program to us is less in the direct marketing that the senior does than in having current senior faces for our advertising—faces that other seniors in their high school will recognize. This is important; if you show a cool senior portrait of someone the viewer knows, you'll definitely capture their attention. As we advertise, we make sure that we include seniors from all the high schools we are targeting—and we try to have a specific mailer designed for each high school, featuring only seniors from that school.

Recognition should be the single most important factor in selecting your studio models. You want the cheerleaders—and not just the average cheerleader but the most popular cheerleader. Senior models should be photogenic, but likability is much more important than beauty. We once selected a cheerleader who was beautiful but had to be one of the most hated people on campus. Every time we used her image, other students would tear it down or draw something on it. (And cheerleaders just don't look good with "Yosemite Sam" mustaches!)

The best way to contact local cheerleaders is to look up the name of the cheerleading coach on the high school's web site. E-mail her with information on what the models receive and the process of photographing them—and make sure to note that that you insist on parent participation (so they know your motives are legitimate). Also, let them know what you will be doing with the images you take. We then send a packet to each cheer coach well in advance to hand out to their girls. Cheerleaders typically love having pictures taken and this usually works very well.

Social Networking Sites. Just because an advertising or marketing idea worked in the past doesn't mean it will continue to perform. In fact, once every studio has heard of (and is using) a certain form of advertising, it immediately becomes less effective. As a result, senior photographers must always be looking for new ways to reach their demographic.

One of the hottest marketing ideas is using social networking sites to market to your seniors. MySpace, Facebook, Twitter—we have all heard of them, but most of us have no idea of how they work and how to use them as a marketing tool.

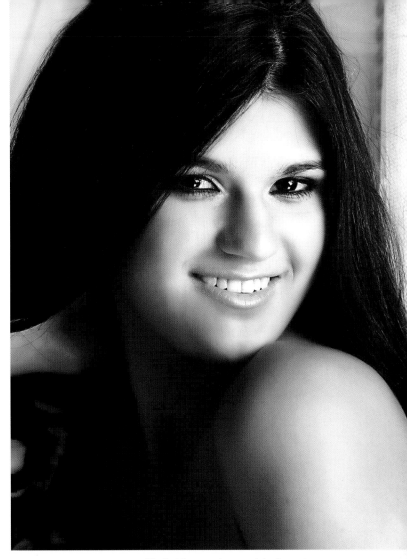

Giving seniors an image file (with your logo added) to share on social networking sites puts your name in front of all their friends.

Social media sites all have their own way of operating and their own characteristics that make them more or less appealing to those that use them. Therefore, for social marketing to be effective, you need to select the right site for your target market and post information of interest to them.

Whether it's on web sites, blogs, or social networking sites, potential clients don't care that you are having coffee, that you're at the airport, or that you put up new pictures—they care about your post if it *pertains to them* in some way. This means you should never mix your personal friends/co-workers with your potential clients. For example, Facebook is the social networking site of choice for high school and college students. It allows an easy exchange of images between friends/users, which makes it

ideal for photographers. For this reason, Facebook is also very popular among photographers.

To keep these two groups separate, I have two Facebook pages/accounts set up under my name. If you look me up, you'll find Jeff Smith (owner and photographer of Smith & Co. Studios) as well as Jeff Smith (author/photographer). On the studio account, all of my friends (approaching 2500) are high school juniors and seniors from my area. You will not find photographers listed as my friends, nor will you find any of my actual friends or family on this account. On my second account/page (Jeff Smith, author/photographer) you will only find photographers, not seniors and no personal friends or family.

The reason that I have an account for each type of "friend" (seniors, for my studio; photographers, for selling my books) and use the phone to communicate with my family and personal friends, is that the posts for one of these groups would totally bore the other groups. Seniors don't care about my tips for becoming a more successful photographer; photographers don't care about whose senior portrait I have just put up—and neither the photographers nor the seniors care if my auntie has a goiter the size of a baseball or my brother has a drinking problem.

I often read photographers' status updates on their Facebook pages that should be directed toward their seniors (posts I shouldn't receive, since I am not a senior) and see vague comments like, "Just posted some new pictures on my web site—check them out!" What does that have to do with any senior?

Because they encourage feedback, social networking sites often make people think others are interested in every single thing they do—but they're not. If you really want to interest your seniors, you could post, "We just added a bunch of seniors' images to our web site—these are just a few!", then add a photo to your post of each senior model from the different schools you market to. Include their first name—never their last—and high school (just in case the thumbnail makes it hard to instantly recognize the subject). Then, tag the subject of each image so the kids in the images are notified that you've posted their photo. Chances are, they'll share the information with friends. (*Note:* Since status-update posts usually allow only one

image, we use Photoshop to create a single image file that includes multiple shots.) Add portraits to every post you make. If you post about preparing for your session, add some photos.

We have also started asking our Facebook friends to help pick out which of our senior models' images we put up in the studio. To do this, we posted four of the best images of each girl—several days apart—and allowed everyone to vote. As *American Idol* and countless other television shows have proven, people love a chance to vote for their favorites.

Anything that will legitimately be of interest to *them* (not just to you) is fair game for a post. Many photographers post top-ten lists—the top-ten mistakes made by seniors planning their session, the top-ten locations to take your senior portraits, the top-ten senior portraits of the week, etc. These work because they are interesting to clients and prospective clients (especially if they know—or *are*—one of the seniors in the best images from the week!).

Social networking sites also build a sense of familiarity. This can be good when it means a client feels like they know you before they walk through the door, but it can just as easily open up a can of worms. You should never say anything to your clients on Facebook that you wouldn't say to them in your studio—even if it's indirectly, such as by becoming a fan of a cause. You are, first and foremost, a businessperson and you should keep your personal views to yourself. Don't join causes, don't play mafia-war games, don't send hugs and kisses, and don't fill out surveys about what kind of lover you are. When you get an invitation, just hit the ignore button. Joining any cause, no matter how noble, can put you in the position of upsetting someone when you don't join their cause even if it is less noble!

___Here's another thing to avoid: spending too much time on your networking sites. In most marketing strategies, there is an inverse relationship between time and money. When something is expensive, it usually doesn't require a lot of your time; things that are inexpensive usually require more time. Social media marketing can con-

FACING PAGE—*Fashion-inspired styles (poses, locations, compositions, etc.) are popular with seniors.*

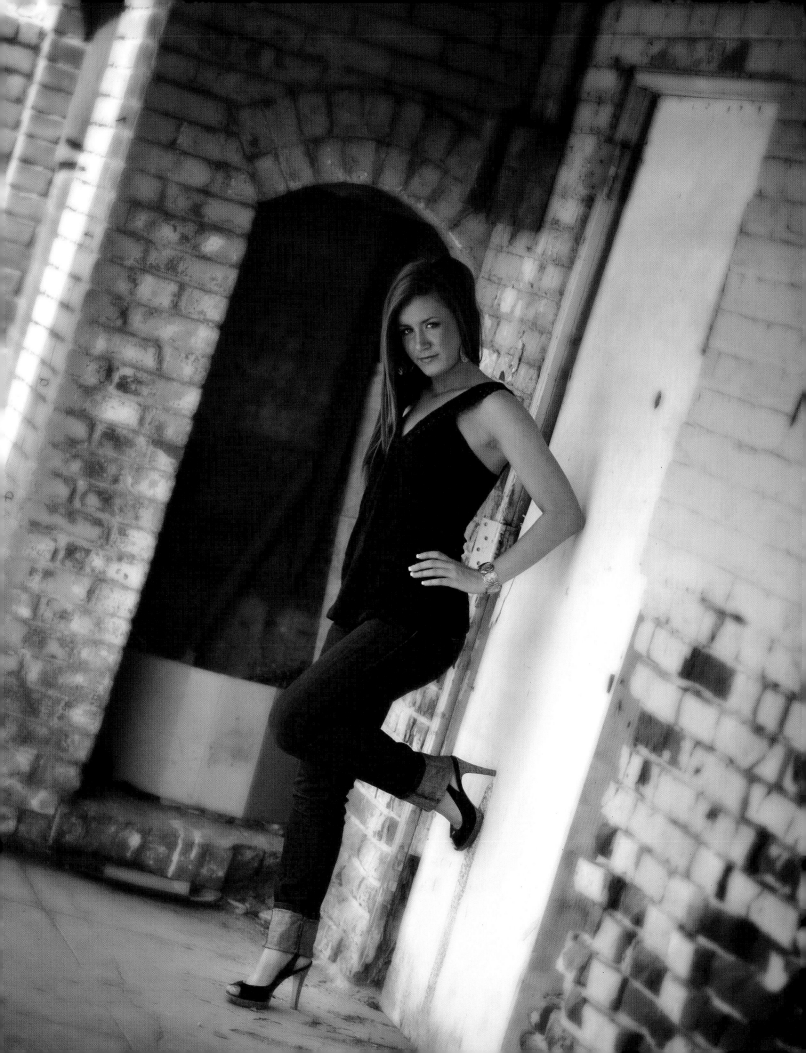

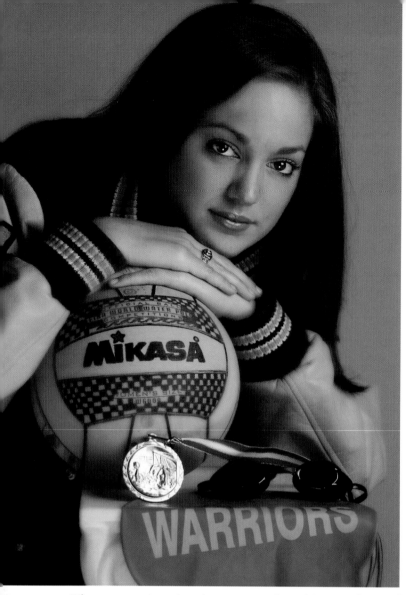

When you post senior pictures, tag the subject so they and their friends will be notified.

sume your life if you let it. I have had to struggle with this; I see the benefit of social marketing, but it takes up my most precious resource: time.

___As I have already said, I have a Facebook account for my studio clients (our seniors) and I have another Facebook account for photographers. I also have a Twitter account to help market a non-photography book called *Achievable Wealth*. I have a Gather account, which allows me to post articles that quickly show up in search engines to promote all of my books. Finally, I have a MySpace account, which I have never had time to do a thing with. As I am writing this book, I am also looking into Flickr.

Each morning, I go on to each account and design a post—but not your typical post ("I am having an egg!").

I create one that will actually result in sales, which means it personally involves my target market. For my "seniors" account, I select the best images from the previous day's sessions (images with subjects who are my Facebook friends) and design a post that allows me to include these images. For my "photographers" account, I write a paragraph or two for my industry friends that relates to one of my many books—and I add a link to the book on Amazon for their possible purchase. After this, I go to my Twitter account, which I direct at people interested in financial freedom, and design a post that will help market my *Achievable Wealth* book—or I direct them to one of my articles on Gather. I repeat the same process each night.

While I have many different things to market, which takes up more time than just marketing my studio would, you can see that social media marketing is no more "free" than doing your own retouching. It takes up your time—but I will say it has been worth it!

In addition to the time it takes to actually design and prepare posts, you must also address the issue of increasing your circle of friends on these sites. You need to get them, keep them—and then get some more! In social media, Facebook especially, no one want to be your friend when you have under fifty friends; everyone seems to want to be your friend when you have over five hundred friends.

The first few friends I made were my previous year's senior models. Knowing how teenagers put things off, I offered them free wallets if they made me a friend on Facebook within twenty-four hours. The bribery worked; within a day, I had ten friends (only a few people flaked on this offer). I then repeated the process (using the same offer with our best clients—people I knew well. By the end of the week I was up to fifty friends and past that creepy "new guy" stage of Facebook membership.

Note that I started out by recruiting people I already knew to be my Facebook friends. Some photographers who are new to Facebook send friend requests to seniors they don't know—and who don't know them. This a sure-fire way to be perceived as shady (after all, there are a lot of people with bad intentions on the Internet who target teenagers). So start slow, with people you know, and build up. Once we reached five hundred friends, I became very

bold at sending out friend requests. At this point, most juniors/seniors could see that we had mutual friends—and it was clear that we are a reputable business that deals with seniors. Almost everyone accepted, and our numbers grew. I was also careful not to request friendship from a student who was already a friend of another studio.

___The majority of junior/seniors are actually *not* on social media, but the *quality* of the students on Facebook makes it a perfect place to market. Facebook has allowed us to reduce the number of mailings we send out each year (cutting our costs) while allowing our numbers to continue to grow.

The rules of the social media sites are constantly evolving, and this is something you must be aware of when using them as part of your marketing plan. There is talk that Facebook may start charging a membership fee, which would probably put an end to its popularity among teens. Facebook may also be changing the way tagged images are sent. Currently, if you tag someone in an image, they receive the photo and information in their news feed—as do all of their friends. This could be change so that only the tagged individual receives the update. Dealing with challenges like this is part of what we do. You never know when the next big idea will come up, but you have to be looking for it.

For more about marketing on Facebook, I suggest checking out the tutorial by photographer Rod Evans at www.rodevans.tv. There are also many good books available for marketing on social networking sites.

Blogs. Blogs are another means of marketing on the Internet. The word "blog" sounds a great deal like "blah"—which is what you think to yourself when you read the typical blog: blah, blah, blah. You give people with large egos a place to share their every thought . . . and you end up asking yourself *why?* I suppose there are some people out there who really care what Kim Kardashian is doing—but I hate to break the news to you: your wife and your mom (quite frankly, I don't even think your dad cares *that* much) are probably the only ones who care enough to read all the things you put into *your* blog.

Unless you are truly gifted at making the everyday happenings of the average Joe (like you and me) sound

riveting and can personalize it to involve your clients, you can put your time to better use. I have talked with many photographers about blogs and I haven't found many who find they work well with seniors.

Mass Advertising. Over the years we've tried radio and television ads and, while it was really cool hearing and seeing my advertisements, they received little attention from our target market. We've used weekly papers and had moderate success, while daily papers and supplements have been a bust. When we used the Yellow Pages, they charged a small fortune for a display ad, and the potential clients who called only asked one question: "How much do you charge?"

In any mass advertising campaign, you have to study the demographics—the age, sex, and economic status of

Mass advertising only works if it directly reaches your target demographic—for senior portraits, this means teenagers.

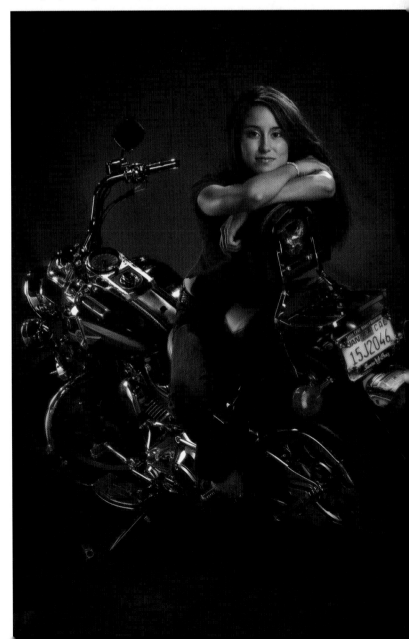

DIRECT MAIL RESPONSE RATES

Direct mail, in any business, has an average response rate somewhere between 2 and 5 percent for a mailing. In a competitive market, a realistic figure for a single mailing is more like 1 percent. It will be even less if the market has no clue who you are. The good news is that a campaign of direct mail—a program in which seniors get a mailer each week for a three-week period or every other week for a six-week period—gives you a better response rate with each mailing.

Of course, these are generalizations based on averages. If your mailers are badly designed or feature images that don't appeal to seniors, you won't get a response rate even close to this. On the other hand, you could be a mailer-designing genius and get a 5 to 10 percent response rate on your first piece. They call it an average for a reason, though: it's a number you can pretty much count on.

the people that your message will reach. Then you have to look at the actual number of readers, listeners, or viewers each individual station/newspaper has. This is a great deal of work, and that's why most people rely upon the advice of the person selling the advertising.

This brings us to the golden rule of advertising (and life): never take advice from someone who's making a commission on what they're selling you. I've seen photographers spend hundreds of dollars on ads in a local weekly paper for their children's portrait services (which the paper has the right demographics for) and then use the same paper for large ads about their high-school senior portraits. Teenagers don't read newspapers and, statistically speaking, the paper is for younger families, so the ads didn't even reach the parents of seniors. The most effective advertising exclusively targets your market. If you have mass appeal like McDonalds, you advertise in mass media. If your clientele is more specific, you must direct your advertising to a smaller group to get the most effective return on the money you invest.

Direct Mail. Direct mail is the top choice of photographers who buy advertising, so it's important to know how and why mailers work. With all the mailers that go

out each year, very few photographers have taken the time to study and learn what makes one mailer work, while another doesn't. What makes a client respond to one studio's mailing piece and overlook another? What types of mailers produce phone calls and what types produce potential clients?

In advertising, there are no sure things. Nothing *always* works. A famous advertising executive said that he figures about half of all of his advertising actually works. If he could only figure out which half it was, he would really have something. Regardless, there are many things that can be done to greatly increase the odds of success.

The best way to understand how to produce a better mailer is to understand what each component of a mailer is and how it benefits the response rate of that mailer. To begin, the portraits in a mailer must really capture the attention of the viewer (in the case of senior portraits, keep in mind that this means appealing to both the teen and their parents). In the sea of mailers, you can't show boring portraits. Also—and this is important—*show only your own work.* You should never use another photographer's work, no matter how much you think your style matches theirs.

Once the images are selected, add a good headline—a short, to-the-point bit of text to entice the viewer to read the copy and find out why they should select your studio. In a mailer that we've used in varying forms for the last several years, the headline reads, "No . . . they're not professional models!" The copy then goes on to explain that they look like models because they came to our studio.

Next, include a clear statement that explains what makes your product unique in the marketplace and how it can benefit the potential client. If your headline states that your studio provides lots of personal attention, you could go on to explain that your clients have more clothing changes and that you take time to find out what they really want out of the session. You can also reassure them that they won't feel rushed, they'll feel more comfortable because they have time to get to know you before their session, etc. The copy also needs to explain what the client needs to do. If you do consultations, explain how the client can schedule one. In our case we have a consultation

CD, so we invite the senior to come in and take one home. During their visit they can also look through the hundreds of sample senior portraits to make sure that we offer the style of senior portraits they are looking for.

Your logo is the most important part of your mailer. If every other part of your mailer is perfect, but you forget your logo—or if your logo is hard to read—the phone won't ring. A logo doesn't have to be anything more than your studio's name set in a distinctive typestyle. And remember: keep everything legible. If potential clients can't read your mailer easily, they won't read it at all. Keep the type clean and crisp.

Your studio hours should be listed in your mailer. How many times have you gotten a piece of advertising with no hours listed on it? Then you call the company that sent the ad only to find they don't have a recording that states the hours. You have to keep calling back until you reach someone. A person might do this for a once-a-year sale, but not it in an overcrowded market like senior portraiture.

SKIP THE CAR WRAP

Putting a sign on your car, or using a car wrap, turns your vehicle into a huge billboard—but that's not always a good thing. Case in point: a local photographer had his name proudly displayed on his car. Without the name being on the car, I would have had no idea who this person was. With his name on the car, however, I knew who was picking their nose while waiting for the light to change! People often forget that the glass of a car is clear and behave in ways they shouldn't. Unless you want to walk onto a high school campus and hear, "That's the jerk who cut me off!" I'd skip putting your name on your car.

Create a Theme. As I mentioned, it takes four to six separate messages for the average person to remember your name and call you when they have a need for what you're selling. Your name alone will not be remembered unless you have a theme that ties your messages together.

The portraits you select for a mailer should be ones that really grab the viewers' attention.

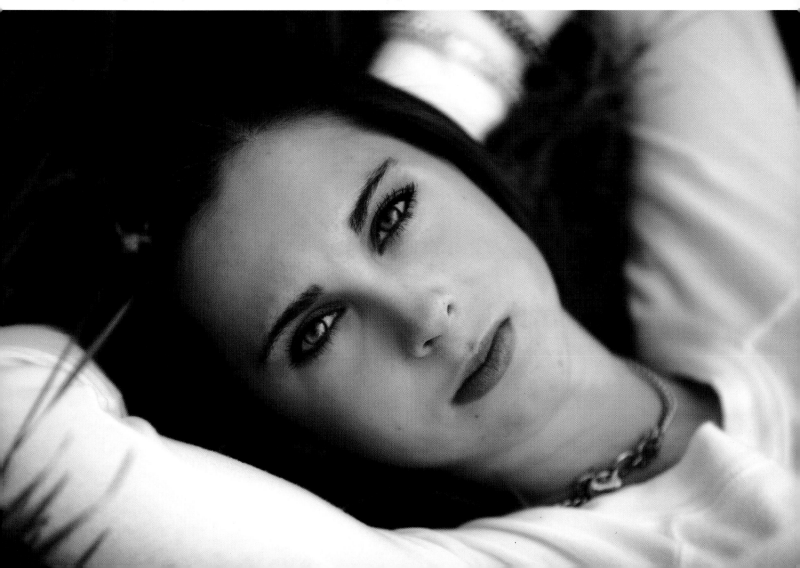

Uneducated advertisers design their ads one piece at a time and do nothing to link those pieces together; savvy advertisers work on designing a *campaign* (many advertising messages tied together with a common theme). The flavor of the campaign will communicate your style to your target audience.

A common theme doesn't mean saying the exact same thing in every ad. It means linking the look and feel of each advertisement together so that when a person gets the mailer (sees the ad, opens your e-mail, etc.), their mind links the current message with the ones they've already seen.

Ask Your Clients. If you're going to do any kind of advertising, I suggest calling the five best senior portrait clients you've had in the last year. Ask them if they read the newspaper and what radio station they listen to. Also ask whether or not they read single-sheet ads (postcards, larger ads) that come in the mail, or if they'd be more likely to open an envelope and read the ad inside. The questions can go on and on depending on the type of advertising you want to do.

The same can be done for any marketing decisions. Make up a focus group of past clients (they don't have to meet in a group) and get the needed information from them. They can decide everything from the paint colors for your walls to your business-card design, to the language you use in your ads. (We're lucky, because many of our employees are past clients, so we run everything past them to make sure we aren't off the mark. Many times, we've written ads using what we considered trendy sayings, and our younger employees alerted us to the fact that we sounded like older people trying to be hip.) This way, you're sure that everything in your business is designed to the taste of the client you want to attract.

Another good idea is to ask first-time clients how they came upon your studio. This tells you what's working, although many times you have to use this information with a degree of common sense. A client might say she came to your studio after a recent mailing, giving you an idea to increase your mailings, but what really sold her on your studio were some of your past clients, an exhibit you did last year, etc. The mailer just happens to be the last thing

BELOW AND FACING PAGE—*Talking to your clients can help you tailor every aspect of your business to their tastes.*

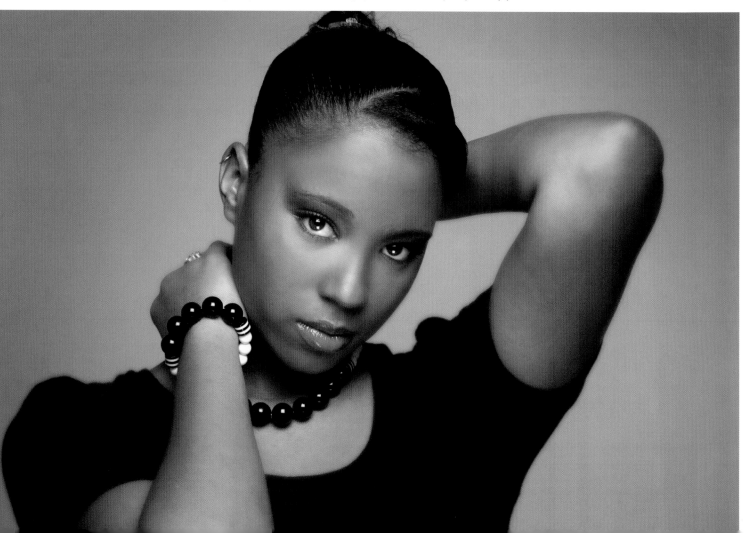

she received, and she held on to it to keep your number on hand.

There Are No Average Seniors

Averages may be numbers you can count on; indeed, I've cited a lot of averages throughout this book. But—pessimists, take hope!—there are no average seniors. That means there is always room in the market for options. If you can bring something unique to the table, there will be people who choose you for it. For example, if the studios that currently contract and market to your local high schools only photograph inside the studio, maybe your local seniors are looking for someone who works at outdoor locations (and after reading my books you will be the outdoor master!).

Believe it or not, in my area there are some crazy seniors who don't come to my studio to be photographed—in fact, there are quite a few! If you look at this from the outside, it sounds crazy. I am the author of twelve books

on professional photography; I am by far the most well-known senior photographer in my area; we have a studio like no other in our area—with a Viper, Harley, and tons of sets and backgrounds available; we shoot at numerous outdoor locations around the city and at the beach (and don't change extra for it); we are located near the premiere shopping area in our city.

Logically thinking, if the average senior could choose to come to me or another local photographer, he or she would be nuts not to come to me, right? However, there are seniors in my contracted high schools who won't come to me because they simply don't like being told where to go. There are seniors I market to who say, "Everyone goes there—I want to go somewhere else!" Some seniors say, "He must be way too expensive!" (usually without having any idea what we charge). That's just the way it is. No one business can appeal to everyone—and thank goodness. I like being able to spend days off with my family, writing my books, and handling my investments.

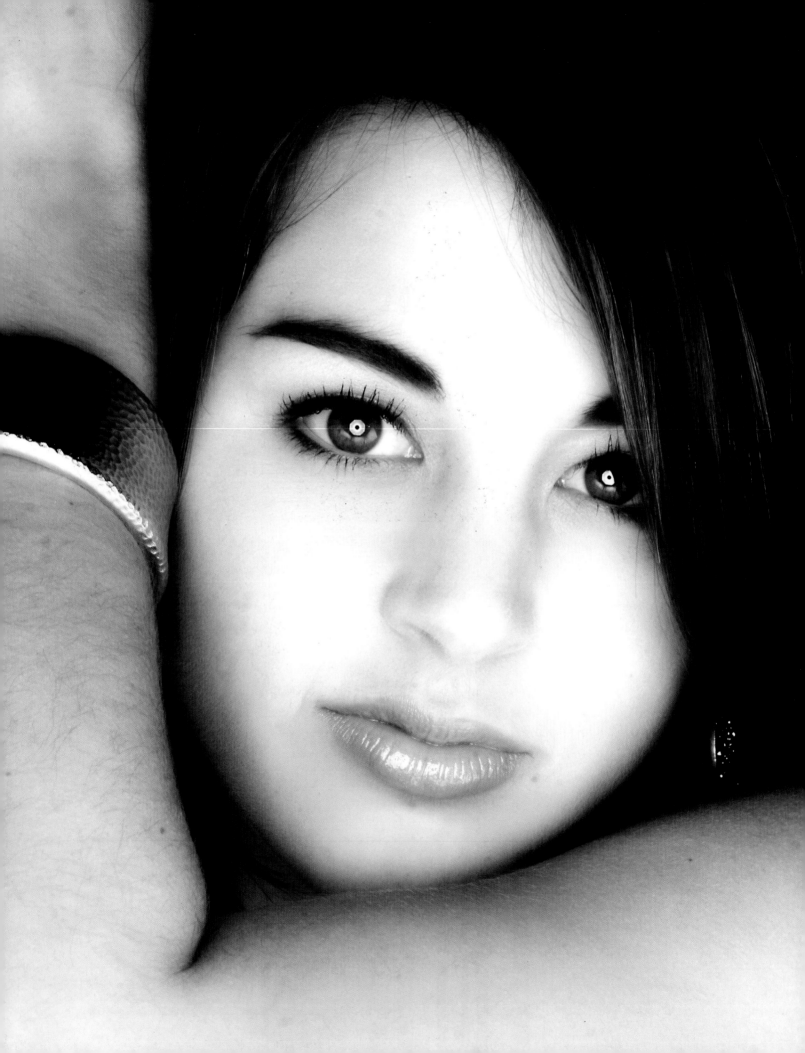

The moral of the story is a simple one: no matter how good the competition is, they will never capture all of the market. Conversely, no matter how bad the contracted studio is, they will capture at least some of the market. These two factors, whether working for you or against you, are just the way it works.

Be Honest, Accurate, and Consistent

Businesses are more likely to thrive when, both verbally and non-verbally, they accurately communicate what kind of business they are and what type of clients they do business with.

Restaurants are excellent examples of this. Love them or hate them, McDonalds, Carl's Jr., and Taco Bell don't try to be anything other than what they are—a fast, cheap place to get food. Nicer restaurants don't try to lure you in by looking like cheap fast-food places and then shocking you with the cost of your meal only after you've ordered. In fact, most nicer restaurants post a menu in their window or front display just to make sure you know what they charge and that you'll like what they have to offer.

Restauranteurs of all kinds understand some things that most photographers don't. First, the buying public isn't stupid; they know the difference between fast food and fine dining just like they know the difference between the work of a professional senior portrait photographer and an untrained amateur. Second, a restaurant wants the buying public to know what they charge and what they offer. If the price or selection isn't right for a given client, it is far better that they go elsewhere—there's no point trying to fit a round peg in a square hole. This is a major lesson for those photographers that find themselves working with too many problem clients; problem clients are usually just people who weren't a good fit for your business in the first place.

Photographers tend to want to work with everyone, but to be successful you must send some business away. The fact that I send away as much business as I do plays a

BELOW AND FACING PAGE—*Everything about your business—from your marketing to your studio location and design—should communicate your identity to clients.*

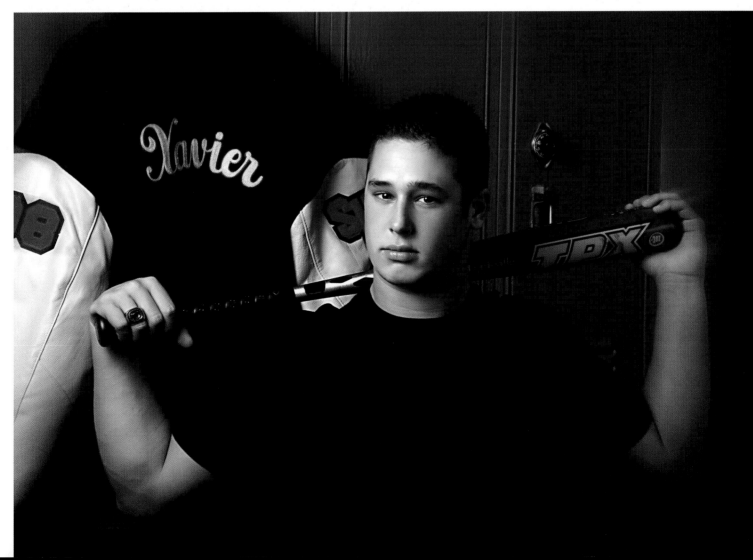

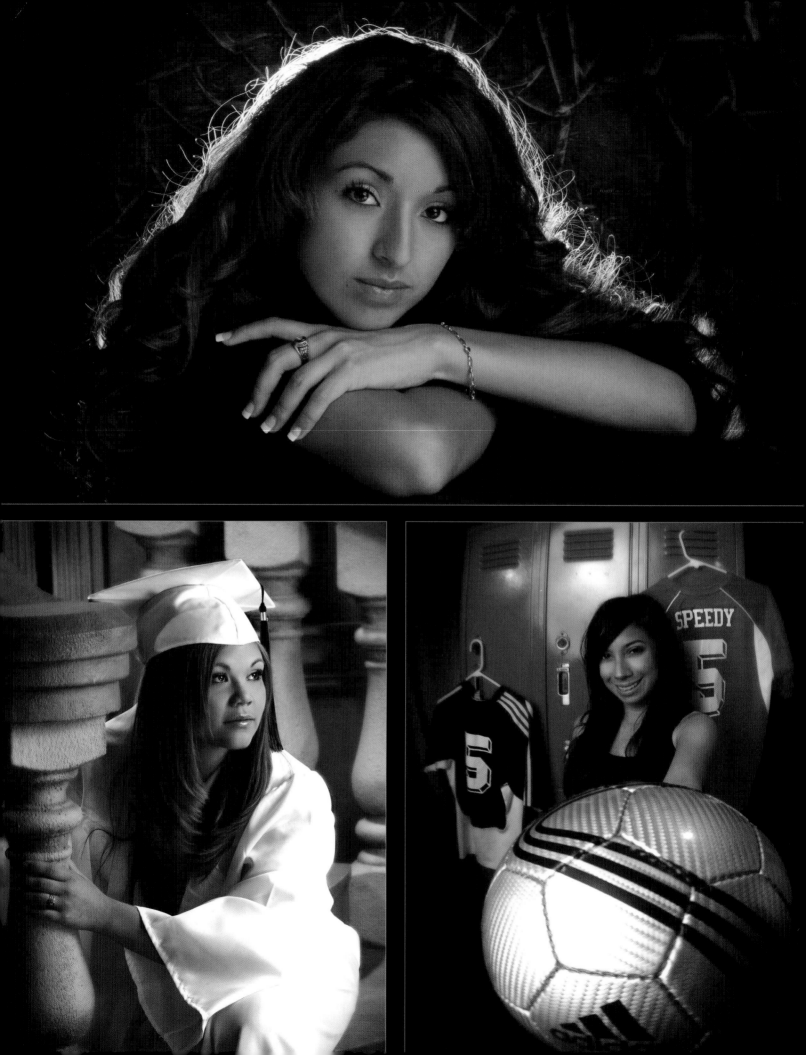

significant role in my success. Because I accept only clients who are a good match (they want what I sell), every time I pick up a camera I am assured that I am making a considerable amount of money per hour. The best way to ensure that the clients who are coming to your studio are a good match? Be accurate, honest, and consistent in your marketing—and, for that matter, in every aspect of your business to which clients are exposed.

Cultivate an image that reflects the tastes of your target market. Everything from the message contained in your radio ad, to the color scheme you use in your print advertising, to the interior of your studio must attract the desired clientele. The portraits you display in your studio and the music you have playing in the background must also appeal to your target market. By taking these steps, your target market can identify with every part of your business.

When you get really good at this, potential clients should be able to determine at a glance what type of portraits you offer and roughly what they can expect to pay. The images displayed on the ad, the colors you select, even the quality of the printing and the layout, should speak volumes about your studio.

When a person walks into your business, they should know right away whether or not it is right for them. When a potential client walks into our studio, they see nothing but senior portraits. A bride-to-be or mother looking for children's portraits will know right away that she's in the wrong place. The color schemes and furnishings used in the studios are slightly upscale but are modest enough not to scare off any of our contracted seniors, some of whom have modest budgets. The music is a little louder than in most businesses and is always set on the station that the high school seniors listen to the most.

Most photographers never think about their studios in these terms. They pick out everything according to their personal tastes—without thinking about their clients. Many photographers in a general studio display portraits they like, rather than using their display portraits to help define their business. I have gone into studios that photograph many seniors, but they have nothing but wedding and children's portraits on display. This would be like going into a Chinese restaurant and seeing sombreros and Mexican blankets all around for decoration—it wouldn't make much sense.

Select your decor to match your desired pricing. Many photographers want to charge more for their work, but they have an old, torn sofa in front of their studio that's been there since the '70s. Some studios select furnishings that are too nice, and this can also be a problem. If you walked into a restaurant for a casual, low-cost lunch and saw fine art on the walls, overstuffed chairs at each table, and columns and marble floors as far as the eye could see, your heart would start racing! You'd turn and leave before ever looking at the menu. As a result, you'd never find out that they had good food at reasonable prices.

Similarly, many inexpensive studios scare their market away by using expensive paper and elegant designs in their

BELOW AND FACING PAGE—*People who walk into our studio see nothing but senior portraits.*

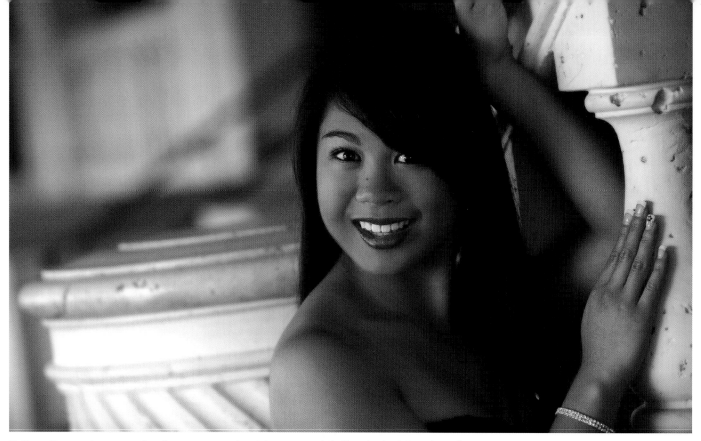

Believe it or not, perception has more to do with a potential client's decision than facts.

advertising. Many "upscale" studios, on the other hand, have only an upscale *price*; their advertising, studio location, and/or design lack the needed sense of luxury and exclusiveness.

Believe it or not, perception has more to do with a potential client's decision than facts. Clients aren't stupid, but if they get the wrong message, they'll make the wrong assumptions. For example, one senior portrait studio in our area is actually priced toward the higher end of the spectrum, but because they constantly offer discounts they are perceived as being a discount studio. How this works out for them, I couldn't tell you; I suppose they must have a great deal of phone calls with a very small percentage of those callers becoming their clients.

Watch Your Budget

You could spend limitless amounts of money and time on marketing, so guard your marketing dollars carefully. There are always skilled salespeople waiting to sell you on advertising schemes—most of which won't make any financial sense for a senior portrait studio. For senior portraits, I would urge you (in general) to avoid the Yellow Pages, large daily newspapers, coupon-clipper booklets, local magazines (unless you live in a city with a magazine directed at teenage clients), television, billboards, and any other form of advertising that doesn't directly target your potential clients. T-shirts might also be added to this list. I buy them, but I consider them a give-away to clients who have ordered, not a way to advertise. Have you ever decided to do business with a company (other than, perhaps, Hooters) based on their t-shirt? I haven't. The same is true for pens, pencils, and all the many other products that companies will offer to print your name on. Save your money.

Final Thoughts

Look for as many avenues as possible to keep your name and images in front of potential clients; avoid paid advertising messages that don't precisely target your demographic. Come up with a budget, stretch it as far as you can and don't use one dollar of your budget for anything else other than the advertising you have decided on—unless you genuinely believe that something new would be more effective. That's the long and short of it.

Being Profitable

As I noted earlier, in senior/teen photography, you have two buyers: the senior/teen and the parent (*i.e.,* the person with the money). That results in a number of business challenges, which are the subject of this chapter.

Prepaid Sessions

Because you have two clients, you can easily experience a breakdown in communication. Most of the time, the senior/teen is the one who gets the information and makes the appointment—but the parent must also be there and have the funds to buy the portraits. Even if you (or your staff) clearly tell the senior everything about the session and ordering, about half of the information won't make it to Mom or Dad. Even if information is mailed to the family's home, in most cases the parent will simply give the information packet to the senior without looking at it.

The best way to ensure parental involvement in the planning of the session is to have each client pay for their session when they schedule it. When the senior asks for Mom's credit card, I guarantee she'll start to ask some questions. Doing only prepaid sessions ensures that you are dealing with serious clients who will show up for their sessions. Seniors/teens are very impulsive—they will see a display or receive a mailer and call that second without giv-

Requiring sessions to be prepaid ensures that teens and their parents are on the same page before booking the session.

ing any thought to the timing, their parents' schedules, the budget, or anything else. If left to their own devices, seniors will make an appointment, then cancel it again and again and again. Before we started requiring sessions to be

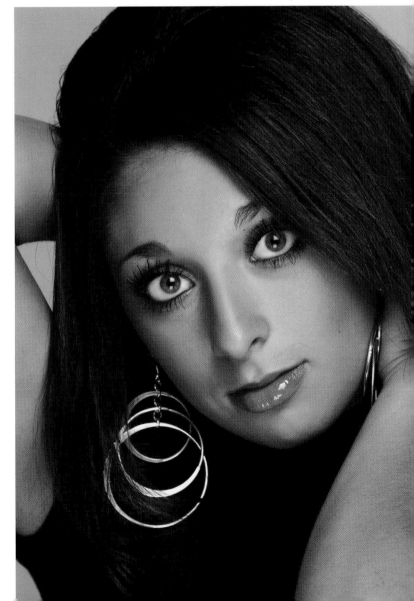

prepaid, we tracked one senior who canceled and rescheduled her appointments *six times* over the course of her senior year. If you don't have a prepayment policy, your only other option is overbooking to account for no-shows.

These ideas might not be right for everyone, but I encourage you to give them a try. When clients prepay for their session, you know they are committed to the entire process of ordering senior portraits. And if a client calls to make an appointment but doesn't schedule because they have to prepay, isn't that better than standing around waiting for no-shows who don't value your time?

Insist a Parent Accompanies the Senior/Teen

Since you are dealing with underage children, you must request that a parent sign in the senior/teen and stay with them throughout their session. We live in a litigious world, so I want a mother to follow her daughter through every part of the session; I never want anyone to question anything that went on. Secondly, many parents who drop off their senior use it as a way avoid paying for the portraits. If the parent is not present at the session, you will hear a lot of, "Oh, my mom forgot to give me a check. She'll just mail it to you." That's no way to run your business.

Shoot It, Show It, Sell It

In chapter 2, we looked at the importance of showing your images to your clients immediately after the session. In this market, you will lose between 20 and 40 percent of your sales if you send proofs (in whatever form) home with clients or have them make a second appointment to come back and view their images.

Think about it: you don't see too many jewelry stores sending home four or five diamond rings for a client to choose from. That's because we all know those rings have intrinsic value. When you send your work home with clients, you're basically saying that it doesn't have value—in which case, who cares if the images are copied, returned, or ever ordered from?

In today's litigious society, insisting that a parent is present for the session is a reasonable precaution.

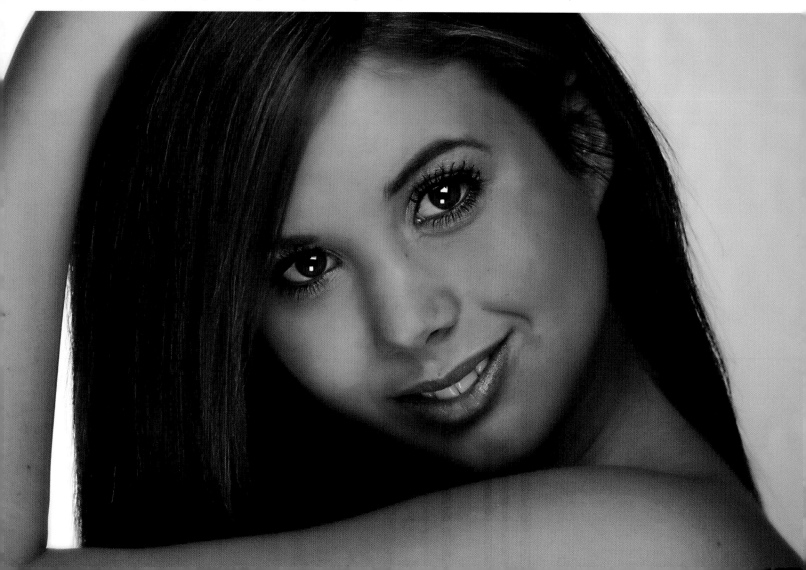

You don't have to believe me. Look at any of the national photography companies you see in department stores and malls—they all use instant previewing for two important reasons: one, people are excited; two, they are there. If you put off the sales session to a later date, the excitement diminishes and there is a good chance the client will miss the appointment. For senior sessions, ordering on the day of the session also ensures the parents will know what is going on. When you explain to the senior that the session is prepaid and they will be ordering on the day of the session, they have no choice but to inform the parent of the process.

There are two questions that you will get in objection to this whole process. The first one is what salespeople call a stall—a question that allows the buying decision to be put off: "What if I am not ready to order after the session is over?" To this, your response should be, "Well, then let's wait to make an appointment for your senior portraits until you are ready to order." No one can argue with that.

The second question is a little trickier: "You mean your studio is forcing me to order?" Here, your response should be along the following lines: "Not at all. You obviously have the choice to order or not—but if you love the portraits, which you will, wouldn't you expect to order from them?" Most clients understand this. The few who have a problem with this process can go to one of the many photographers who not only sell images, but allow clients to come in and "visit" with their unpurchased portraits as many times as they wish. ("So you're coming in today to order your daughter's seniors portraits?" these photographers ask. "No," replies the client, "I brought her grandmother in to see them—we're just visiting!")

Protect Your Copyright

In this digital age, where every home has a decent computer and either a flatbed scanner or a printer with a decent scanner built into it, copying of our work is a serious problem. Younger people—your demographic—are particularly accustomed to not paying for copyrighted products (music, for example), but even more upscale older clients who would have never have thought of copying your work ten years ago now see copying as a way to save money. To

Ordering right after the session builds on the excitement of the shoot.

ensure your business is successful, you must stop your clients from copying your images.

To accomplish this, we do three things—and if you do them, you will save the cost of this book hundreds if not thousands of times over.

Add Your Logo. The first thing you must do is to create a logo that goes on each and every image that leaves your studio. We designed ours to be almost transparent, similar to the watermark on images you see on the web. The idea is to have your studio name on the front of each image, so when a client takes one of your prints to a lab—say at Target or Kinko's—to make more copies, the more reputable businesses will see the logo and not violate the copyright laws by duplicating it. That being said, you don't want the logo to be *too* prominent or it will look as

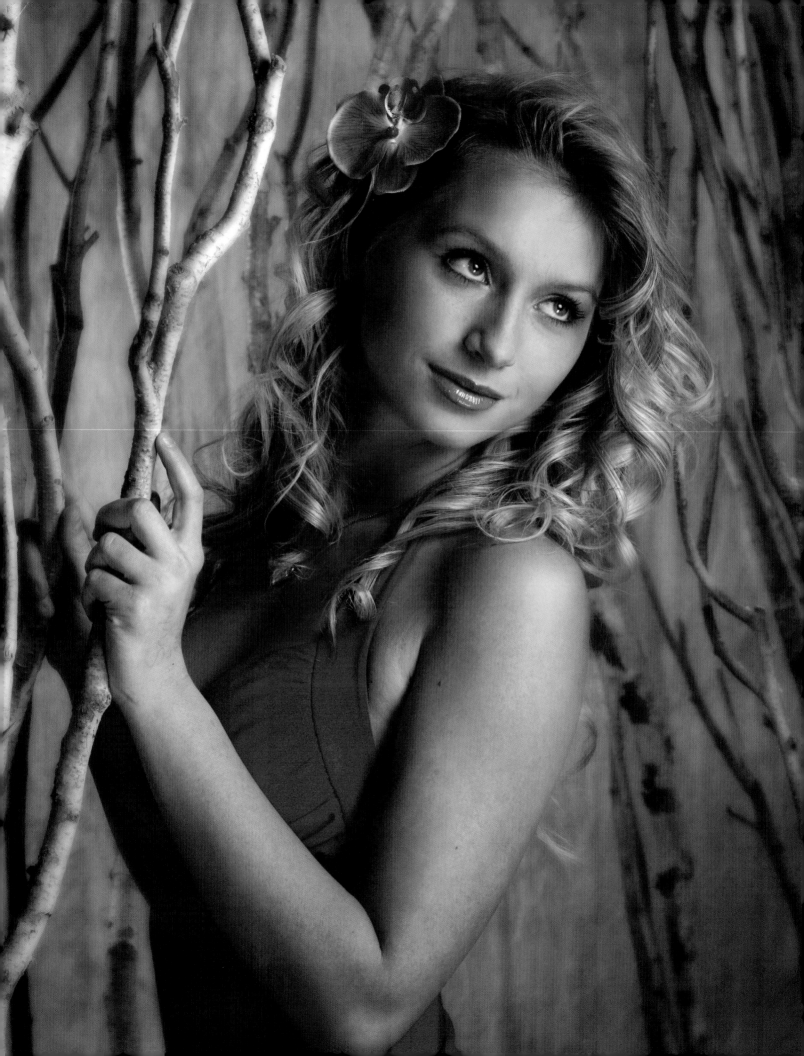

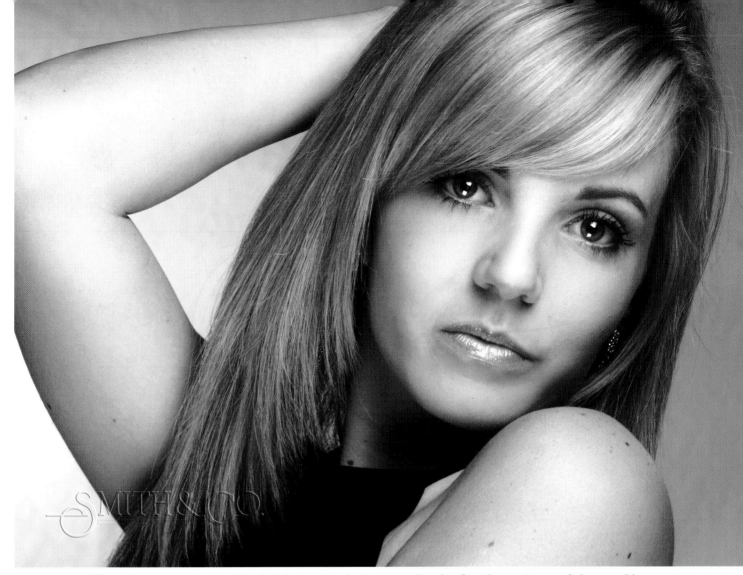

FACING PAGE—*When clients are pleased with their images, ordering immediately after the session won't be a problem.* ABOVE—*Adding a subtle logo to every print that leaves your studio helps to protect your copyright.*

though you are blatantly advertising across the front of your clients' portraits. It should be very subtle, so you really don't notice it just looking at the portrait.

Be prepared: when you first do this, some clients will complain—but those will typically be clients who have taken your work to Kinko's and been sent away; no client has ever complained about our logo at the time they picked their order up at the studio. When a client does complain about the logo, we explain that practically every product you buy has a logo on it—from clothing to cars—and we are no different. Most clients want our logo, just like most women want the Coach label on the outside of their handbag. We finish by saying that, "Typically, the only time someone is bothered by the logo is when they are trying to copy one of our images and are turned away

because of the copyright laws." This statement doesn't accuse them, but it uses your experience with other clients to let them know that *you* know the real reason they are calling. After these comments, there is little argument.

Add Texture to the Prints. The second step in stopping clients from copying is to texture your prints. Many photographers today don't even know what texturing is, but years ago, some studios would sell linen or canvas texturing on their final portraits and charge a premium price for it. The idea never really caught on because most clients didn't want to pay more for a textured print. However, the texture on the print makes high-quality copying almost impossible. This type of texture is offered by most labs, or you can buy a texture machine. These work like the older rollers for wringing the water out of clothing. There are

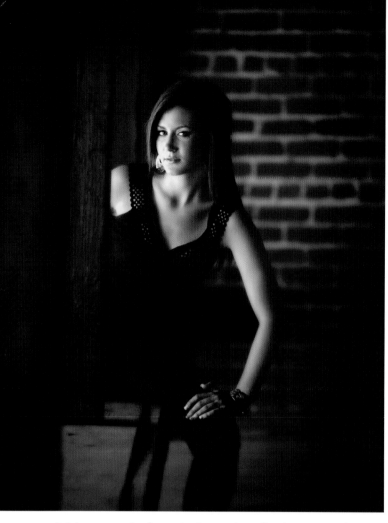

Pricing your single portraits at virtually the same price as a small package reduces the incentive to copy your images.

two heavy rollers with the texture pattern on them, and as the print goes through the two rollers the pressure embeds a permanent texture on the print surface.

The most popular texture is linen. A canvas texture is too smooth to stop copying, and a pebble texture is too heavy; it becomes an eyesore in your portraits. You don't notice a linen texture at a normal viewing distance or under glass, but the lines of texture pop right out when copying and degrade the quality of the copy. As a result, copies from these textured prints will not be something that most paying clients will want to give away. If your lab doesn't offer roller textures (some machines use a screen), see page 123 and e-mail me for the name of a company that sells the machines. While they can run $1500 or more, it is an investment in your profits.

When using texture and logos on your work, you must make sure that every print your clients see in your studio has the same texture and logo on it—you do not want it to be a surprise when they pick up their order. In our studio, we only texture prints up to 8x10 inches, but our logos are on every print size.

Stop Selling Single Prints. The last step in eliminating copying is to stop selling single portraits from a session. Do you have clients who order one 8x10 and nothing else from a beautiful session? Then you have just identified your worst copiers—copiers who don't even care if you know they are copying or not. These are the people who think that they are entitled to copy your work because they paid a sitting fee. The average person will at least order a small package or a few prints so you don't suspect them of copying. The single portrait buyer is the worst, so stop selling them.

Notice I said stop *selling* them, not stop *offering* them. If a client wants a single image, sell it to her—just make sure it is virtually same price as a small package would be. Some photographers eliminate this problem with a minimum print order. Everyone knows that the cost of a portrait is in the retouching, enhancement, and testing to make sure that final image is flawless. After that, whether you print one portrait or ten, the cost is about the same—at least that is the way you explain it to your clients when they ask why one portrait is the same price as your smallest package.

Selling individual, untextured prints with no logo on them is giving your work away. It also causes suspicion in your relationship with your client; you can't look at your clients as copyright violators and still treat them with the respect they deserve. In reality, people most often do the right thing. If you remove the temptation to do the wrong thing, you'll be secure in the knowledge that your clients are treating you with the same respect you show them.

In Closing

I hope that you have enjoyed this book. If you have any questions or comments you can e-mail me at jeff@jeffsmithphoto.com. I try to return e-mails within 48 hours. For additional products you can visit our web site at www.smithandcostudios.com or www.amherstmedia.com.

Index

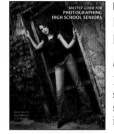

DOUG BOX'S
GUIDE TO POSING
FOR PORTRAIT PHOTOGRAPHERS

Based on Doug Box's popular workshops for professional photographers, this visually intensive book allows you to quickly master the skills needed to pose men, women, children, and groups. $34.95 list, 8.5x11, 128p, 200 color images, index, order no. 1878.

500 POSES FOR PHOTOGRAPHING WOMEN

Michelle Perkins

A vast assortment of inspiring images, from head-and-shoulders to full-length portraits, and classic to contemporary styles—perfect for when you need a little shot of inspiration to create a new pose. $34.95 list, 8.5x11, 128p, 500 color images, order no. 1879.

PROFESSIONAL PORTRAIT PHOTOGRAPHY
TECHNIQUES AND IMAGES FROM MASTER PHOTOGRAPHERS

Lou Jacobs Jr.

Veteran author and photographer Lou Jacobs Jr. interviews ten top portrait pros, sharing their secrets for success. $34.95 list, 8.5x11, 128p, 150 color photos, index, order no. 2003.

MONTE ZUCKER'S
PORTRAIT PHOTOGRAPHY HANDBOOK

Acclaimed portrait photographer Monte Zucker takes you behind the scenes and shows you how to create a "Monte Portrait." Covers techniques for both studio and location shoots. $34.95 list, 8.5x11, 128p, 200 color photos, index, order no. 1846.

THE BEST OF PORTRAIT PHOTOGRAPHY
2nd Ed.

Bill Hurter

View outstanding images from top pros and learn how they create their masterful classic and contemporary portraits. $34.95 list, 8.5x11, 128p, 180 color photos, index, order no. 1854.

SOFTBOX LIGHTING TECHNIQUES
FOR PROFESSIONAL PHOTOGRAPHERS

Stephen A. Dantzig

Learn to use one of photography's most popular lighting devices to produce soft and flawless effects for portraits, product shots, and more. $34.95 list, 8.5x11, 128p, 260 color images, index, order no. 1839.

THE BEST OF FAMILY PORTRAIT PHOTOGRAPHY

Bill Hurter

Acclaimed photographers reveal the secrets behind their most successful family portraits. Packed with award-winning images and helpful techniques. $34.95 list, 8.5x11, 128p, 150 color photos, index, order no. 1812.

RANGEFINDER'S PROFESSIONAL PHOTOGRAPHY

edited by Bill Hurter

Editor Bill Hurter shares over one hundred "recipes" from *Rangefinder's* popular cookbook series, showing you how to shoot, pose, light, and edit fabulous images. $34.95 list, 8.5x11, 128p, 150 color photos, index, order no. 1828.

PROFESSIONAL PORTRAIT LIGHTING
TECHNIQUES AND IMAGES FROM MASTER PHOTOGRAPHERS

Michelle Perkins

Get a behind-the-scenes look at the lighting techniques employed by the world's top portrait photographers. $34.95 list, 8.5x11, 128p, 200 color photos, index, order no. 2000.